Lyre Leaved Sage

John Banister: Clergyman + first
naturalistic

a. Blue Bell: March - June - propagated
by seed or dividing
the plant in fall - Plant
seed immediately upon
gathering -

Southern Wildflowers

Published by
LONGSTREET PRESS, INC.
2150 Newmarket Parkway
Suite 102
Marietta, Georgia 30067

Printed in the United States of America

1st printing, 1989

Library of Congress Catalog Number 88-083934

ISBN 0-929264-17-7

This book was printed by R. R. Donnelley and Sons, Willard, Ohio.
The text type was set in ITC Garamond by Typo-Repro Service, Inc., Atlanta, Georgia.
Color separations by Color Response, Charlotte, North Carolina.
Design by Paulette Lambert. Cover photo by David Martin.

To my siblings,
Linda, Diana, Sharee, and Lee

Southern Wildflowers

LAURA C. MARTIN

Illustrated by Mauro Magellan

LONGSTREET PRESS
ATLANTA, GEORGIA

Contents

Fall

Appendices

Southern Wildflowers

Introduction

Wildflowers are irresistible. Real wildflower enthusiasts will crawl on hands and knees or scale the highest mountain to catch sight of their favorite wildflower in bloom. But even an armchair enthusiast can enjoy wildflowers, for these lovely treasures of nature grace the landscape in not only hard-to-reach places, but also very common and easily accessible locations as well. Drive along roads in all parts of the South and the gaudy bright colors of roadside plants will delight your eye.

The Southeast is blessed with a tremendous diversity of native plants. Wildflowers in the South come in every size, shape and color and can be found in the many different ecosystems that make up our area. High in the mountains, intricately detailed wildflowers peek out from underneath the high canopy of evergreens. Along the coast, hardy species withstand heat and salt air to color the landscape with their bright hues.

Some of our wildflowers are so specialized that they can grow only within a very small area. The canebrake pitcher plant, for example, grows only in a few counties in central Alabama. Its cousin the northern pitcher plant is so adaptable that it grows throughout both the Southeast and the Northeast.

Some of our wildflowers are so common that many people consider them weeds. Dandelions, though beautiful when viewed individually, are generally scorned as being pesky weeds.

Some of our rare and endangered species were found and identified hundreds of years ago. Oconee bells *(Shortia galacifolia)* were first discovered by André Michaux in 1787. Others, however, have been only recently discovered. Harper's beauty *(Harperocallis flava)* was found by Professor Sydney McDaniel of Mississippi State University in 1965. This lovely member of the lily family has thus far been located only within the Apalachicola National Forest in the Florida panhandle.

Many of our southern wildflowers, both common and rare, have played an important part in the history of our region. To the Indians they supplied food, medicine, and often magic. The impor-

tance of these plants to the Indian culture is clearly evident in the number of myths and legends that include the flowers and plants.

To early explorers, the native plants were not only beautiful jewels in a new and exciting land, but also often tasty additions to bland camp food. Learning from the Indians, pioneers were also able to use many of the roots and leaves of plants for necessary medicines.

Sometimes native plants were important economically. Daniel Boone is said to have greatly supplemented his income by collecting and selling ginseng roots. Later, John Ruch of Franklin County, Tennessee, supplemented his farming income by growing and selling a new species of clover called crimson clover.

Today we are still dependent on our native plants, both spiritually and physically. Many contain important medicinal chemicals. Mayapple *(Podophyllum peltatum)* provides two different chemicals used in cancer-fighting drugs. Bloodroot *(Sanguinaria canadensis)* supplies us with a chemical used in toothpaste to help fight plaque and tooth decay. Perhaps one of the more unusual uses of plants today is that of spiderwort *(Tradescantia virginiana).* The stamen of this common wildflower changes colors when exposed to radiation, so scientists can use the plant as a quick and inexpensive radiation detector.

Native plants will always be important to us. Physically, we will need them for the chemicals they contain. For use in medicine and industry, these plants have always been and will always be essential. But perhaps the true importance of our native plants lies in their beauty that boosts the spirit. Our wildflowers are the most beautiful and exciting natural resource of our region.

Southern Wildflowers is a celebration of this resource. Through exploration of the myths and legends surrounding these plants, the people involved in their discovery, and the myriad uses for which they have been employed, each of our southern wildflowers takes on a new importance and a unique personality.

Each wildflower is beautiful in its own right. Some are showier than others, some boast a richer history than others, but each is important for what it has given us and for the potential that it holds.

William Blake said that he could see heaven in a wildflower. If Blake came south and looked around, he would find himself in heaven on earth.

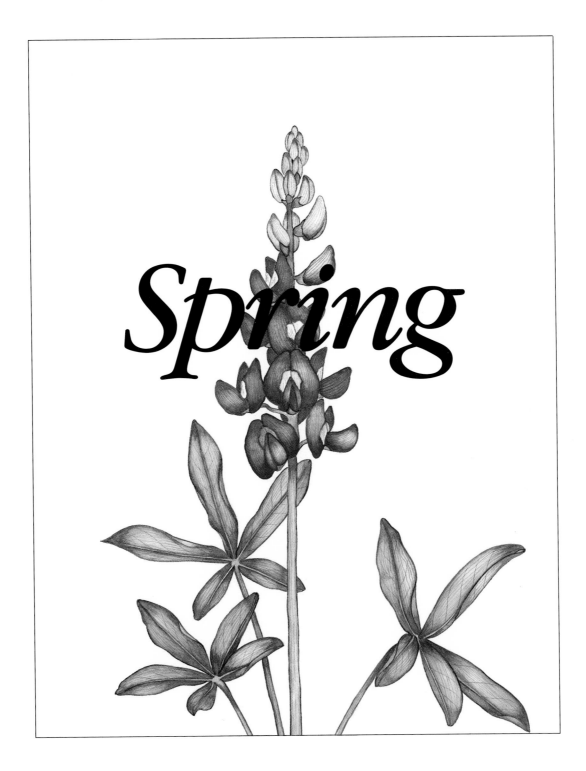

Spring

Bloodroot
(Sanguinaria canadensis)

Fragile rays of an early March sun dapple the forest floor of an eastern Tennessee mountain slope. Bloodroot, curled tightly as a cocoon, valiantly pokes through the ground, defying the threat of cold and frost that still hangs heavy in the air. As the sun grows warmer and the days stretch longer and longer, bloodroot blossoms become bolder still and grow and bloom. The first stark white petals are a startling contrast to the still dark forest floor.

Eight to ten petals surround a cluster of golden stamen, looking like a freshly starched petticoat. The leaves, protective as a chaperone at a high-school prom, stay curled around the blossom to shield it from the danger of a late frost. Like all chaperones, however, the leaves soon outgrow their usefulness. Once the flowers have been pollinated, the dance is over and the petals drop one by one. Now is the time for the leaves to come into their own. They unfurl, displaying their lovely, unusual shape, and grow richly and fully until midsummer when they, too, drop to the forest floor.

Although the flowers and leaves are of great beauty, the root of the plant gives it both its common and genus names. *Sanguinaria* is from the Latin word meaning "blood." If the root is cut or slashed, bright blood-red sap runs freely from the wound. Touch it, and this vibrantly colored sap will stain your fingers.

North America Indians used the sap for more than staining fingers, though. The sap, mixed with other ingredients, was used as war paint and also as a dye for blankets and baskets. Today Appalachian craft stores are full of dark rust-red baskets dyed with the sap of the bloodroot.

In his 1612 diary, Captain John Smith suggests that the Indians used bloodroot dye for other purposes as well. He relates how the Indians sent "a woman fresh painted red (from bloodroot)" to bed one of the colonists.

The Indians did not limit their use of bloodroot to cosmetic purposes. They believed, perhaps, that anything so vibrantly colored

must have other virtues as well. The sap they used as an insect repellent. The root was dried and used to cure the bite of a rattlesnake. Juice from the plant was also used to treat malignant tumors.

Early American pioneers, learning from the Indians, found bloodroot useful in treating coughs and colds. A drop of sap on a lump of sugar was an effective but dangerous cough remedy. The sap, if taken in too great a quantity, causes unpleasant side effects. It is caustic and corrodes and burns tissues on contact.

We are still learning from the Indians. Because the root was used with some effectiveness in treating tumors, researchers today have taken a particular interest in bloodroot. Because both the sap and an infusion from the root have been found to be chemically caustic and capable of destroying tissues, bloodroot has been effectively used to treat ringworm and eczema. Ingredients from the plant are also now being used in toothpaste to help fight plaque and decay.

Name: Bloodroot *(Sanguinaria canadensis)*
Family: Papaveraceae
Description: Early in spring, bright white blossoms are surrounded by a deeply lobed dark green leaf. The blossom is one and one-half to two inches wide, has bright golden-orange stamen and eight to ten petals. The leaves sometimes have a bluish tint and measure three to seven inches across. After the plant blooms, the leaves, which grow on a stalk separate from the flowering stalk, grow much larger. The stem and root contain a bright orange-red sap.
Blooms: February through May
Natural habitat: Found growing in rich woodlands throughout the region.
Propagation and cultivation: Bloodroot plants are readily available from reputable native plant nurseries. The easiest means of propagation is by division. The seeds must be sown while they are still quite fresh. If they are allowed to dry out, germination will be very poor. This plant likes rich soil and will perform better if given an annual dose of rotted leaves or compost. It likes best an area under deciduous trees so that it receives early spring sunlight but is then protected from the hot summer sun.

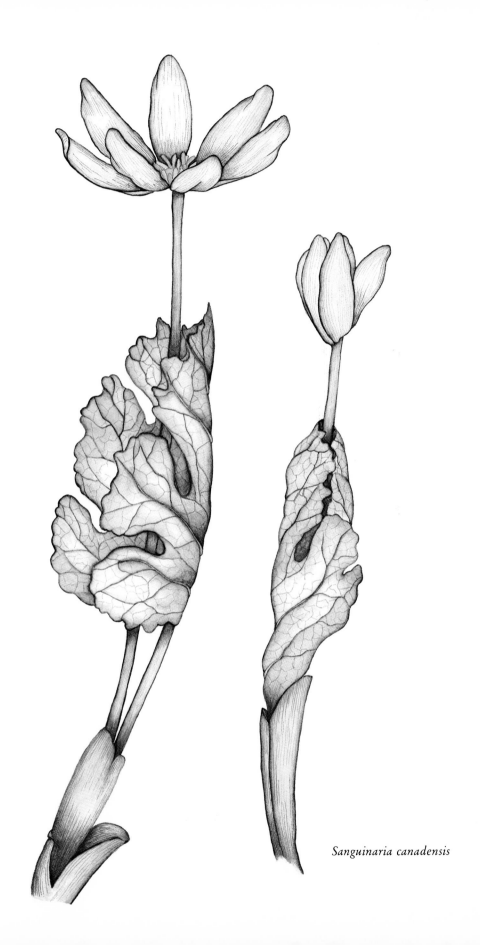

Sanguinaria canadensis

Virginia bluebell
(Mertensia virginica)

Plants and flowers have always provided humans with food, medicine, and pleasure. Since ancient times people have looked to plants to cure their ills, feed their stomachs and lift their spirits. It is no small wonder, then, that with the discovery of North America, explorers spent considerable time, effort, and money to find out what unknown plants grew in this unfamiliar world.

Collecting plants was a difficult job, for dangers were ever present in the colonies. Floods and fires, rapids and earthquakes, attack from Indians, and the threat of disease faced each explorer as he set out in unknown territory to find new plants. Collecting plants was, however, a very lucrative job as well. Sponsors from England included heads of state and members of royalty and nobility, as well as wealthy merchants and nurserymen.

One of the first and best known plant explorers in North America was John Banister, a clergyman and graduate of Oxford University. In addition to his skill as a clergyman, Banister was an avid naturalist with an insatiable curiosity that led him to the East Indies as a young man and to North America in his later years.

His sponsor was the Bishop of London, Henry Compton. At Compton's request Banister was sent to Charles Court, Virginia, in 1678, where he immediately began exploring the surrounding country. He kept scrupulous notes and in two years' time had catalogued all the plants he had found. His records were printed in 1688 in the *Historia Plantarum* and are considered to be the first written account of flora in North America.

Banister's love of adventure and great curiosity finally ended his life. In 1692, while on an exploring trip fifty miles above the falls in the James River in Virginia, Banister died. The romantic in us wants to imagine that Banister was reaching for an unnamed and exquisite specimen when he fell to his death. In actuality, there is some rumor that Banister was accidentally shot by a member of his own party.

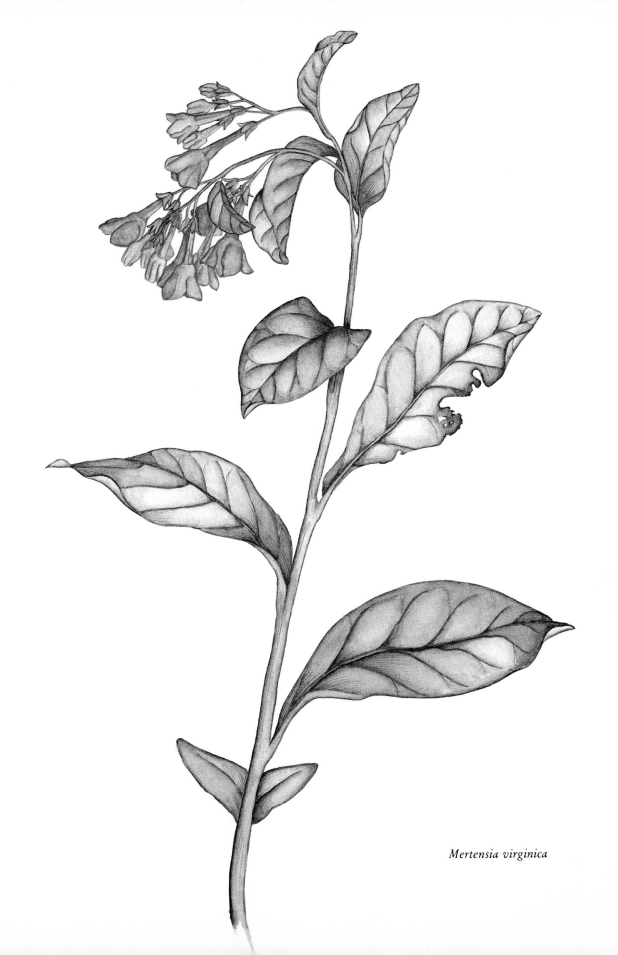

Mertensia virginica

One of the most beautiful of all the plants that Banister collected and sent back to England was the Virginia bluebell, *Mertensia virginica*. Reginald Farrer described the *Mertensia* genus as "this glorious race almost all of which are choice delights."

Also known as Virginia cowslip, Virginia bluebells hold but scant resemblance to the English cowslip or primrose. The flower buds start out bright pink and then turn a lovely shade of blue as the buds open.

The genus was named for Frank K. Merten, a professor of botany at Bremen University in Germany.

There is no known folk usage of this plant.

Name: Virginia bluebell *(Mertensia virginica)*
Family: Boraginaceae
Description: The flower buds are a distinct pink color and change to sky-blue only as they open. Each flower is about an inch long and has a five-lobed corolla. The leaves are smooth, gray-green, and two to eight inches long. It grows to a height of twelve to twenty-four inches.
Blooms: March through June
Natural habitat: Most often found on floodplains or in wet woods. It grows in this region south to northern North Carolina and Alabama.
Propagation and cultivation: Virginia bluebells need moist soil rich in organic matter. An area receiving high, open shade will supply the plants with sufficient sunlight to bloom but will protect them from the intense afternoon sun. A thick layer of rotted leaves and mulch will help preserve moisture. This plant can be propagated either by seeds (which should be sown immediately after collection) or by dividing the plants as they go dormant in the fall.

Texas bluebonnet
(Lupinus subcarnosus)

I had heard of them, of course, these bluebonnets of Texas. Who has not been entertained with stories of how the roadsides turn into waves of blue in early spring when bluebonnets are in bloom? Stories of their expansive beauty have spread across the nation, each story getting bigger and better than the last until these tales begin to sound like Paul Bunyan legends.

But a thousand descriptions could not begin to prepare me for the world of bluebonnets that met my eyes. Hundreds of thousands of blossoms nodded in the breeze, each flower perfectly formed, each upper petal bejeweled with a perfect white spot.

This expanse of blossoms reminded me of descriptions of the prairies. In 1875 a Texas ranger said that one could travel for hundreds of miles on a bed of flowers. I was mesmerized, lulled into a peaceful state by the thousands of blossoms before me. I felt like Dorothy in the *Wizard of Oz* when she was tripping through the poppy fields. I wanted just to lie down among them and let their beauty wash over me.

The following Indian legend tells how the first bluebonnet came to be:

> *It was a long time ago, before the white man came to the plains, that the land lay heavy with drought. It had not rained for many, many months, and the earth lay cracked and bare. The Indian people were becoming desperate, for the grass upon the plains was dying, and both the animals and the people knew great thirst. Day after day the sun beat down upon them with no relief from the sky. Not even a cloud passed through the sky to break the constant and fierce anger of the sun.*
>
> *The leaders of the Indian tribes were worried. They knew that without rain, their people could not live much*

longer, for without water there was no life. Finally they called all the people together for a council.

"We must pray to the Great Spirit for rain. We must give great sacrifices and be pleasing to the Great Spirit, for it is only through this magic that rain will once more fall upon the earth. Each one of you must give from your heart." The leaders spoke and their people listened, for they knew that without rain, they could not live.

All of the people went back to their homes to determine what they could give to the Great Spirit that would show a great sacrifice. Among the people was a young Indian girl whose prized possession was a beautiful little doll with straight black hair and a beautiful blue dress. The young girl carried this doll with her wherever she went, talking to it and caring for it as if the doll were her own little sister.

The young girl watched as her family gathered together their favorite possessions to sacrifice to the Great Spirit. Her mother put out an exquisitely beautiful bowl, her father gave his favorite spear tip, her brothers brought animal pelts and arrowheads. Being the youngest, the girl was not expected to give anything of her own, and she watched in wide-eyed wonder as these favorite possessions of the family were taken to the sacrificial fire.

Although all the villagers made great sacrifices, still no rain fell. Several days passed, the sun beat down unmercifully, and the earth became drier and drier. Once again the leaders asked for sacrifices, and the people looked deep into their hearts to find what they could give to the Great Spirit.

The young girl watched all that was going on, and it came to her that perhaps what the Great Spirit wanted was her doll. It was the light of her life, the one thing that she loved above all else. She began to cry at the thought of losing her beautiful doll, but she knew that she had to save her people

That night a great fire was built, and the people came, one by one to offer their sacrifices. When all had given, the young girl walked slowly to the fire and, with a small cry,

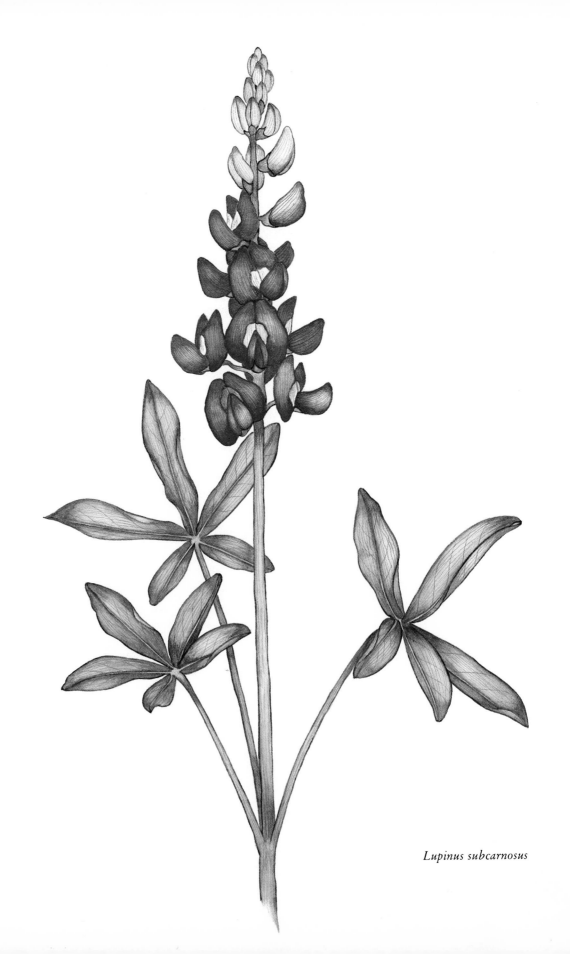

Lupinus subcarnosus

threw the beautiful doll with the bright blue dress into the flames. The fire leapt up, and suddenly it began to rain.

The people shouted with joy and began to dance and sing in celebration, and the young girl was highly praised for her loving heart. The next morning a beautiful rainbow filled the sky, and on the ground where the fire had been, the earth was filled with bright blue blossoms. These blue blossoms come back year after year to remind us that the Great Spirit loves a loving heart.

Bluebonnets still come back year after year, and their numbers have greatly increased thanks to the Texas Department of Transportation. Thousands of miles along the roadsides have been planted in wildflowers, resulting in great beauty and tremendous savings to the Department. Because wildflowers are considerably easier to maintain than turf grasses, the Department of Transportation saves millions of dollars annually due to reduced mowing.

Although different species of lupines grow throughout the South, it is only in Texas and Oklahoma that great expanses of this genus are found. Smaller stands of wild lupine, *Lupinus perennis,* can be found from Maine south to Florida in dry fields and open woods.

Because lupines are generally found growing in poor soils, it was at one time thought that the plants caused the poor soil or robbed it of its nutrients. For this reason, the genus was named after the wolf, *lupus*, who robbed the shepherd of his sheep.

In reality, lupines actually add to the richness of the soil by capturing atmospheric nitrogen and changing it into a usable form. Because of this, lupines and other members of the pea, or Leguminosae family are often used as cover crops.

Other common names for this plant include wolf flower, buffalo clover and the rabbit, for the white tip on the petals reminded some of rabbit ears erect and listening for danger.

Lupines were rarely used medicinally. An herbal dating back to the thirteenth century does suggest that this plant was helpful in curing the spot left after the umbilical cord was cut on an infant. Many species are poisonous so care should be taken when dealing with the plant.

Name: Texas bluebonnet *(Lupinus subcarnosus)*

Family: Leguminosae

Description: Sky-blue flowers are borne in a loose terminal spike. Each blossom has a white "eye" that turns red as the plant matures. The leaves are divided into four to seven segments. It grows to a height of twelve to fifteen inches.

Blooms: April through May

Natural habitat: Found in great profusion in the grassland areas of Texas. This particular species grows primarily in the eastern and southern parts of the state.

Propagation and cultivation: Although it is possible to cultivate some species of lupines throughout the Southeast, it is quite difficult to get the Texas bluebonnet to grow outside of Texas. The seeds are surrounded by a very hard seed coat and often will not germinate for a few years, unless they are pretreated. Perennial lupine will grow in a sunny, well-drained area and can be planted in either spring or fall. This lupine will not tolerate hot, humid weather, which precludes its being grown in many parts of the Southeast.

Bluet
(Houstonia caerulea)

The tiny pale petals of bluet blossoms waved gently in the spring breeze. Growing on a moss-covered rock near the stream, they created a miniature landscape of delicate beauty. I lost myself for a moment in this leprechaunian world, imagining that I was a tiny woodland fairy in a world where bluets were as tall as trees and dew drops were vast oceans.

Green moss hid me as giant ants marched across my tiny lawn, each footprint leaving huge craters in the soft moss. I climbed to the top of a bluet and sat cradled in the blossom, queen of all I could see.

A painted lady butterfly softly glided by, her wings iridescent in the sunlight. Quickly she gathered nectar from the blossoms beside me, then flew off to visit another flower.

A gentle breeze blew through my world with the force of a hurricane, and I clung tightly to my bluet lest I be blown away like a speck of dust. But soon all was calm again, and I found myself face-to-face with a golden honey bee. I said hello, and he nodded his bearded face politely, then flew off into the sunshine.

A shadow fell across my patch of earth, plummeting it into momentary darkness. I looked up and saw my shadow waiting for me to return to the world of tiny bluets and miniature ants.

Blanchan wrote of bluets that "the blue and serenity of heaven [could be seen] in their pure, upturned faces." And, indeed, bluets always seem to remind one of the sweet innocence of childhood, so much so that a common name for the plant is "innocents."

The species name, *caerulea,* is from the Latin words for "sky blue," and the common name *bluets* is the French diminutive form for "blue."

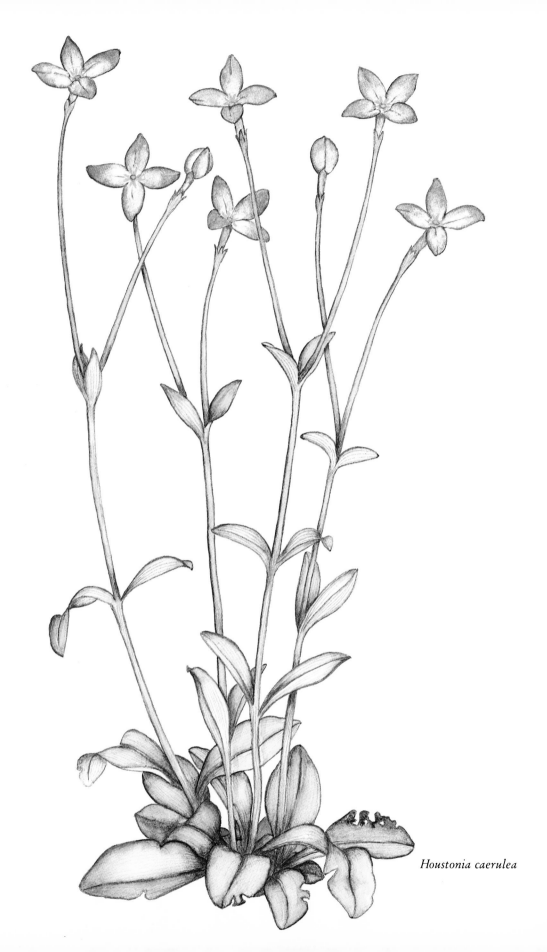

Houstonia caerulea

Other common names include eyebright, because the center of the flower is so noticeable, Venus's pride, little washerwomen, and Quaker ladies, again referring to the sense of innocence that they evoke.

These small four-petaled flowers usually grow in great colonies near streams or lakes. Although they are often confused with blue-eyed grass or wild forget-me-not, bluets are easy to identify by their cross-like blossoms with centers of golden yellow.

Bluets exhibit what is known as dimorphism, that is, the same species showing distinct morphological differences. In bluets, these differences are found in the sexual parts of the plant. One kind has very short stamens and long pistils, while just the opposite occurs on other plants within the same genus. The reason for this seems to be to ensure the plant's cross-pollination.

Name: Bluets *(Houstonia caerulea)*

Family: Rubiaceae

Description: Tiny plants, bluets must be viewed in great numbers before they show up very well. Each individual flower stands about three to six inches tall, and the stems are very slender. The blossoms are light blue, sometimes almost white, each with a golden yellow center. The leaves are basal and grow in tufts.

Blooms: April through June

Natural habitat: Commonly found in grassy lawns, open thickets, and stream banks in the Southeast from Virginia and Maryland south to Georgia and west to Alabama.

Propagation and cultivation: Plant a clump of bluets in a sunny open area where it will receive plenty of moisture. It prefers slightly acidic soils. Because of their small size, bluets are wonderful additions to a rock garden.

Buttercup
(Ranunculus acris)

May Day begins early in our house. As the sun slowly creeps into view and the blackness of night gradually gives way to dawn, the children and I stumble out of bed.

"It's like Christmas, only not as cold," my son says as he yawns loudly. And he's right—it is the same feeling of suppressed excitement, the same warm glow you get when you know you're going to please someone.

Only this, in a way, is better than Christmas. This is our own celebration, and we expect nothing in return for the gifts that we give on the first day of May.

It's an old custom, this celebration of the beginning of spring. The English made an art of it, and the May Pole was the center of attention in many a small village. Decked with ribbons and covered with flowers, the May Pole stood as cheerful testimony to the advent of spring.

In Germany young people would go out early on May Day morning and collect flowers and green branches to hang over the doors of their houses. A sprig of mountain ash or willow over the door on May Day was thought to bring the inhabitants a year of good luck.

May baskets were traditionally filled with flowers from the fields and woods and were carefully decorated with ribbons. The giver of these baskets would place them on the doorsteps of friends, knock loudly and run quickly behind the bushes to hide and watch for delighted faces.

We don't have far to go to collect our May Day wares. The meadow outside our kitchen window supplies us with all the flowers we need.

Armed with clippers and buckets of water, the children and I wade into our sea of flowers, snipping and cutting until our buckets overflow with blossoms. Daisies, blue phlox, lyre-leafed sage, wall-

flower, buttercups and even an occasional dandelion are brought from the meadow to the kitchen.

The kitchen itself is full of baskets and ribbons, and we happily set the buckets of flowers in among them, ready and delighted to go to work.

What we lack in expertise we more than make up for in enthusiasm. Basket after basket fills with flowers and ribbons and love.

And who receives these baskets of love? Grandmothers, of course, and favorite teachers, special neighbors and those folks that we feel might be in need of a little pick-me-up.

The flowers we use in these May Day baskets are not fancy or exotic; they are just meadow flowers, common and sturdy. But transformed by our love and a bit of satin ribbon, they attain an unequaled beauty and elegance.

The brightest spot in each basket is the shiny little yellow buttercups. As we pick them, my daughter takes each one, holds it under her chin and dances around the meadow, asking us if she loves butter. I check her chin a dozen times and assure her that her chin shines yellow, and, yes, she must love butter.

Care must be exercised when picking buttercups, however, because nearly all species of the plant are poisonous, sometimes even to the touch. Prolonged contact with the acrid juice from the plant causes blisters to develop on the skin. If taken internally, this juice causes severe inflammation of the mouth and throat.

For many years it was believed that butter obtained from cows grazing on buttercups would be a superior color. Buttercups were even rubbed on the cows' udders for this purpose. But eventually it was discovered that buttercups not only would not improve the color or flavor of milk and butter, but actually alter severely the quality of dairy products. Cattle generally will not graze on these acrid plants.

Buttercups growing in a field produce nitrogen-killing substances through their roots, thus preventing the growth of clovers in that area. Some people believe that buttercups in the vegetable garden stunt the growth of peas and beans. An old country name for buttercup is "crazy weed" because people believed smelling buttercups would cause madness.

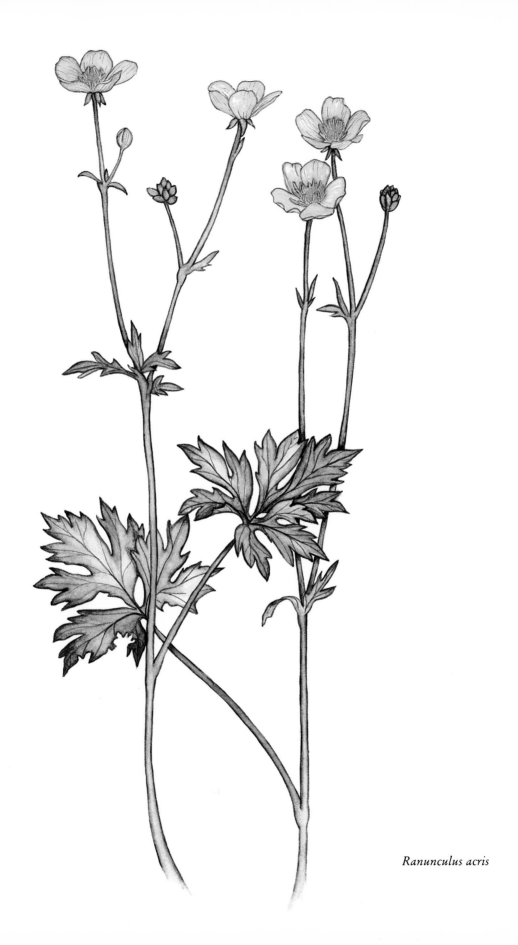

Ranunculus acris

Buttercups are in the genus *Ranunculus,* a Latin name meaning "little frog." The association with frogs is probably due to the preferred moist habitat of many species of buttercups. Ranunculus was also thought to be the name of a young Libyan boy who had a beautiful voice and was always singing. He sang so often that the wood nymphs living close by soon became quite tired of the noise. According to the tale, they changed him into the flower that today we call a buttercup.

Name: Buttercup *(Ranunculus acris)*
Family: Ranunculaceae
Description: Several bright, shiny yellow flowers can be found on a multi-branched stem of this plant. The blossoms each have five petals and five sepals. The leaves are deeply segmented. It grows to a height of twenty-four to thirty-six inches.
Blooms: April through September
Natural habitat: Found throughout the Southeast in fields and disturbed areas.
Propagation and cultivation: Although buttercup is attractive, the wild varieties are considered too aggressive to be useful as a landscape plant.

Cattail
(Typha latifolia)

Deep in a swamp near Pelahatchie, Mississippi, cattails stand guard. Brown, fuzzy stalks rise above the murky water, creating an aura of deep, dank mystery. Like a primeval pool, the swamp is teeming with life. Small minnows dart in and out of watery roots while water striders skate quickly along the surface.

Though uninviting to human visitation, swamps contribute a vital ecosystem to the earth. It was from similar murky waters that the first plant life on our planet emerged. The reproductive processes of the first plants were directly dependent on water, for they reproduced not from seed, but by swimming sperm.

After thousands of years plants have become more sophisticated, and most are no longer tied so closely to water. Even so, wetlands represent one of the most productive ecosystems on earth. Reeds, sedges, and wetland grasses combine with cattails to create a rich carpet of green in our southern swamps. Cattails are capable of producing a tremendous amount of vegetative material and, because of their growth habit, are extremely efficient in capturing solar energy.

Norman Myers, in his book *A Wealth of Wild Species*, relates that in southern Mississippi records show that cattails can produce over fifty metric tons of biomass per hectare per year. And what good is fifty tons of cattail? The biomass can be converted to fuels of various types. It has been estimated that one hectare of cattails could generate at least twenty thousand cubic meters of methane.

American Indians, never dreaming of the needs of an energy-hungry twentieth century, found many uses of their own for cattails. Food, medicine, building material, insulation—all were supplied by the cattail plant.

Perhaps the best known use of cattail is for woven mats, chair seats, and baskets. Rush-bottom chairs are durable, attractive, and comfortable. North American Indians used the leaves to weave

23

sleeping mats and a covering for their summer wigwams. The seed heads, dipped in tallow, were used as torches.

The soft waterproof down was used by the Indians to pad cradle boards and make very warm sleeping bags. During World War II a scientist from Chicago spent considerable time and effort researching the possibility of using this down as stuffing for life preservers and toys and as padding for tanks and airplanes.

Cattails supply a surprising number of tasty treats. Early in spring before the young shoots appear above the water surface, take a rake and pull up the rootstock. Here you can find a series of sprouts, plump and ready to shoot forth. These are delicious either boiled until tender or crisp and raw.

When the tall young sprouts appear, cut them at the bottom and take the outer sheath off, leaving the whitish tender inner growth. These too can be eaten either boiled or raw.

The immature flower head, while still sheathed, is also edible. Remove the outer sheath, steam until tender and eat like corn on the cob. Once the flower has matured and set pollen, these golden grains can be gathered and used as an additive to flour in making muffins or bread. To gather pollen, shake the long pollen spikes over wax paper and allow the pollen to dry in the sun.

The large rootstock can be ground into a nutritious flour. Not only is it useful in cooking; it has medicinal value as well. Tea made from the flour is useful in treating diarrhea. A paste made from the flour can be used to soothe poison ivy rash or bee stings.

If dried, cattail heads hold their shape and form for many years. They are particularly attractive in an arrangement of dried wild plants.

Name: Cattail *(Typha latifolia)*
Family: Typhaceae
Description: Most conspicuous in fall when the brown seed heads are apparent, cattail grows to a height of three to nine feet. Male and female flowers are borne on separate stalks. Male flowers usually have three stamen and fade after flowering. Female flowers have a one-stalked pistil. The leaves are taller than the flowering stalk and are flat and about one inch wide.
Blooms: Conspicuous seed pods August through December
Natural habitat: Found in freshwater marshes throughout the region.

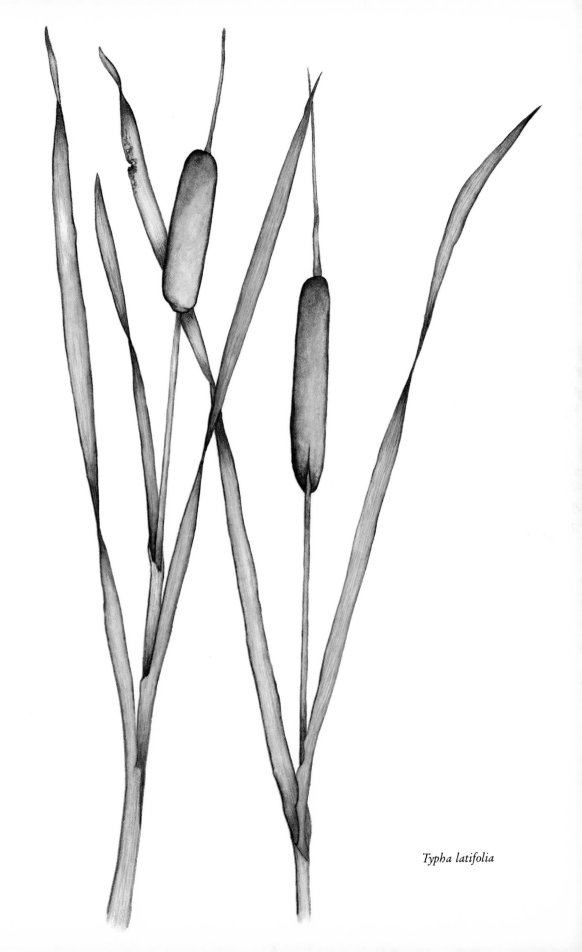

Typha latifolia

Propagation and cultivation: Cattails grow aggressively and are not suited to every wildflower garden. For a small pond it is best to grow these plants in a pot so that they will stay contained. Cattails need constant moisture and should be planted one to two feet apart in full sun. Plants can be divided in early spring.

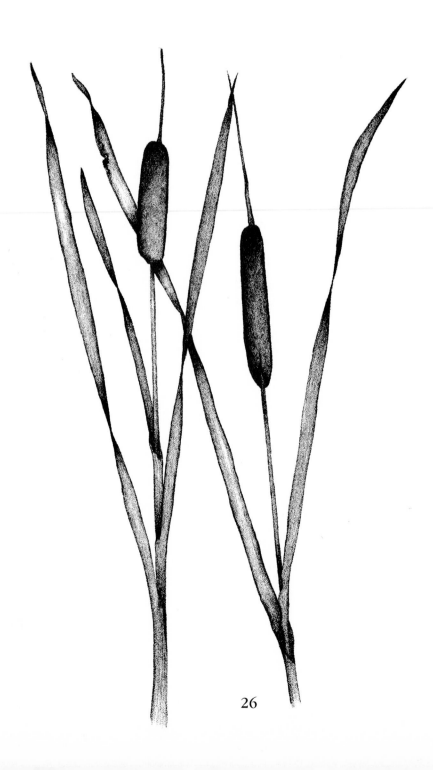

Cherokee rose
(Rosa laevigata)

(Adapted from a Cherokee Indian legend)

Ataga sat by her father's house weaving a basket, her mind working as quickly as her speeding fingers. The afternoon had brought much excitement to the small Cherokee village.

The Cherokees frequently fought with neighboring tribes over hunting grounds, and on this particular afternoon a skirmish had left one of the enemy critically wounded. Rather than leave him to die, the Cherokee braves had brought the young Indian man back to their village as a prisoner. Even now, he lay heavily guarded, shivering in the cold.

Finally Ataga could sit still no longer, so she crept quietly inside to stand beside her father. Chief of the village, her father was a strong and imposing figure, but he loved this young daughter more than any of his other children.

Ataga stood straight and strong before her father.

"Father, the stranger that you brought to our village is quite ill. May I not see to his wounds?"

Her father looked at her in surprise. "Ataga, you know that the man will be put to death anyway. Why help him to recover if he is only to die later?"

Ataga hesitated before answering. "The Great Spirit is pleased when an Indian comes to him whole and with pride. Let me help this stranger so that he can go to the Great Spirit proudly."

Unable to refuse his daughter, the chief agreed to let her nurse the young captive until he was once again well.

27

Ataga spent much of her time with the young stranger, and, as often happens with young people who are thrown together by chance, they fell in love. As the captive began to get stronger and stronger, he begged Ataga to come away with him to live with his own tribe. Finally Ataga could refuse no longer. Late one night she crept out of her father's home to run away with the handsome stranger whose life she had saved.

As she stood looking at her village for the last time, tears filled her eyes, for she knew that she would never be able to come back. Suddenly, she bent and plucked a bit of the beautiful white rose that grew around her father's house. This she would take with her and plant in her new home to remind her of the village she had left behind.

The rose is now known as the Cherokee rose.

This could not possibly be a very ancient Indian legend, for the Cherokee rose is not indigenous to the United States. It was brought to the southeastern United States by way of England and arrived here in the mid-1700s.

The plant is originally from China but has adapted to growing conditions in the South so well that is has now naturalized in many different areas.

Twenty-six species of roses are native to the United States, but over 90 percent of the roses grown in cultivation are non-native species. Modern roses are said to have been originally bred from several different species, one of which is *Rosa canina.* Fossils of this species dating back thirty-five million years ago have been found in Montana.

Almost all rose species have culinary and medicinal value. Rose hips contain more vitamin C than almost any other fruit or vegetable and were much sought after in England during World War II. Rose petals were used during medieval times for flavoring and compressed petals were made into beads strung together to create rosaries.

Name: Cherokee rose *(Rosa laevigata)*
Family: Rosaceae

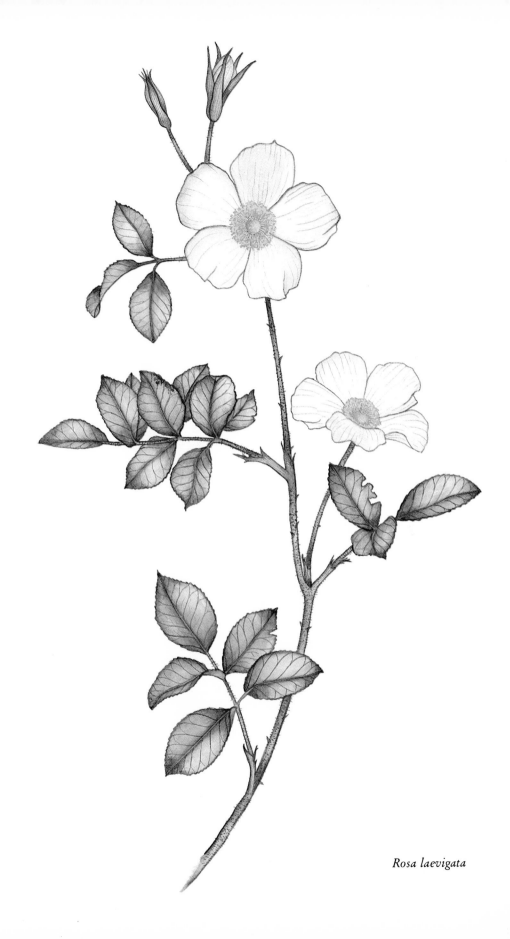

Rosa laevigata

Description: A tall shrub, Cherokee rose sometimes grows as high as fifteen feet. It is covered with three- to three-and-one-half-inch fragrant white flowers and shiny green leaves. The entire plant is covered with pronged prickles.

Blooms: May through June

Natural habitat: Infrequently found in open thickets and clearings in the upland regions of Georgia, Alabama, Tennessee, and North and South Carolina.

Propagation and cultivation: Because of its somewhat ragged appearance, Cherokee rose is not cultivated very often. It is attractive when in full bloom, however, and plants should be put in partial shade and given sufficient moisture until they are established.

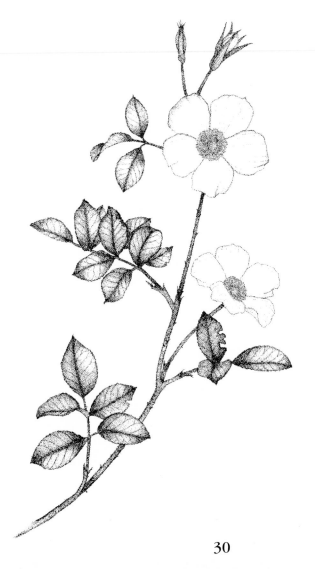

Clover

(Trifolium incarnatum)

John Ruch was an unusual man. In the words of his descendent, Mary Lillian Thomason, "as a husband and father, he was affectionate, gentle and considerate. In his contact with men, he was clean and straightforward in all his dealings. As a citizen, his record was above reproach, and as a Christian gentleman, he was unsurpassed."

As a farmer, John Ruch was a man who loved to stay in tune with the times. When Ruch moved to Franklin County, Tennessee, in 1873, he became very interested in all the newest farming techniques. He was one of the first in the area to practice crop rotation and was one of the first farmers in the country to realize the benefits of using commercial fertilizer. Because of his innovative and successful farming techniques, John soon attracted the attention of the state Commissioner of Agriculture, Robert Essary.

In spring of 1892 John Ruch and his son Lee were in the fields sowing red clover and oats when a package arrived from Commissioner Essary. John stopped long enough to open the package and take out a peck of a different kind of clover, called crimson clover, with a note from the Commissioner suggesting that John try this European crop.

Anxious to try anything new, John and Lee sowed a strip of crimson clover right down the center of the field. The new crop came up well and in spring was covered with crimson blossoms that looked like a rich red rug. John and Lee were pleased and invited friends and neighbors by to take a look at this strange new clover that no one else in the country had grown.

It took several years for the popularity of crimson clover to catch on, but within ten years farmers throughout the country began to realize its value. During World War I when the seed could not be imported from France, farmers turned toward Lee Ruch and his neighbors in Franklin County to fill their orders for crimson

clover. By 1936, five thousand acres in the county were planted with crimson clover.

Today many kinds of clover are grown throughout the United States, primarily for fodder or as a green manure crop designed to improve the fertility of the soil. Crimson clover may be the only clover grown for its ornamental value as well. Each year in the Southeast many miles along the roadsides are planted with this unusually attractive plant

Clover has been known and used for centuries and has long been considered a symbol of fertility and domestic virtue. Since medieval times it has been thought lucky to find a four-leaf clover. An old superstition says that if a girl finds a four-leaf clover and puts it in her shoe, she will marry the first man she sees.

Another superstition says that a girl who puts a four-leaf clover under her pillow will dream of her future husband. If she swallows the clover instead, she is supposed to marry the first man she shakes hands with.

Tea made from clover was once thought to be particularly useful in soothing bronchitis, asthma and coughs. Country folks used to drink clover tea to improve the texture of fingernails and toenails. A lotion made from the blossoms was used to treat athlete's foot and burns.

Unfortunately, pharmacologists today have found no scientific data to support the folk uses of clover. The blossoms also impart a delicate flavor that was once used in wine, cheese, and tobacco.

Name: Clover *(Trifolium incarnatum)*
Family: Leguminosae
Description: Small deep red to purplish flowers appear on inch-long cones above hairy stems. The leaves are also slightly hairy. The height of the plant is eight to fourteen inches.
Blooms: May through August
Natural habitat: Widely planted by the Department of Transportation, crimson clover makes a wonderful roadside plant. This annual grows throughout the region in open, grassy areas.
Propagation and cultivation: Seeds of crimson clover need to be planted in the fall. Although it will tolerate a wide range of environmental conditions, it will do best with full sun and ample moisture.

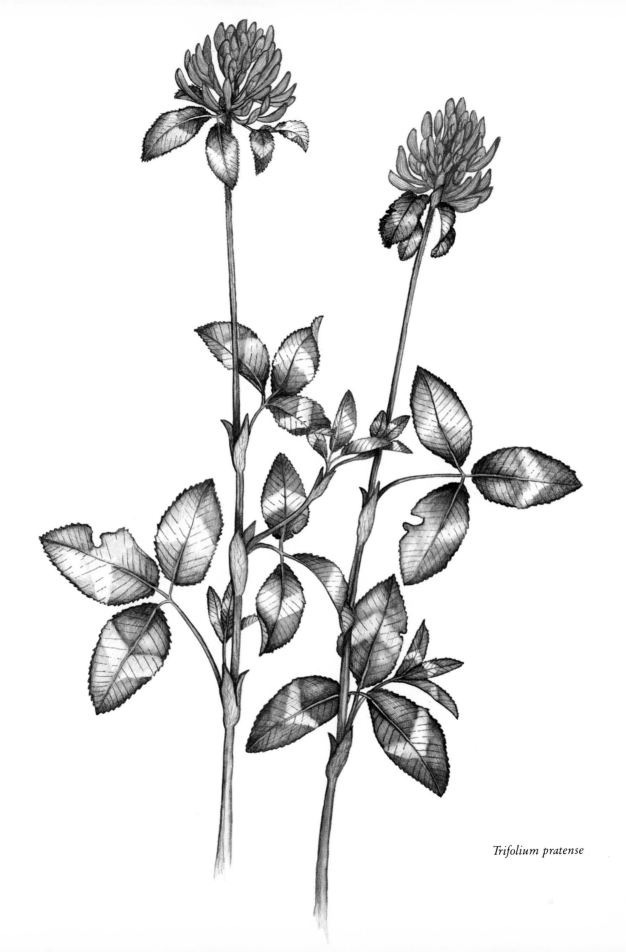

Trifolium pratense

Columbine
(Aquilegia canadensis)

Virginia's Natural Bridge area is a favorite of tourists and nature lovers. The bridge itself is a remarkable rocky formation that does, indeed, make a bridge-like structure. Nestled in the Shenandoah Valley, the bridge and surrounding area are clothed in a profusion of wildflowers in mid-spring.

Travel the trail from the bridge into the woods, and there, nodding in the gentle breeze, capturing the delicate sunbeams that filter through the leaves, is our native columbine.

You can't mistake it for any other wildflower. Five petals, red on the outside and yellow on the inside, form hollow spurs that unite under five yellow sepals. These spurs are adapted to pollination from long-tongued visitors, such as the hummingbird.

The unusual configuration of the plants suggests many different common names. The genus name, *Aquilegia,* was given to the plant by Linnaeus. It comes from the Latin word for "eagle," for to Linnaeus the flower spurs looked like the claws of an eagle.

The name *columbine,* however, comes from the word meaning "dove," for to other people, the circle of spurs reminded them of doves' heads. The circular spurs led to at least two other common names: meeting house, for to some the spurs looked like heads sitting around a table, and Granny's nightcap.

One other common name refers to the plant's preferred habitat: rocky soil. Ralph Waldo Emerson wrote:

> . . . A woodland walk
> A quest of river grapes, a mocking thrush
> A wild rose or rock-loving columbine
> Salves my worst wounds.

Columbine has been used for medicinal purposes for many centuries. A picture of columbine appears in the border of a

handwritten manuscript dated late in the fifteenth century. During the Middle Ages it was used to cure a variety of ailments including measles, smallpox, sore throats, and swollen glands. In 1373 it was used with seven other herbs to cure the "pestilence."

Plant breeders have developed many wonderful cultivars from the native columbine species. These, however, have strong ties to their original roots. Seedlings from hybrid plants nearly always revert back to a muddy color, a yearning towards the original hues of the species.

John Gerarde, author of a sixteenth-century herbal wrote of columbine as "the herbe wherein the lion doth delight," referring to the ancient superstition that lions ate columbine in the spring to revive their strength. Another ancient superstition suggests that dogs will not bark at someone carrying columbine.

The flower of columbine, particularly the blue species, was often included on ancient heraldic badges and coats of arms. A "branche of Collobyns" was recorded as being included in the crest of the Barons Grey of Vitten.

According to the Victorian language of flowers, columbine is a symbol of folly. It was considered an insult to give this plant to a man and bad luck to give it to a woman. Columbine was often used as a sign of a deserted lover, as is evidenced in William Browne's *Britannia's Pastorals*:

> The Columbine by lonely wand'rer taken,
> Is there ascribed to such as are forsaken.

Folklore associated with columbine seems to be full of contradictions. Here is a plant that symbolizes both the eagle and the dove and has the power to enliven lions yet keeps dogs quiet. It is a sign of a deserted lover yet takes a proud place among the most prestigious coats of arms. Perhaps is it best simply to enjoy the beauty of the columbine and to allow it, as Emerson suggests, to salve our worst wounds.

Name: Columbine *(Aquilegia canadensis)*
Family: Ranunculaceae
Description: Red-and-yellow flowers are drooping and bell-like with five long spurs pointing upwards. The flowers are one to two

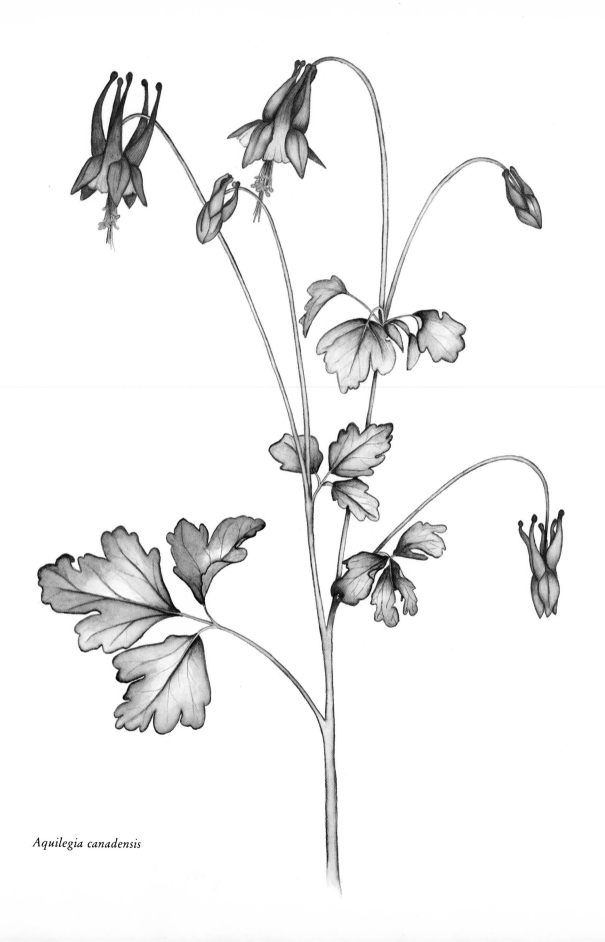

Aquilegia canadensis

inches long. Light blue-green leaves are four to six inches long and generally have three lobes. The plant grows to a height of one to three feet.

Blooms: April through July

Natural habitat: Found on rocky slopes, open woods and well-drained mountainous areas south to Georgia and Tennessee.

Propagation and cultivation: Columbine prefers slightly acidic to neutral soil. Good drainage is necessary. Soil that is too rich in nutrients will cause the plant to produce more foliage than blossoms. Columbine prefers partial shade but can withstand full sun if given sufficient moisture. This plant does not transplant very easily so is most successfully grown from seed. The seeds need a cold period to break dormancy and should be sown immediately after being collected or should be stored in the refrigerator until ready for planting.

Dandelion
(Taraxacum officinale)

Common names of plants often capture the essence of the plant itself. Such is the case for a little known but very descriptive name for the dandelion—"tramp with the golden head."

There is nothing sophisticated about the dandelion. It is a weed, scorned and despised by many a gardener. Yet, even though its liabilities far outweigh its assets, there is something comically pleasing about the dandelion. It is like a class clown—sometimes humorous, sometimes irritating, but always good at heart.

Even the most irritated gardener must grudgingly admire the stamina shown by dandelion plants. With roots that go very deep into the ground, dandelions are nearly impervious to grazing animals or to gardeners who, in their haste, snap off the upper foliage, leaving the life-supporting root still firm in the ground. The plants seem to weather unusual heat and cold with little problem, are bothered by few pests and diseases, and appear to grow cheerfully in even the poorest soils.

The most outstanding feature of the plant, however, is its prodigious powers of reproduction. Once they find fertile ground, dandelion seeds are capable of germinating within three days. The seeds are attached to silken parachutes and are easily dispersed by the wind or by children who find the small puffballs irresistible and manage to scatter the seeds with a good, hard blow.

What will happen to that lucky child who can blow off all the seeds of a dandelion seed head? Aah . . . the world lies at his feet! His wishes will come true and good luck will be his for a day. In different parts of the world, the number of seeds left on the puffball means different things. In the southeastern United States, it merely means your wish won't come true. In other places, the number of seeds left will tell you how many children you will have or perhaps what time it is.

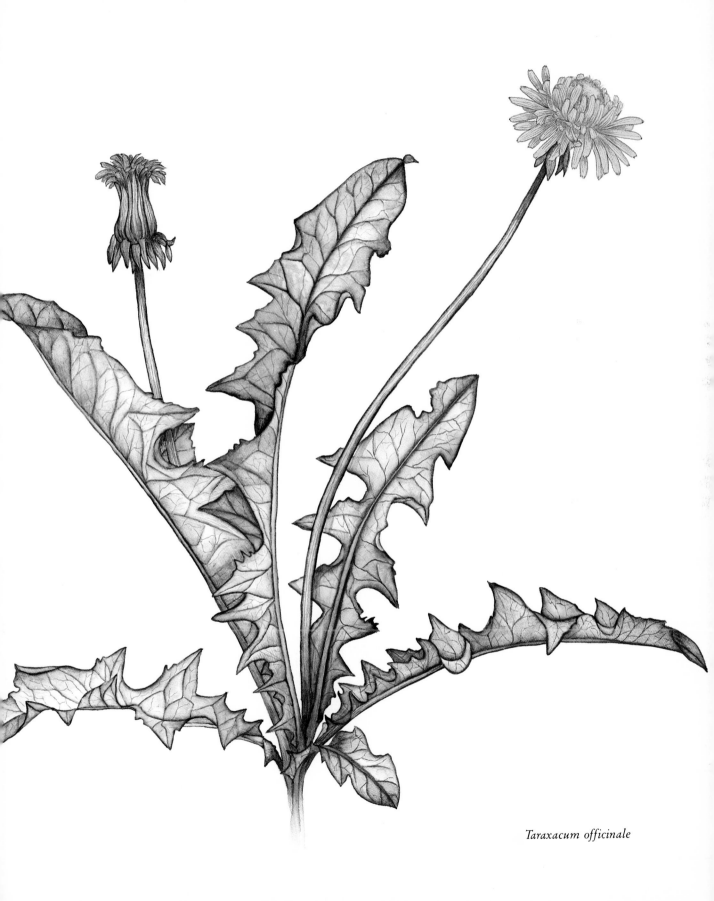

Taraxacum officinale

The name *dandelion* is from the French words *dent de lion*, meaning "tooth of the lion." Someone with a vivid imagination thought that the toothed margins of the dandelion leaf looked like large teeth and, more specifically, like lion's teeth. The name stuck, and in every country where this plant grows it is referred to as the "teeth of the lion."

In spite of the fact that Americans spend tremendous amounts of money in an annual war against dandelions, the plant has many attributes. It was intentionally introduced to this country by European settlers who considered the leaves a favorite spring vegetable. The leaves are both flavorful and nourishing, for they are very high in both vitamins A and C.

Native American Indian tribes soon developed a liking for the plant and discovered many uses for it. The Mohegans made tea from the leaves and drank this as a general spring tonic. Other tribes used the tea to cure heartburn. In the Appalachian mountains, dandelions became a favorite medicine for rheumatism. Superstition holds that if you drink dandelion tea every morning and every evening, you will never be troubled by rheumatism.

As popular as dandelion tea is, however, it is wine made from the blossoms that captures the heart. Sitting in a rocking chair on the front porch, sipping on a glass of dandelion wine, is a southern tradition untouched by time.

Dandelion blossoms can also be eaten. Wash large, plump blossoms, dip them in a fritter batter, and fry until crisp.

The following is a Pennsylvania Dutch recipe for dandelion salad:

Dandelion Salad

1 pound (2 large bunches) dandelion greens
1/2 pound unsliced bacon
2/3 cup half-and-half cream
3-4 tablespoons vinegar
3-4 tablespoons sugar
1 tablespoon flour
2 hard-boiled eggs
Salt and pepper to taste

Wash the greens and remove all tough stems. Dry thoroughly and keep in a slightly warmed bowl at room temperature.

Cut the bacon into small strips and fry slowly until the bacon pieces are crisp and brown. Drain and crumble coarsely. Reserve the fat in the pan.

Combine the cream, vinegar, sugar, flour, salt, and pepper. Beat with a whisk until smooth. Pour into the hot fat and bring to a boil, stirring constantly with a whisk until smooth and thick. Pour over the greens, add the bacon, and toss to coat greens. Garnish with eggs and serve. Serves four to six.

And here's the recipe for dandelion wine:

Dandelion Wine

Put one pint of dandelion blossoms in a large crock. Pour one-half gallon boiling water over the blossoms, cover with cheesecloth, and let stand twenty-four hours. Strain through cheesecloth. Return the liquid to the crock and add the following ingredients:

1¹/₂ pounds sugar
1¹/₂ packages yeast
1 thinly sliced orange
1 thinly sliced lemon

Stir and cover for ten days. Strain and return to the crock. Add 1¹/₂ pounds of sugar, stir well and cover. Let stand one more day. Then drain, leaving the sediment in the crock. Bottle and keep until Thanksgiving.

Name: Dandelion *(Taraxacum officinale)*
Family: Compositae
Description: Bright yellow heads appear at the ends of hollow stems. The flower heads are composed of hundreds of square-tipped ray flowers. The leaves are three to sixteen inches long and are often deeply lobed. If growing in the shade, however, the leaves will be entire, lacking toothed edges. The height of the plant is 6 to 18 inches.
Blooms: February through May

Natural habitat: Quite common in lawns, roadsides, and fields throughout.

Propagation and cultivation: Dandelion usually grows quite well without any help from man. It is sometimes cultivated in fields for its culinary value. It grows best in rich, well-drained soil in full sun.

Dutchman's pipe
(Aristolochia durior)

Leo Collins caught sight of the vine from across the cove. The S-shaped blossoms of Dutchman's pipe are not terribly conspicuous, but the unusual shape makes them quite noticeable to the trained eye, and Dr. Collins's eye is one of the most trained in the state of Tennessee. As botanist with the Natural Heritage Program sponsored by the Tennessee Valley Authority, this Vanderbilt University graduate has spent the last eighteen years studying the flora of Tennessee.

Dr. Collins carefully collected a few of the flowers and leaves of Dutchman's pipe to take back to the herbarium and then continued his exploration of the area. As dusk began to fall, he reluctantly turned his steps toward home. On the way he decided to stop and visit with his grandmother, Will Collins.

As he entered his grandmother's home, he took with him some of his collected specimens to show her. When Will caught sight of the Dutchman's pipe, she began to smile.

"I've smoked plenty of that!" she exclaimed.

He looked at her, puzzled. "What do you mean smoked it? You mean you burned it or used it to fumigate the house or something?"

Will Collins laughed. "No, no. I smoked the stems just like you would a corncob pipe. They are porous and easy to smoke. Used to be that when I was a teenager some of my friends and I would sneak off down into the woods and light up. Wasn't exactly like a cigarette, but we thought it was mighty fine."

Although Will Collins and her friends smoked the stems of this plant, the blossom itself looks like a miniature pipe. To some folks, though, the blossom looks more like a human fetus than a pipe. Based on the doctrine of signatures (see page 64), the plant was often made into a concoction used during childbirth. Another common name for the vine is birthwort.

The genus name, *Aristolochia,* is from the Greek for "best childbirth." The species name, *durior,* means "harder" or

43

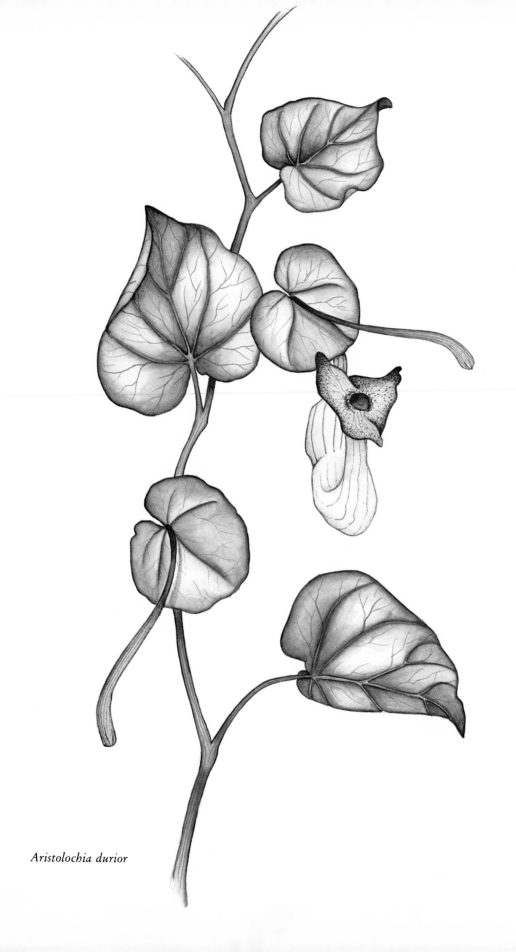

Aristolochia durior

"harsher" and refers to the bitter taste of medicine made from the plant.

A species similar to Dutchman's pipe is Virginia snakeroot, which was used extensively as an antidote for snakebite. Native Americans chewed the root, swallowing some and using the remainder as a salve on the bite. It was also sometimes used to cure the bite of a rabid dog, for malaria and typhus, and as an antidote for poisoning.

Virginia snakeroot seems to affect the circulatory system, and a few drops were taken when the hands and feet were extremely cold. Thinking it to be useful as an appetite stimulant and an aid in digestion, innkeepers often kept snakeroot, steeped in rum or whiskey, on hand for their patrons. Although small portions seem to be harmless, taken in quantity, the plant can cause vomiting and vertigo.

Virginia snakeroot is not a vine, as is Dutchman's pipe, and the flowers are often hidden among the leaves on the forest floor. The flowers are pollinated by carrion flies, which are attracted by the strong, musky odor.

Name: Dutchman's pipe *(Aristolochia durior)*
Family: Aristolochiaceae
Description: Brownish purple flowers are tubular and resemble a pipe. These are found on vines that can climb as tall as ten feet or more. The leaves are large and heart-shaped.
Blooms: April through June
Natural habitat: Found from Virginia south to Georgia and Alabama along streams or in moist woods.
Propagation and cultivation: Dutchman's pipe should be planted in fall in an open shady area. The soil, ideally, should be rich, well-drained and neutral or slightly acidic. Because it is a vine, it should be planted close to something that it can use for support.

Evening primrose
(Oenothera speciosa)

Grant Park in Atlanta, Georgia, is one of the city's oldest parks and is home to the Atlanta zoo. The area surrounding the park was at one time one of the finer of Atlanta's neighborhoods. Like many intown areas, however, Grant Park fell upon hard times as people fled to the suburbs. Houses and gardens were neglected and greatly suffered. Only recently has the area become popular again and begun slowly to regain its beauty.

Throughout the years of neglect, there was one bright spot that remained. Every spring thousands of pink evening primroses would push their way through sidewalk cracks, gallantly bloom amongst heaps of trash and rubble, and defiantly spread throughout the area.

Now that the neighborhood is once again in vogue and the lawns and gardens are clipped and manicured, the small pink wildflower refuses to release its hold. As if to remind the neighbors that it stuck around during the hard times and deserves to be there during the good, pink evening primrose still blankets the area in spring. Wherever there is a break in the vigil of the lawnmower, wherever a homeowner is negligent in keeping the weeds at bay, the pink evening primrose rises to the occasion and fills the gap.

Throughout the Southeast the Easter-egg pink blossoms of *Oenothera speciosa* color the spring landscape. In Texas, fields of this flower burst into bloom in spite of often severely dry conditions.

Over one hundred species are found in the *Oenothera* genus, over sixty of these in the United States. In addition to being popular as a (usually uninvited) garden flower, evening primrose is also a source of a fatty acid essential to humans. Research has shown that evening primrose is also one of only two natural sources of gamma-linoleic acid, the other being human milk. Seeds of this plant contain an oil rich in this acid, which has the potential

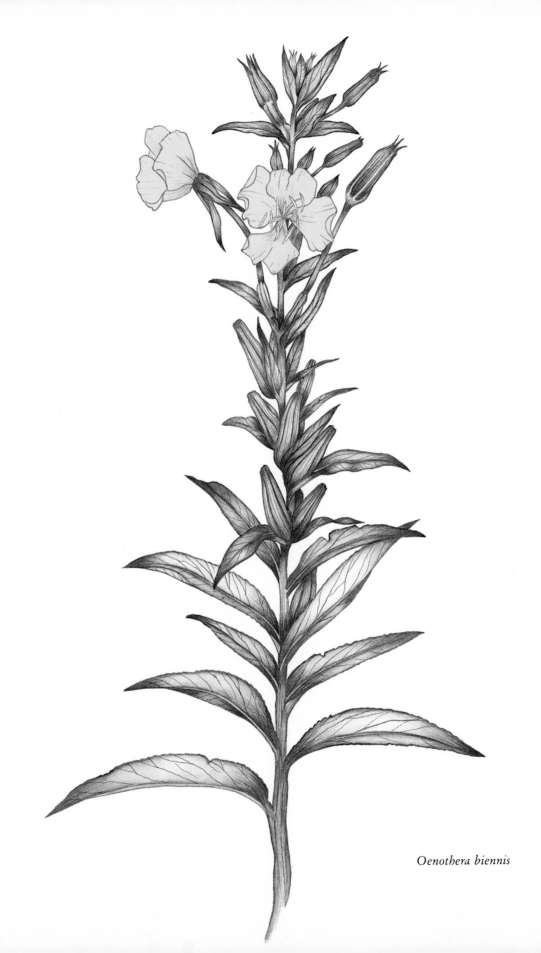

Oenothera biennis

to cure such various ailments such as eczema, arthritis, schizophrenia, and heart disease. In addition, this acid may also be useful in treating impotence and alcoholic hangovers.

The name *evening primrose* comes from the scent of the plant (which bears slight resemblance to that of the true primrose) and the fact that for many species blossoms open late in the evening.

The species *Oenothera biennis* is particularly common in the Southeast and is almost always included within meadow seed mixtures put together for this region. This is a night-blooming species with the heavy musky scent characteristic of plants that bloom in the cool of the evening. If you observe the plant a bit after sundown, you can stand and watch as the buds open up fully. It takes ten to fifteen minutes for them to go from a tightly closed bud to an open flower, but the movement makes you feel as if you're involved in time-lapse photography.

William Hamilton Gibson wrote of the evening primrose: "How few of us have ever stopped to witness that beautiful impatience of the swelling bud, the eager bursting of its bounds, and the magic unfolding of the crinkly yellow petals."

Oenothera biennis is a biennial plant. It develops a strong root system the first year and does not bloom until the second growing season. The leaves have a rich, peppery taste and are especially good in a salad. The first year roots slightly resemble pale pink carrots and have a distinctive flavor. To cook evening primrose roots, slice them into slivers and boil for about thirty minutes, changing water at least three times during the cooking process. Served with butter and seasonings, they make a delicious substitute for potatoes or cooked carrots. The early spring roots are more tender and have a more delicate flavor than the summer and fall roots, which are quite peppery tasting.

The genus name *Oenothera* is from the Greek and means "wine imbibing." Supposedly, a concoction made from this plant would enhance your wine-drinking capabilities.

A tea made from steeping fresh leaves in boiling water for five minutes was once thought to be effective in soothing an upset stomach. Older folks say that drinking evening primrose tea twice a day helps to keep their minds clear.

Name: Evening primrose *(Oenothera speciosa)*

Family: Onagraceae

Description: This short (eight- to twenty-four-inch tall) plant bears lovely white or pink blossoms on slender, hairy stems. The blossoms are three inches wide and have four petals. The leaves are long and narrow and have wavy edges. The center is yellow, as are the conspicuous stamen.

Blooms: May through July

Natural habitat: Occurs throughout the Southeast in fields, disturbed areas, and roadsides.

Propagation and cultivation: Many species of evening primrose make excellent specimens for the garden. Particularly lovely and easy to grow are *Oenothera tetragona* (sundrops) and *Oenothera fruticosa*. Each of these needs full sun and well-drained soil. They grow easily from seed, the germination rate being quite high. They are perennials, and it is also possible to divide established plants in the fall.

Wild geranium
(Geranium maculatum)

The June 19, 1852, entry in Henry David Thoreau's journals reads, "Buttercups and geraniums cover the meadows, the latter appearing to float on the grass. It has lasted long, this rather tender flower."

The tender flower that Mr. Thoreau refers to is not the bright, gaudy hothouse geranium, but our small, delicate native geranium.

Many people balk at the thought of learning scientific names of plants. "It's too hard," or "I can't remember it," or "It's all Greek to me," they complain. No better example can be given for the need of botanical names than the wild geranium.

Say the word *geranium* to a botanist or informed layman, and he or she will look at you with a puzzled expression. "Do you mean the popular red or pink bedding plant, geranium, or do you mean the attractive little wildflower so common in our southern woods, *Geranium maculatum*?"

The bright blossoms of the plant that we commonly call geranium are not actually in the *Geranium* genus. Confusion first arose over these names in the early 1600s when new plants were being introduced to Europe at a fast and furious pace. Among these new plants was a species from South Africa that vaguely resembled some of the common members of the geranium family native to Europe. People began referring to the new African plants as geraniums, and the name unfortunately stuck. The African "geraniums" are actually in the genus *Pelargonium*.

The genus name *Geranium* is from the Greek word for "crane," *geranus*, and was given to this group of plants because the seed pods are elongated, resembling the beak of a crane.

A similar species growing in our southern woods is *Geranium Robertianum*, commonly called herb Robert. The Robert of this name seems to be in some question. Some folks think that it refers to Robert of Normandy. Others say that it refers to French Abbé

50

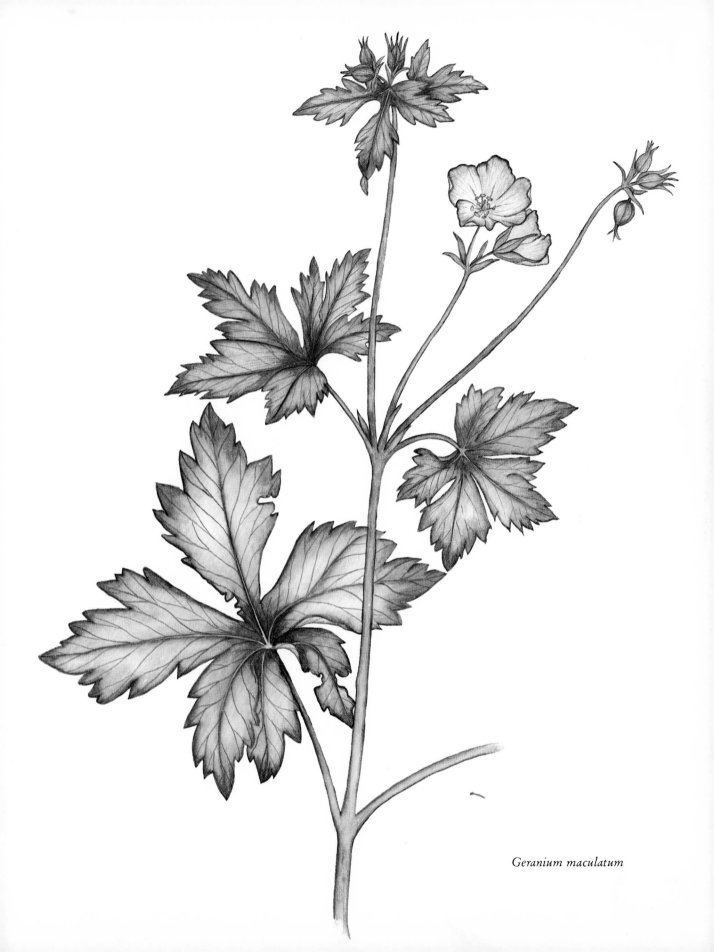

Geranium maculatum

Robert, who founded the Cistercian Order in the eleventh century. Another possible source for the name is Robert of Molesme. Still others suggest that the name actually came from Robin, who was a mischievous woodland figure during medieval times, commonly known to us today as Robin Hood.

Throughout the ages wild geranium has been used for various purposes. An ancient hair tonic was made up of wild geranium, lady's smock, and twayblade and given to bald men. The leaves, thoroughly bruised and rubbed on the skin, were thought to keep away mosquitoes

Wild geranium was used extensively by both pioneers and Indians. From 1820 through 1916 the plant was listed in the *U.S. Pharmacopeia*, a reference book for pharmacists. Today dried root or extract can be found in some health-food stores.

The medicinal value of the plant is found in the tannin content within the rhizome. This acts as an astringent and as an agent to stop bleeding. Taken internally in the form of tea, wild geranium can be effective in treating diarrhea. North American Indians used a solution made from the powdered root as an eyewash and to treat mouth sores in children. The root, ground into a poultice, was applied to swollen feet.

Name: Wild geranium *(Geranium maculatum)*
Family: Geraniaceae
Description: The blossoms of wild geranium are lavender pink and occur in loose clusters at the end of the flowering stems. Each flower measures only one to two inches across, but the entire plant stands one to two feet tall. Each blossom has five rounded petals and five pointed sepals. The deeply lobed leaves are gray-green and are often mottled.
Blooms: April through June
Natural habitat: Found in open woods and thickets throughout the region from Virginia south to Georgia and west to Missouri.
Propagation and cultivation: The germination rate from seeds is generally low, but divisions made in the fall are generally quite successful. The rhizome should be dug, cut into two or three pieces, then replanted an inch below the soil. Rich, moist soil and dappled sunlight make good conditions for growing this plant. It must have water throughout the growing season.

Wild ginger
(Asarum canadense)

If it is true that the meek shall inherit the earth, then the earth should be covered with wild ginger. Shy and unassuming, the blossom of wild ginger just barely peeks above ground and chooses to stay hidden among the leaf litter on the forest floor.

Like a bashful boy at his first dance, a wild ginger blossom clings to the familiar, preferring to blend into the background rather than call attention to itself. In comparison to the splendor of many spring-blooming wildflowers, wild ginger must seem quite common. But, as with most shy and unassuming things, wild ginger has its hidden attributes.

The flower itself, though hardly beautiful, has a certain charm and appeal. The reddish brown blossom grows right at ground level in the joint between a pair of large, hairy heart-shaped leaves. Children take great delight in uncovering these small cup-shaped flowers and have nicknamed them "little brown jugs" or "little pig's feet." The word *ginger* is from the Sanskrit word *srngaverem*, meaning "horn body" and refers to the shape of the blossom of both the true ginger plant and the wild ginger.

It is the root rather than the blossom, however, that has been used for centuries. Because it has a strong odor similar to that of true ginger sold commercially for flavoring, it has often been used as a substitute for ginger. Many Indian tribes cut the root, boiled it until it was tender, then dipped it in a sugar syrup, concocting an unusual woodland candy.

The odor of the blossom itself is not particularly appealing. It smells somewhat similar to spoiled meat, but this odor serves to attract carrion flies, which pollinate the plant. Some Indian tribes liked the unusual odor and used the blossoms to flavor meat.

Both Indians and pioneers used wild ginger medically. A common name for the wild ginger family (Aristolochiaceae) is birthwort because many species found within this family are used

during pregnancy and birthing. Wild ginger was made into a tea given to women during pregnancy to reduce aches and pains. This same tea was also used to relieve gas, to increase perspiration, to help break a fever, and to cure whooping cough.

Care should be exercised in taking great quantities of the plant, however. According to the Reader's Digest book *The Magic and Medicine of Plants*, studies indicate that wild ginger has the potential for causing cancer.

Other common names for wild ginger include Canada snakeroot and Vermont snakeroot (perhaps because it grows in areas where snakes are prevalent), colicroot, false coltsfoot, and Indian ginger.

Name: Wild ginger *(Asarum canadense)*
Family: Aristolochiaceae
Description: The flowers of this plant are small, brown, and inconspicuous, particularly because they grow at ground level and are often hidden among fallen leaves on the forest floor. Each blossom measures about one and one-half inches across and is reddish brown or sometimes a green-brown. They are cup-shaped and have three lobes. The leaves are heart-shaped, often hairy, occur in pairs and are about three to six inches high. The plant stands six to twelve inches tall.
Blooms: April through May
Natural habitat: Common throughout the Southeast from Virginia to South Carolina and Georgia west to Missouri. It can be easily found in rich woods.
Propagation and cultivation: Wild ginger makes a wonderful ground cover, for the leaves are evergreen. It grows best in a woodsy area in soil that is rich in humus and is slightly acidic. The plant can be propagated by taking summer stem cuttings or by dividing the plants in fall.

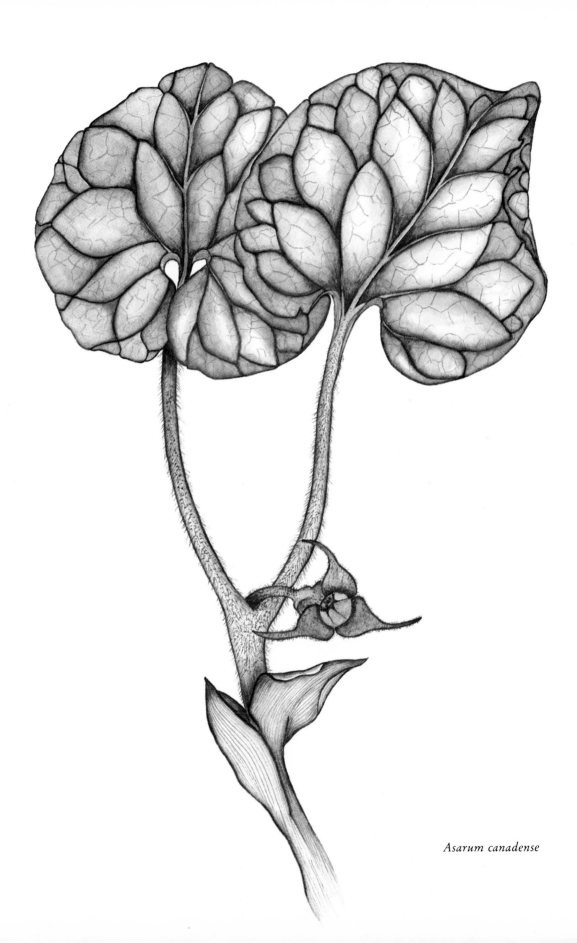

Asarum canadense

Ginseng
(Panax quinquefolia)

They say, you know, that only the pure in heart can find the ginseng root.

Manroot, root of life, elixir of life, a dose of immortality, *garantoqueen* — all are names for ginseng. It holds greater mystique and is reputed to contain more magical powers than any other native American plant.

A Chinese legend tells of the origin of ginseng:

> *A lovely young woman was married to a handsome man, and she looked forward to many long years of happiness with her husband and the children they would have together. Year after year passed, though, and the woman never became pregnant. Custom in the land said that after three years, if the wife bore no children, the husband could take a concubine, and knowledge of this custom made the young wife very unhappy.*
>
> *Finally, when three years had passed and she was still barren, the young woman dreamed about an old man who lived in the mountains. In her dream the man held a strange plant, the root of which looked like a child's body. When she awoke from her dream, the young woman immediately went to the mountains to find this man and his strange plant. After many days of searching, she finally found him, and he gave her a piece of the plant to eat. Upon returning home, the woman became pregnant and soon bore a fine son. The young woman went back to the mountains to thank the man, who was actually a god in disguise. He was so pleased with her happiness that he filled the woods around her home with the strange plant, which today we call ginseng.*

56

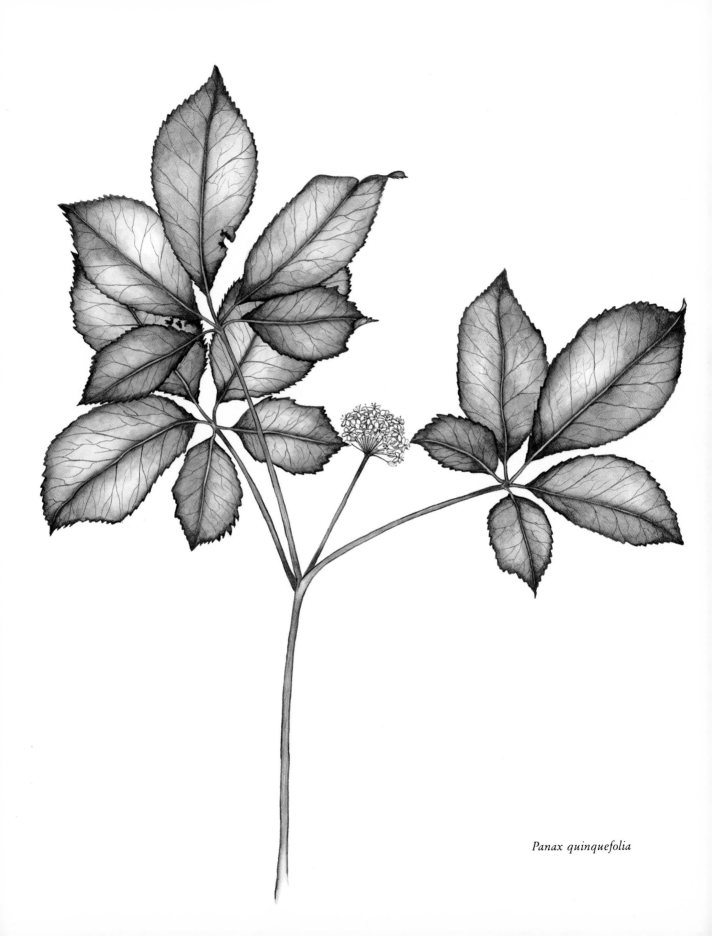

Panax quinquefolia

The use of American ginseng, *Panax quinquefolia*, is relatively recent. It was first discovered in 1716 by a Jesuit missionary working in Canada. He shipped roots to China, where they were enthusiastically received.

Soon ginseng was found growing throughout the eastern United States, particularly in mountainous deciduous forests. Digging for "sang" became a lucrative business, and many trappers dug ginseng roots to supplement their income. Perhaps the most famous of these was Daniel Boone. He is said to have once lost a fifteen-ton cache of ginseng roots when his boat sank. In today's market, that would be worth five million dollars.

The United States produces between two and three hundred tons of ginseng annually. Most of this is cultivated ginseng, and most of that is grown in Marathon County, Wisconsin.

And what is ginseng used for? What makes it so very special?

Chinese ginseng, which is very closely related to American ginseng, has been used by the Chinese for many centuries. Records have been found indicating that the Chinese emperor Shen Nung used ginseng roots five thousand years ago. For a long time only Chinese nobility were allowed to use ginseng root because it was thought to be too fine for commoners.

Ginseng's greatest medicinal powers lie in its use as a general tonic (the genus name, *Panax*, is from two Greek words: *pan*, meaning "all," and *akos*, meaning "cure"). It has been used more specifically as a digestive aid, as a general stimulant for the elderly, and particularly as an aphrodisiac.

Soviet scientists have taken a close look at the medicinal value of ginseng, and ginseng is now being cleared by Soviet doctors for use in commercial medicines. A recent article in *Soviet Life* magazine suggests that ginseng is very versatile and totally harmless. Scientists first began testing the root to determine how effective it is. The data they collected is staggering, for it indicates tremendous versatility in curing disorders and building general good health. It has been determined that ginseng improves the system responsible for the functions of all the cells in the body; thus, if that system is affected, the whole body will be affected. Tests have shown that ginseng can protect cells from radiation and may even be able to prolong the life of individual cells, thus slowing the natural degeneration of the body and improving resistance to disease.

Very little of the ginseng used throughout the world is now found in the wild. Chinese ginseng is nearly extinct, but cultivated ginseng has been grown in China for about six hundred years. Cultivated ginseng roots are much heavier but not as well developed as the wild root and are about the size of a medium carrot. Wild roots are very light and cork-like and command a much greater price than the cultivated roots. The Chinese consider the wild root a gift from the earth and believe that medicinal powers are much more potent in wild roots than in the cultivated ones.

Ginseng can be made into tea by slicing a dried root and steeping it in boiling water for ten minutes. Ginseng tincture can be made by placing one or two dried roots in a glass jar filled with vodka or gin. The roots should be removed after two to three weeks, and the resulting liquid can be added to fruit juice or other drinks for flavoring.

The first recorded use of ginseng was in a book of medicinal traditions written in the first century A.D. Of ginseng it was written: "It is used for enlightening the mind, and increasing the wisdom. Continuous use leads one to longevity."

Name: Ginseng *(Panax quinquefolius)*
Family: Araliaceae
Description: Ginseng is rather an ordinary looking plant. The blossoms are small, greenish white, and somewhat inconspicuous. They measure only one-half inch across and have five petals. These blossoms rise from a circle of three large (five- to twelve-inch) compound leaves. The plant grows to a height of eight to fifteen inches.
Blooms: May through August
Natural habitat: Found in moist woodlands, particularly in cool mountainous areas. In this habitat it can be found in the region from Virginia to Florida.
Propagation and cultivation: Shade is a primary growing condition for ginseng. In addition to this, cool, humus-rich woodland soil is also preferable. In the wild this is most often found under hardwood trees and seldom grows in the acidic soils under evergreens. Small nursery-grown plants are available. Plant them eight inches apart, putting the eye of the rootstock two to three inches deep. Plant in fall or early spring.

Goldenseal
(Hydrastis canadensis)

The old medicine woman gently probes the wound. Although her fingers are gentle, the young boy flinches and tears come to his eyes. He and his friends had been playing out in the woods, and Jonathan jumped from a tree, straight down onto a sharp stick. The stick made an ugly wound in the boy's leg, and, although he is trying to be brave, his nine-year-old eyes are brimming with tears.

His grandmother wipes away his tears and strokes his face. She learned the art of healing from her mother, who had, in turn, learned it from her mother. Today, although a modern medical facility is close by, most of the people in the community still come to this gentle woman, well versed in the art of healing, to soothe their aches and cure their ills.

The old woman carefully takes a piece of root from her bag of herbs.

The boy looks at her skeptically. "What is it?"

She smiles to calm his fears. "Goldenseal. It's very difficult to find this plant now. It is very strong medicine, and for many years people have collected it. Now there is very little left. I have been saving this piece for a very special person so that he will feel soon feel better."

She deftly grinds the root into a powder and creates a yellow salve, which she places on the boy's leg. He visibly relaxes under her ministrations, and she chatters on about the marvelous goldenseal.

Folk healers agree that goldenseal is one of the most effective herbs in the plant kingdom, and its popularity has resulted in overcollection and greatly reduced populations of the plant.

Not only has the plant been useful medicinally, but it has also been a source for a brilliant yellow dye, used as paint for Indians' faces. Mixed with bear grease, yellow *puccoon*, as goldenseal is sometimes called, has also been used as an insect repellent.

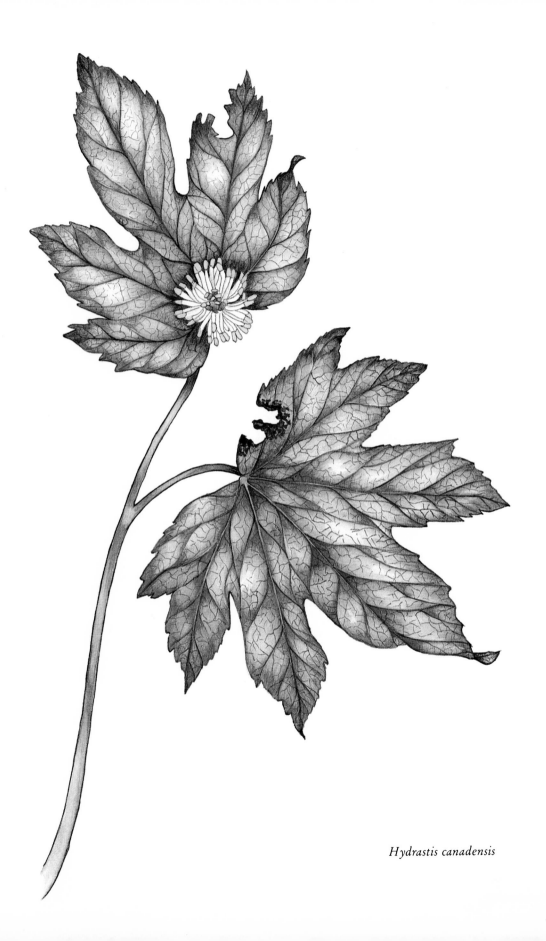

Hydrastis canadensis

Goldenseal has been credited as being effective medicine for many different ailments, among them cancer, mouth ulcers, tuberculosis, dropsy, morning sickness, urinary problems, and inflamed eyes. In addition to its own powers, goldenseal has also been thought to enhance the effectiveness of other drugs as well. For this reason, old herbals and books on healing often include a drop or two of goldenseal in many different treatments.

Modern testing has found that goldenseal is quite effective as an antiseptic and in stopping bleeding. Commercially, alkaloids extracted from the plant are included in some eyedrops. These same alkaloids, effective in treating eyes, are quite poisonous if taken internally in large quantities. No amount of the plant should be eaten unless prescribed by your doctor.

Like Solomon's seal, the name *goldenseal* comes from scars along the rootstock that resemble an old-fashioned wax seal. The genus name, *Hydrastis*, is from the Greek *hydro*, meaning "water," and refers to the preferred moist habitat of the plant.

Name: Goldenseal *(Hydrastis canadensis)*
Family: Ranunculaceae
Description: The flowering stem is hairy and holds two leaves (each with five lobes) and the blossom, which is whitish green, one-half inch across, and has many stamen. A basal leaf is borne on a separate stem. It is thick and deeply wrinkled. The plant attains a height of twelve to sixteen inches.
Blooms: April through May
Natural habitat: Found in rich woods from Virginia south to Georgia and west to Alabama.
Propagation and cultivation: Grow in a shady area with rich, humusy soil and make sure ample moisture is available. Obtain container-grown plants from a reputable nursery.

Hepatica
(Hepatica americana)

Quietly and shyly, hepatica gently heralds the coming of spring. The soft pastel blossoms peek demurely out from amongst the leaves, coyly nodding in the spring breeze. Like a little girl who can't quite make up her mind about which is her favorite color, hepatica blossoms sometimes occur in pale pink, sometimes white, and sometimes light purple.

Hepatica is in such a hurry to bloom early in spring that it must borrow leaves from last year, for the new foliage won't come out until the flowers have quit blooming. The plant looks like a little girl dressed in her Sunday best, but wearing last year's tattered coat.

The fresh hepatica blossoms contrast greatly with the leathery leaves, which are generally a little worse for wear. Farmers searched the woods in early spring for these quiet heralds, for they knew once the hepatica began to bloom, it would soon be time to plant.

The trilobed leaves have an uncanny resemblance to the human liver, a fact that did not go unnoticed by folk healers of the past. Hepatica is a marvelous example of the doctrine of signatures, a thesis which at one time aided healers in knowing which plants had medicinal value. For centuries mankind has used plants to cure various aches and pains. How could we know which plants would cure which ailments?

The answers came slowly. Witch doctors and folk healers in every civilization learned through trial and error and from the experiences of their ancestors. Eventually they gained knowledge of the plants—which ones were good, which were evil, which could cure and which could harm. This knowledge was accumulated year after year and passed on generation to generation. Still, it was difficult to determine which plants had medicinal value.

During the early 1500s a Swiss physician, Paracelsus, contemplated the problem and came up with a unique, though very

human-oriented solution. A deeply religious man, Paracelsus assumed that God must have given man some means of discovering which plants were useful to us and what these uses were. He postulated that each plant might bear a sign or signature, giving healers a clue as to its hidden medicinal value. Therefore, whatever the plant physically resembled, it must cure.

Thus hepatica, which closely resembles the human liver, was believed to cure problems of the liver and a series of symptoms thought to be associated with liver disease. These included cowardice, freckles, and indigestion.

Examples from the doctrine of signatures abound throughout the plant kingdom. Plants with heart-shaped leaves were used to cure heart problems. Stinging nettle, covered with small black hairs, was used to cure baldness. Bellwort, which hangs downward, resembles the human uvula (that little pink thing that hangs down in the back of the throat) and was thus used to cure uvularian problems.

The doctrine of signatures was very popular during its time, and many books and dictionaries were written describing various plants and their related medicinal values. Although today we look at this with a great amount of skepticism, it is easy to understand that in a less sophisticated age, the doctrine of signatures offered an explanation and shed light on the mystical world of healing with plants.

Name: Hepatica *(Hepatica americana)*
Family: Ranunculaceae
Description: The blossoms of hepatica are sometimes light purple and other times pink or white. They are small and dainty and are made up of five to nine petal-like sepals. There are no true petals. The stamen are numerous and conspicuous. Basal wine-colored leaves measure two to two and one-half inches across and have three rounded lobes. The plant grows to a height of four to six inches.
Blooms: March through June
Natural habitat: Found throughout the region in dry, open woods.
Propagation and cultivation: The plant does best where it gets morning sun but is sheltered from hot afternoon sun. It likes slightly acidic humus-rich soil. Plants can be purchased from a

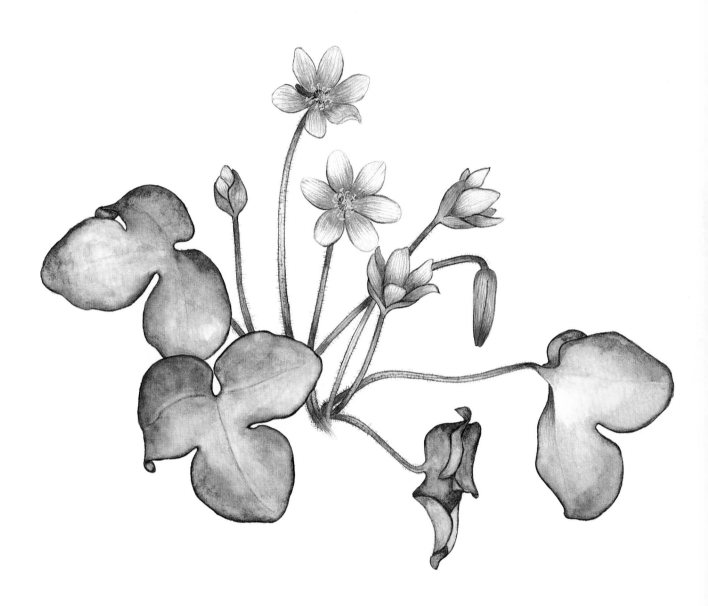

Hepatica americana

native plant nursery and should be set out in early spring or fall. They should be planted eight to twelve inches apart with the shoots just barely above soil level.

Iris
(Iris cristata)

*C*lovis I called a halt to his men and wearily got off his horse. The year was 496, and for the past several years this Franco king had been waging battle after battle to conquer the surrounding lands. His kingdom was extensive and keeping it united was a difficult job.

On this particular day, however, it seemed as if he might lose much of what he had worked so hard to win. The opposing army had been pushing them back for days and finally had the Francos trapped. A large lake was behind them, and to go around would mean losing precious time and being caught in the open without protection.

Clovis shook his head wearily and tried desperately to think of a plan that would save his army. To think more clearly, he walked quickly to the shore of the lake and stood gazing across the water, lost in thought.

Where could they go? How could they escape? Who could help him?

For a moment he wished that he shared his wife's faith in the Christian god. His lovely wife had pleaded with him for years to convert to the Christian faith that she found so warm and reassuring. Clovis had resisted, though, believing that he needed no divine intervention to run his life successfully.

But now, in his hour of need, Clovis bent and prayed to the Christian God, asking Him for help. As he rose from his prayers, Clovis caught sight of something that made his heart leap. Midway across the lake there grew a clump of yellow flag irises. Quickly he called his men, and further investigation showed several colonies of these bog plants growing in the lake.

The implications of this soon became clear to all. If the water was shallow enough to support the roots of the

67

iris, then it would be shallow enough for the army to march through. And, indeed, that proved to be the case. The entire army quickly waded across the shallow lake. As they arrived safely on the other side, the soldiers picked armsful of the iris blossoms, and Clovis declared them a symbol of victory. The three petals of the iris, he told his men, represented faith, wisdom, and valor. Clovis told his soldiers that the iris blossoms had been a sign from the Christian god and suggested that, when they returned home, he and his followers all convert to Christianity.

Clovis's men were enthusiastic about the idea, and on Christmas Day, 496, Clovis and three thousand of his followers converted to Christianity.

The yellow flag iris growing in southern woods today has escaped from cultivation. It is not one of the native iris species. Many iris species are indigenous to the southeastern United States, however, and few of these are more appealing than the small dwarf-crested iris, *Iris cristata*.

Like a miniature copy of its big brother, dwarf-crested iris has violet blue flowers crested with a beard of yellow with white ridges and purple streaks. It grows only four to eight inches tall and has short, broad, sword-like leaves.

All irises were considered sacred to the Greek goddess of the rainbow, Iris. Iris took messages of love from sky to earth, using the rainbow as a bridge. It was the duty of this goddess to escort the souls of women to the Elysian Fields, and as a tribute to the goddess, Greek men often put iris blossoms on the graves of their beloved women.

Based on Clovis's legendary episode with irises, the flower was eventually included on the French banner and is the basis of the French fleur-de-lis.

Many nationalities have found the iris appealing, either because of its beauty or perhaps because of its medicinal value. Throughout the Middle Ages, irises were grown in monastery gardens to provide a variety of cures for everything from ague, epilepsy, chills, and fever to headaches, loose teeth, coughs, and colds.

The Romans also used the iris root, although Pliny, a notable author and statesman, suggested that only those in a state of chastity were able to gather the roots successfully.

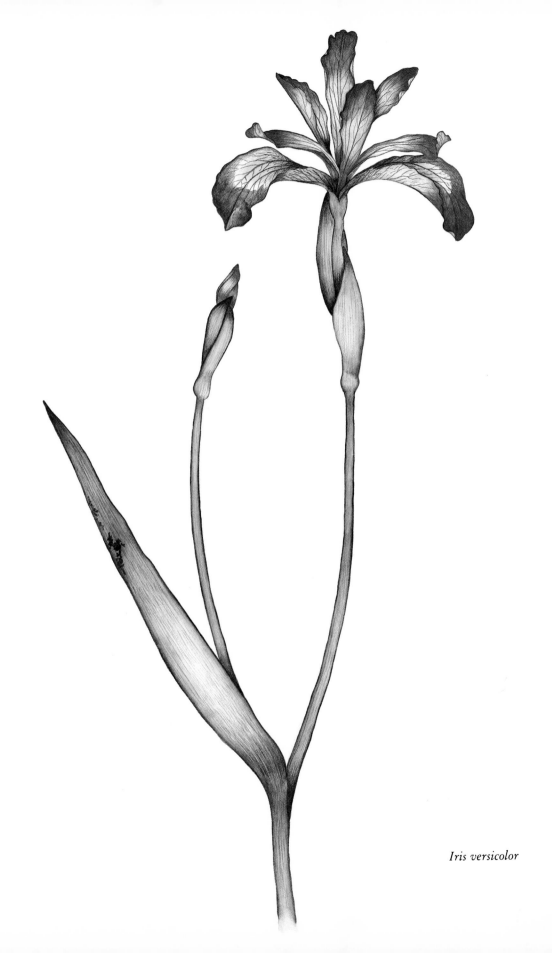

Iris versicolor

Plant breeders have done a wonderful job with native iris species, and today the gardener is enticed by irises in nearly every hue.

Name: Dwarf crested iris *(Iris cristata)*
Family: Iridaceae
Description: Dwarf crested iris looks like a miniature garden iris. It grows only four to nine inches tall. The purple blossom is made up of six parts, three petal-like sepals and three narrow arching petals. The leaves are flat and narrow and continue to grow after the plant has bloomed.
Blooms: April through May
Natural habitat: Found in ravines and shady hillsides from Maryland and Virginia south to Georgia and west to Mississippi.
Propagation and cultivation: The primary requirement for growing this plant is well-drained soil. It can take full or partial shade and will do best in ordinary, rather dry soil. Seeds can be collected in the spring and sown immediately. If the seedbed is kept moist, seedlings should appear the following spring. The plant can also be easily divided in late summer as the foliage turns yellow but before it disappears.

Jack-in-the-pulpit
(Arisaema triphyllum)

Deep in the woods along the Yazoo River in Mississippi lives an entire congregation of preachers. Quiet and stately, these preachers do not shout their words, but allow their beauty to carry their message. The preachers are all, of course, named Jack, and each has his own pulpit.

Although Jack himself is almost always dressed in understated dark maroon, the pulpit is sometimes all green, sometimes green and maroon stripes, and sometimes a more mottled color. Both Jack and his pulpit are shaded from the hot sun by large olive green leaves.

During spring and summer Jack is relatively inconspicuous, but in autumn he adopts his fire-and-brimstone suit, for the fruit that Jack produces is brilliant red and creates quite a spectacle. The berries are eaten by ring-necked pheasants and wild turkey.

Jack-in-the-pulpit is one of the most descriptive of all wildflower names. "Jack" refers to the erect club, or spadix, growing in the center of the plant. This club bears the tiny flowers. Sometimes both the male and female flowers are borne on the same plant. Generally, however, only one or the other can be found on a single plant, a situation which creates the need for cross-pollination by an insect. This job is carried out admirably well by the fungus gnat. Some experts suggest that the young plants (three years or younger) bear the male flowers. As the plant ages, it undergoes a sex change so that older plants bear the female flowers. This change in sex is not unique to the jack-in-the-pulpit plant but occurs in other perennial plants as well.

Jack's pulpit is a curving ridged hood called a spathe. This is actually a modified leaf that serves to protect the spadix.

Jack-in-the-pulpit holds its hidden dangers. Needle-like calcium oxalate crystals are found in the tuber. When the tuber is eaten raw, these crystals become imbedded in the skin and cause

71

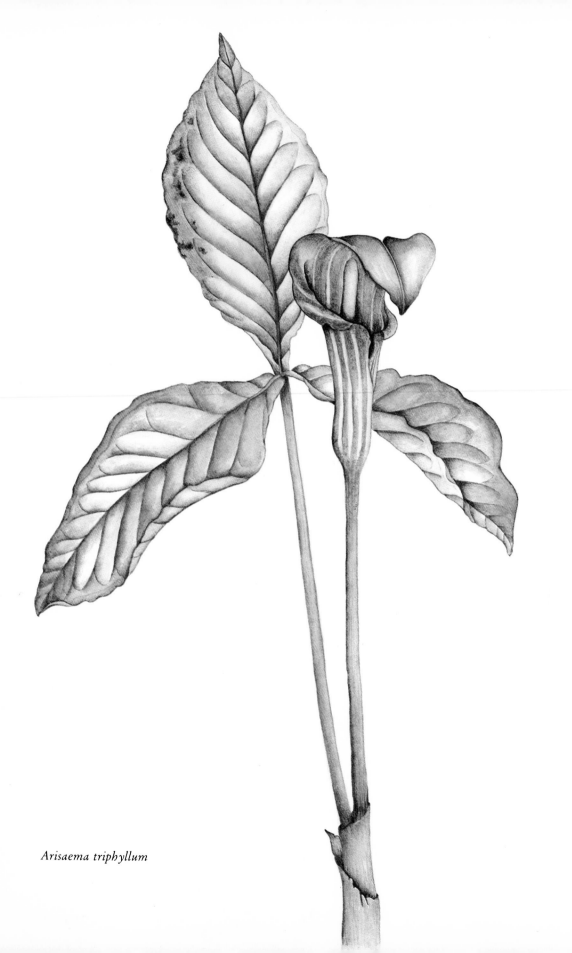

Arisaema triphyllum

an extreme burning sensation, similar to that caused by scalding liquids. This is followed by inflammation and tenderness, which can be somewhat alleviated by drinking cold milk.

If the tuber is cooked, though, these crystals are broken down and become harmless. If prepared correctly, the plant is considered quite a delicacy and is a wonderful source of starch. North American Indians ate it so often that jack-in-the-pulpit soon acquired another common name, Indian turnip. The Indians also ate the ripe boiled berries.

Jack-in-the-pulpit was occasionally used for medicinal purposes. Indians sometimes used carefully prepared measures of the root to treat whooping cough, bronchitis, and croup. The dried root, ground into flour and made into a salve, was applied externally to the forehead to rid the patient of a headache.

Name: Jack-in-the-pulpit *(Arisaema triphyllum)*
Family: Araceae
Description: Jack-in-the-pulpit is one of the easiest wildflowers to identify. The "jack" is the erect club or spadix. His pulpit consists of a curving hood that is actually the spathe. This spathe is either green or purplish brown and is often striped. The entire plant stands approximately one to two feet tall. The leaves occur singly or sometimes in pairs and are a dull green color.
Blooms: April through June
Natural habitat: Found on stream banks or in rich woods and swamps throughout the Southeast.
Propagation and cultivation: In the fall seeds can be collected, cleaned, and sown into prepared seed beds. The plants need to be grown in a shady area that receives ample moisture. The soil should be constantly moist or wet. Fertilizer can be applied lightly during the winter months only.

Lady's-slipper
(Cypripedium acaule)

Pink lady's-slipper is one of our most beautiful southern wildflowers, but it is unfortunately considered threatened in many states. Many people try to bring this beauty home with them and grow lady's-slippers in their own gardens.

Because pink lady's-slippers are very difficult to propagate and take quite a long time (sometimes as many as seven to ten years) to grow from a seed to a blooming plant, most native plant nurseries can afford neither the time nor the space to grow these plants to sell. The result is that most of the plants that are sold are dug from the wild.

Even if they were easy to propagate and the nurseries were full of container-grown plants, growing pink lady's-slippers in the home garden would be difficult. This species shares a symbiotic relationship with a woodland fungus (called a mycorhizal fungus), making it almost impossible for the plant to grow and reproduce when this fungus is not present. In addition, lady's-slippers are quite exacting in their environmental needs. Soil composition, pH level, moisture, and sunlight are all critical factors in the successful growth of our native orchids.

Yellow lady's-slipper is somewhat easier to grow and can be successfully propagated by rhizomal division. This species likes rich, moist woodland soil and, with care, can be grown in a wildflower garden. Lady's-slippers, like all members of the orchid family, are highly specialized in terms of their pollination process. Nearly all orchids are entirely dependent upon insects for pollination.

The lower petal is curled inward, forming a lip. The unusual configuration of this petal is responsible for giving the plant many common names, including lady's-slipper, whippoorwill shoes, Noah's ark, and moccasin flower.

When an insect enters the blossom to find nectar, he easily slips into the curled lip. After drinking his fill, he tries to continue

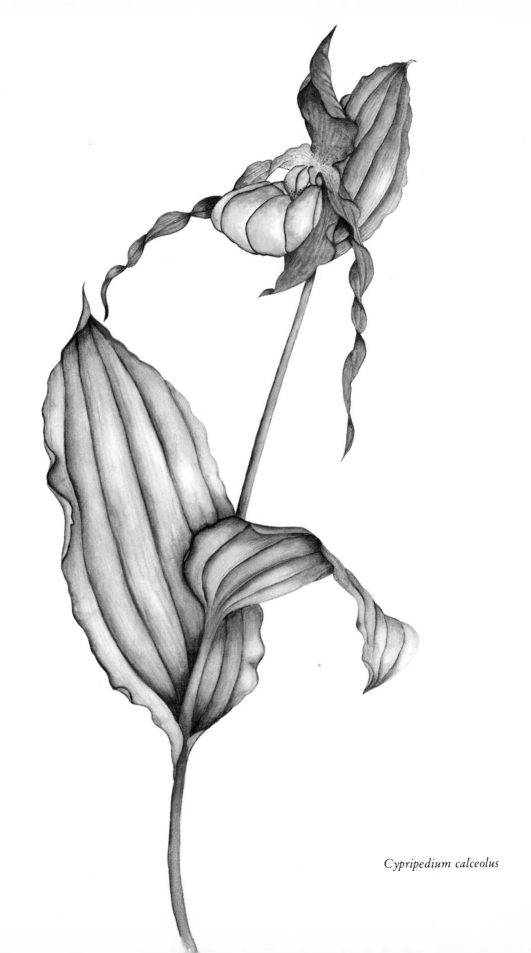

Cypripedium calceolus

his journey on to another plant, only to find that he cannot get out of the flower the way he came in, for the lip is curled inward.

The only escape route is through a tiny hole at the back of the blossom. This hole is large enough for the insect to squeeze through, but in doing so he transfers pollen from one plant to another, thus ensuring each individual plant of cross-pollination.

Yellow lady's-slipper contains chemicals that have been used medicinally. American Indians boiled the root, extracting a substance that they used to calm nerves. Because the plant somewhat resembles garden heliotrope, or valerian, early pioneer women often used yellow lady's-slipper as a substitute, and the plant was sometimes referred to as American valerian. In Europe valerian was used as a light sedative for children.

In our own country, yellow lady's-slipper soon became a favorite soothing herb and was prescribed to treat hysteria, irritability, delirium, and headaches. Although the plant has not been tested thoroughly enough to determine its exact effect, indications are that yellow lady's-slipper is a somewhat effective light sedative.

Name: Lady's-slipper *(Cypripedium acaule)*
Family: Orchidaceae
Description: The blossom is delicately colored pink and has a moccasin-shaped flower. The petal has dark pink or reddish veins. The lip of the flower is about two inches long, and the sepals and side petals are long and slender.
Blooms: April through July
Natural habitat: Found in dry woods, particularly under evergreens. It grows naturally in the region from Virginia south to Georgia and west to Alabama and Tennessee.
Propagation and cultivation: Extreme care should be exercised when purchasing this and other species of lady's-slippers to make sure that they have been propagated ethically and not dug from the wild. They are difficult to propagate and are not readily available for purchase. If the plants have been propagated or moved from a site that was to be cleared, put them in an area that has fertile, acidic humus-rich soil. Mulch with decayed leaf mold that contains a necessary mycorhizal fungus.

Lily of the valley
(Convallaria majalis)

Saint Leonard was a good-hearted soul and a close friend of King Clovis I. A skilled swordsman, Leonard was as brave a fighter as could be found anywhere in the country. In spite of his skills as a fighter, however, Leonard was a gentle man and preferred to spend his days in quiet meditation.

Leonard was a popular figure at court and was often called upon to enter into the games and festivities. But he soon became tired of life at court and in 559 A.D. he asked to be allowed to leave and go live in the woods, where he could freely meditate among the trees and flowers.

Permission was reluctantly granted, and Leonard packed up his few belongings and went to live in the woods. In these very woods lived the fierce dragon, Temptation, who was furious with Leonard for invading his privacy. He appeared to Leonard one day and demanded that he leave. Leonard, however, was at prayer and did not heed the dragon's demands.

The dragon became even more furious and went to Leonard's hut and burned it down with his fiery breath. When Leonard returned, the dragon accosted him and a ferocious battle ensued. It lasted for three days and much blood was spilled.

Wherever a drop of the dragon's blood fell, a poisonous weed began to grow. Wherever Leonard lost a drop of blood, a lily of the valley plant began to grow. In the end, Leonard was able to slay the dragon Temptation.

Dark green veined leaves create a perfect backdrop for the delicately formed white bell-like blossoms of lily of the valley. These plants are the friendly sort and crowd in with one another, forming dense colonies.

Lily of the valley is native to most European countries. It has found growing conditions much to its liking in the southeastern

United States as well and has now naturalized within many of the Southern states.

Its medicinal use dates back many years. Lily of the valley is poisonous though, like foxglove, it has been used extensively as a heart medicine. Ingesting lily of the valley will make the heart beat faster although the substances in it seem less strong than those in foxglove.

During the sixteenth century herbalists suggested that lily of the valley, steeped in wine, would help strengthen the memory and soothe sore or inflamed eyes. This liquid was also thought to help restore speech to one who was struck dumb. A concoction made from lily of the valley rhizome smeared on the forehead was thought to increase common sense.

Some believe that Mary's tears turned into lilies of the valley when she wept at the Cross. For this reason, the flower is sometimes called Mary's tears. Other common names include ladder to heaven and Jacob's tears.

Considered a symbol of purity, humility, and renewed happiness, lily of the valley has been believed to help humans envision a better world.

Name: Lily of the valley (*Convallaria majalis*)
Family: Liliaceae
Description: Attractive dark green ribbed leaves accompany an arching flowering stem. The blossoms are tiny, white, and bell-like and hang down underneath the stem. This grows to a height of six to eight inches tall.
Blooms: April through May
Natural habitat: Having escaped from cultivation, occurs in rich, shady woodland areas.
Propagation and cultivation: Lily of the valley prefers rich, moist soil but is adaptable to drier conditions. It will bloom best in filtered sun where it gets the morning light but is protected from the hot afternoon sun. This plant spreads rapidly. Clumps can be divided in the fall or very early spring just as the leaves appear above ground.

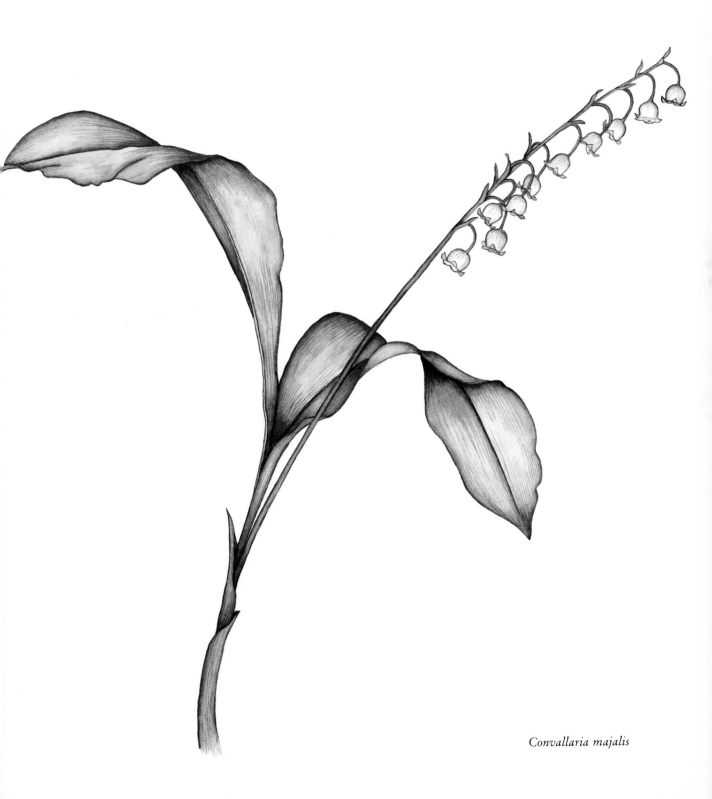

Convallaria majalis

Mayapple
(Podophyllum peltatum)

Highway 17 in western North Carolina follows the cold and beautiful Nantahala River for many miles. It's easy to tell how cold the water is by watching people who are rafting. When they get splashed by an unexpected wave or get dumped by a strong rapid, grimaces usually replace smiles. In spite of the cold water, however, the Nantahala is a favorite river to canoe or raft on. The current is strong and challenging, and the scenery is wonderful.

Only those who are very brave or very foolish paddle the river early enough in spring to take advantage of the spectacular stands of Mayapple that can be found along the riverbanks. New succulent green leaves appear to carpet the forest floor. No small, inconspicuous foliage for this plant, however. Its leaves are its most outstanding feature.

Each individual leaf is large, sometimes measuring a foot across. Deeply lobed, they bear some resemblance to an umbrella and, for this reason, Mayapple is sometimes called umbrella plant.

The blossom is small and white with golden stamen and can be found nodding underneath the leaves. As you search for the blossoms, it is useful to remember that only plants bearing two leaves are capable of bearing a flower as well.

The root is quite thin and looks something like the root of the European mandrake, giving rise to another common name: wild mandrake. Mandrake has long been considered a symbol of fertility, and this association has been passed on to Mayapple. For example, it was believed that if a woman dug up Mayapple, she would soon become pregnant.

North American Indians throughout the eastern United States used Mayapple extensively for its medicinal properties. Various tribes used the root for such diverse ailments as intestinal worms and warts. One tribe even used the sap as an insecticide on their agricultural plants.

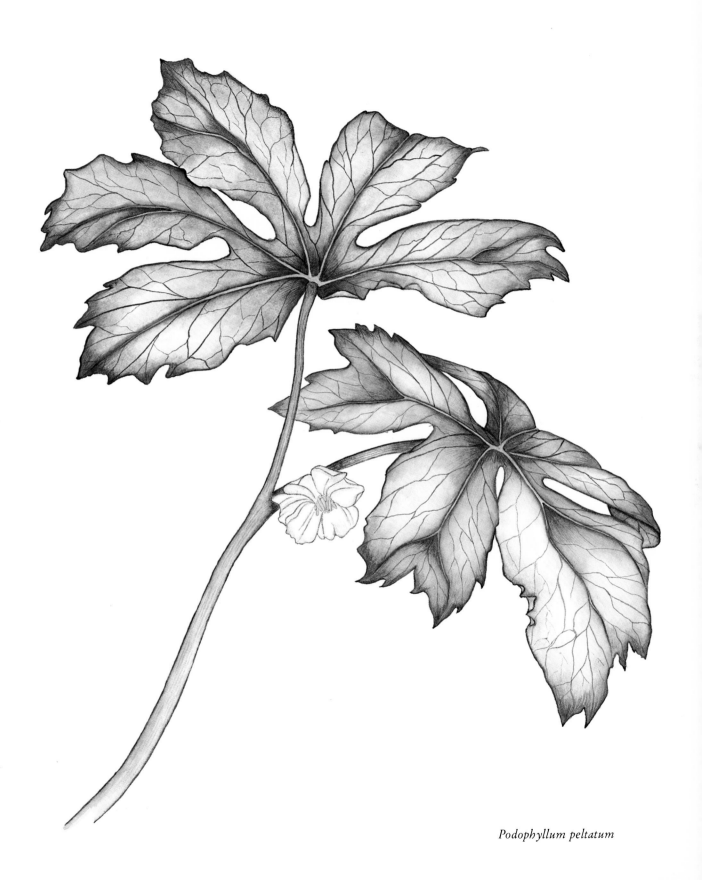

Podophyllum peltatum

The Penobscot Indians used Mayapple to treat malignant tumors. Discovery of this fact encouraged modern researchers to examine the plant closely in hopes of finding chemicals useful in the current war against cancer. Rhizomes were carefully analyzed and found to contain two strong anticancer agents. Drugs containing these are now being used to treat various kinds of cancer.

Like many plants with medicinal value, Mayapple is considered poisonous. All parts of the plant, other than the ripe fruit, are poisonous. The toxic substances are so pronounced that there are reports of the roots and leaves being used by Indians as a suicide plant.

The fruit itself is an entirely different matter. Although not particularly sweet, the fruit has an unusually pleasant taste. It can be used to flavor a drink made with sugar and wine and serves as the basis for a unique marmalade.

Name: Mayapple *(Podophyllum peltatum)*
Family: Berberidaceae
Description: The most conspicuous part of Mayapple is the large umbrella-like leaf. The blossom is small, white, and waxy and can be found only on those plants having two leaves. The plant grows to a height of twelve to eighteen inches.
Blooms: April through June
Natural habitat: Often found along mountain roads or in shady clearings. It grows from Virginia south to Florida and west to Texas.
Propagation and cultivation: Growing in optimum conditions, Mayapple is somewhat aggressive and can cover the forest floor within only a few short years. It prefers soil with a pH of between four to seven that is rich in organic matter. It should be grown in partial shade and given ample moisture. The plants can be easily divided at the end of the growing season.

Phlox
(Phlox divaricata)

Walking through southern woods on a clear spring afternoon can be one of life's richest experiences. Thick layers of ancient forest debris cushion your steps, and your footprints are lost among those that have preceded you for hundreds of years. Let your thoughts wander as your feet do, and the possibilities are endless. Indians? Pioneers? Explorers? They all might have walked on the same trails, explored the same ravines, thrilled at the site of the same waterfall that delights you now.

It is not only your sense of sight that finds delight in the forest, however, for many small wildflowers are so full of sweet fragrance that your sense of smell will be pleased as well.

The reason for this incomparable perfume? To attract pollinators, of course. Plants cannot live by beauty alone, and in their basic need to attract pollinators and fulfill their place in nature's scheme, many plants use fragrance to help. Generally those fragrances are pleasant to our poorly developed sense of smell. Sweet or spicy, fruity or minty, flower fragrances are usually ones that we find pleasurable. A plant that combines beauty and sweet fragrance is truly a treasure.

One such plant, lovely to look at and pleasing to smell, is the small blue woodland phlox, *Phlox divaricata*. Clusters of pale blue flowers cause the short, slender stems to bend with their weight. Light green succulent leaves turn dark as the summer progresses. This phlox multiplies rapidly and often spreads to form great carpets of flowers on the woodland floor.

The little blue phlox is not the only species that grows in the South. Moss phlox, *Phlox subulata*, is low-growing and produces small pink to lavender flowers. This is a plant often used in rock gardens, for its mat-like growth habit makes it exceedingly useful for this purpose.

The showiest of the phloxes is *Phlox paniculata*, or garden phlox. The plant has been so extensively hybridized that it is now often difficult to find the original pink or lavender form.

The name *phlox* is from the Greek word for "flame" and refers to the lovely bright pink flowers. Phloxes were among the first wildflowers collected in the New World and sent back to Europe. British gardeners were delighted with this new plant and were even more pleased to find that it adapted well to growing conditions in England. Plant breeders found phlox plants easy to work with, and today they can be obtained in a multitude of colors and sizes.

During the Victorian Age in England, phloxes were often included in small bouquets, or tussie mussies. These were small bunches of flowers carried by ladies when they had to traverse the streets. Sanitation was not terribly good during this time, and the flowers dispelled the unpleasant odors.

Phloxes were also popular in bouquets because of the secret message they carried. In the language of flowers, in which each variety was thought to carry a different message, phlox meant a proposal of love and a wish for sweet dreams, a most welcome message for any young girl.

Although the leaves of phlox were sometimes made into an ointment used to soothe skin disorders, the usefulness of phlox comes not from its medicinal value, but from its cherished beauty and the scent of its blossoms.

Name: Blue phlox *(Phlox divaricata)*
Family: Polemoniaceae
Description: Blue phlox grows only about ten to twenty inches tall and is covered with purplish blue five-petaled flowers measuring three-quarters of an inch to an inch across. The leaves are one to two inches long, ovate and entire.
Blooms: April through June
Natural habitat: Grows in the northern part of the region, from Virginia south to South Carolina and west to Alabama and eastern Texas. It can most often be found in shady clearings or in woods.
Propagation and cultivation: So popular is this species as a garden plant that many hybrids and cultivars have been developed from it. Among the most often used is white phlox, variety

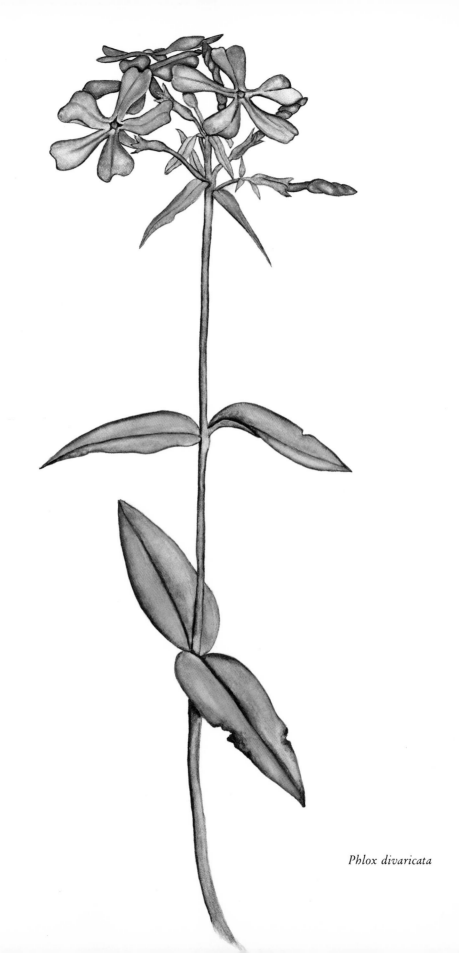

Phlox divaricata

albiflora. All varieties of *Phlox divaricata* need neutral to slightly acidic soils and prefer abundant moisture. The soil should be rich in organic matter. This species spreads very well when grown in a suitable spot. Plants can be divided in the spring or late summer.

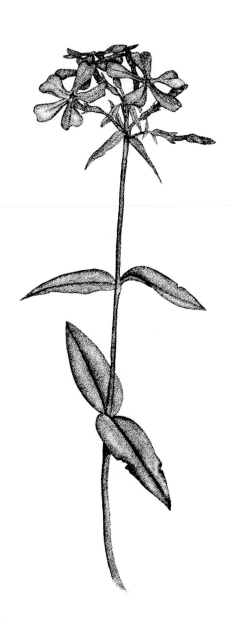

Rhododendron
(Rhododendron catawbiense)

Hazel Hamilton gently cups the orange-yellow blossom. The flower is unusually exquisite in a family known for its beautiful blossoms.

She turns and smiles. "It's named for me, you know. This is *Rhododendron Hazel Hamilton*. We found it on the property in Atlanta when we first moved here in 1952, and it was really what started us off on this love affair with the rhododendrons."

It is not a secretive affair, this thing that Fred and Hazel Hamilton have with rhododendrons. Their corner lot in an Atlanta suburb is filled with impeccably groomed rhododendrons. Brilliant purples vie for attention with subtle pinks. Orange blossoms wave from across the walks, and white flowers sit quietly waiting for a passing word of praise.

From their first "Wonder what it is?" when they discovered some native azaleas and rhododendrons on their property to an expertise that is known from one side of the continent to the other, the Hamiltons have brought beauty and pleasure to innumerable people through their rhododendron collection.

Fred and Hazel Hamilton's interest in these native shrubs led them to the North Georgia mountains, where they bought a house on Lake Chatuge. There, their woods, with a small mountain stream and waterfall, became a perfect spot for a large collection of rhododendrons.

Public interest in this collection was so great that in 1982 the Hamiltons donated the plants (then numbering more than seven hundred) to create the Rhododendron Garden on the grounds of the Hiawassee State Fair in north Georgia.

The word *rhododendron* comes from two Latin words: *rhodon*, meaning "rose," and *dendron*, meaning "tree." Rosetree is an apt name for shrubs of such beauty.

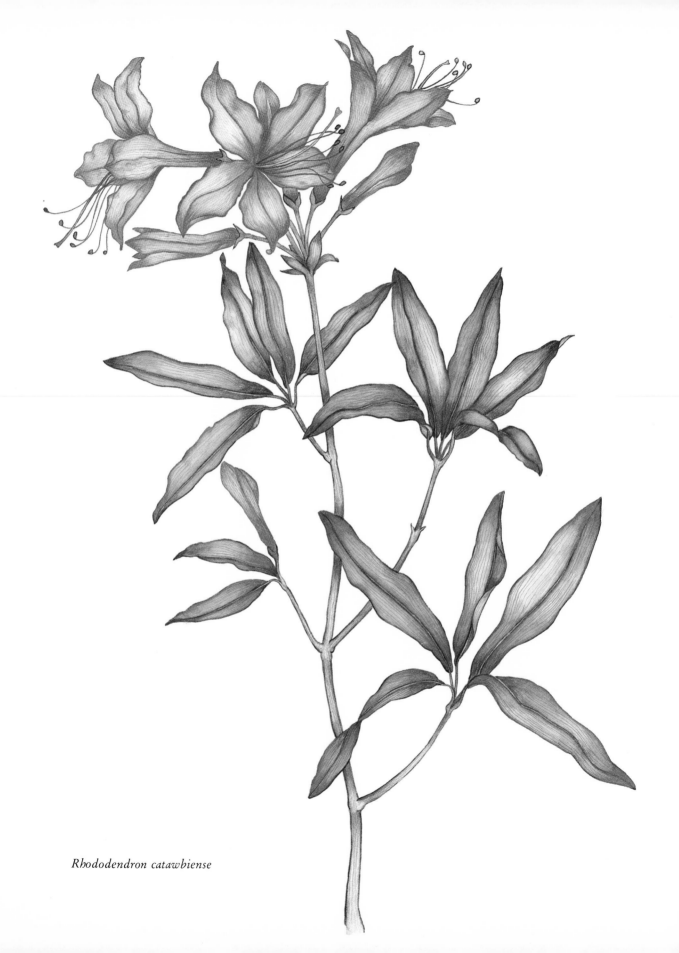

Rhododendron catawbiense

In the southern Appalachian mountains, native rhododendrons put on quite a show in late spring and early summer. Perhaps of all shrubs, Catawba rhododendron is the favorite of visitors to the mountains. These shrubs hold a profusion of large pinkish purple blossoms. Against a backdrop of shiny evergreen leaves, the flowers are beautiful to behold.

Many miles south of the cool mountains grows another native shrub, *Rhododendron prunifolium*. This species was discovered by Cason and Virginia Callaway growing on their property in southeastern Georgia. Unusually beautiful with bright pink flowers, this rhododendron species is a favorite of all those visiting Callaway Gardens today.

Name: Rhododendron *(Rhododendron catawbiense)*
Family: Ericaceae
Description: A beautiful shrub, this rhododendron species can vary in height from three to twenty feet. The large purple or rose-colored blossoms occur in clusters. Each flower is two to two and one-half inches across. The thick evergreen leaves are two to six inches long.
Blooms: May through June
Natural habitat: Found on rocky slopes and stream banks and in wooded areas throughout most of the region.
Propagation and cultivation: Rhododendrons need rich, slightly acidic, very well-drained soil. Woodland soil is best, but garden soil amended with generous amounts of organic matter will be sufficient. The plant will perform well if given sufficient moisture and if grown in an area that provides protection from the hot afternoon sun. This species has been extensively hybridized with a Himalayan species to give us some outstanding garden specimens.

Shortia
(Shortia galacifolia)

George Hyman sighed and slowly closed his notebook, stashing it carefully in his knapsack. He glanced at the sun and sighed again, knowing he would have to hurry to make it home in time for dinner. In spite of the late hour, he looked around himself and grinned with pleasure. McDowell County, North Carolina, in 1877 was a beautiful place, and for a seventeen-year-old boy with a passion for wild plants, it was heaven on earth.

George slung his knapsack on his back and began walking quickly back down the trail. It had been a good day, he decided. His notebook was full of information about plants he had seen—nothing new or spectacular, but interesting enough to satisfy himself.

As the early spring sun dropped lower and lower in the sky, George began to hurry and decided to take a shortcut along the Catawba River. Far down the steep bank he caught sight of a clump of white flowers. He stopped momentarily, then shrugged and hurried on. Probably just a patch of late bloodroot, he reasoned. But, no, the stems were too tall and slender, and the blossom had a distinct pinkish cast to it. Couldn't be bloodroot.

His steps slowed as his mind went over all possible identities for the plant. None of them fit, and he finally turned and retraced his steps. He found the plant and bent low to examine the single pinkish white bell-shaped flower. The leaves were round and shiny, resembling galax, but the plant was definitely not galax.

Holding his excitement in check, George carefully collected a sample of this plant, which, unbeknownst to him, had been collected only once previously, and that nearly a hundred years earlier.

In 1788 André Michaux, a French botanist was exploring the mountains of the eastern United States, hoping to find new species of useful plants. In his explorations, he collected the same plant that George Hyman was to find a century later.

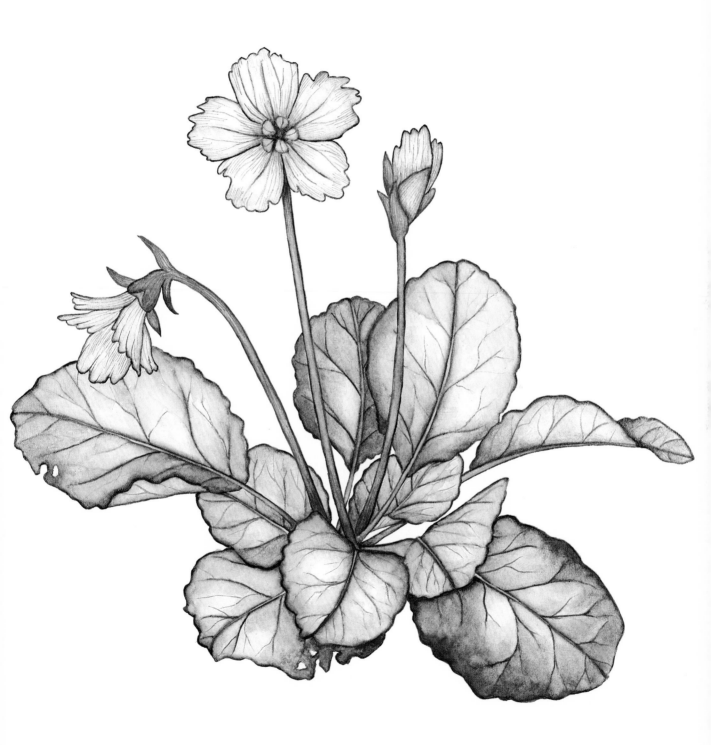

Shortia galacifolia

All of Michaux's collection went to a herbarium in Paris, where much of it lay uninvestigated and unnamed for many years. In the 1840s, the famous botanist Asa Gray found the mystery plant at the herbarium, placed it in the *Diapensiaceae* family and named it *Shortia galacifolia*: *Shortia* after Dr. Charles W. Short, a Kentucky doctor and avid plant enthusiast, and *galacifolia*, referring to the galax-like leaves.

Asa Gray had not seen this plant before and launched a great search to find it in the wild, but with no luck. It wasn't until George Hyman stumbled across it years later that natural populations of the plant were found. George's discovery created quite a stir in the plant world. Botanists and interested laymen rushed to the area to collect the plant, and soon it became quite scarce in this first spot of rediscovery.

Luckily, exploration of wild gorge areas in surrounding counties revealed several other locations where shortia grew. The plant is often called Oconee bells because it grows in Oconee County, South Carolina.

Because of its rarity, shortia was not used for food or medicine. Other than the interesting episode surrounding its discovery, the plant remains merely a beautiful jewel in our southern woods.

Name: Shortia *(Shortia galacifolia)*
Family: Diapensiaceae
Description: The attractive flowers of shortia are white, have irregularly toothed edges, and occur one to a stem. The leaves are equally attractive and have rounded, lobed edges. The leaves are three to five inches across and are shiny and smooth. It reaches a height of two to eight inches.
Blooms: March through April
Natural habitat: Extremely rare in the wild. It occurs naturally in only seven counties where Georgia, North Carolina, and South Carolina meet. It is generally found in moist, rich woods along stream banks.
Propagation and cultivation: Shortia is surprisingly easy to grow in a wildflower garden. It is essential that buyers purchase this plant from a reputable nursery and make certain that the plants were not dug from the wild. Plant shortia in a shady, moist location where the soil is rich in humus matter.

Skunk cabbage

(Symplocarpus foetidus)

There are simply more pleasant places to be than in a swamp in late winter. Deep, dank cold is everywhere, creeping into your bones until you feel thoroughly chilled. Stagnant water stands partially frozen, and miniature snowdrifts pile up on fallen leaves. Stalks and stems left over from warmer days stand guard in this quiet, cold world.

But not all is silent and still in this frozen landscape. Even while snow is still on the ground, the life force of the swamp plants is growing strong. By late February, tips of skunk cabbage leaves can be seen pushing their way through snow and ice, shoveling aside old, withered leaves to make way for new growth.

Like a primitive beast, skunk cabbage pushes through the mud and muck to find air and sunshine. So determined is this plant to grow and bloom early in the season that it sometimes pushes right through the snow and ice.

As it grows, skunk cabbage produces a tremendous amount of heat. Records show temperatures within the flower bud that are twenty-seven degrees Fahrenheit warmer than the surrounding air temperature. This internal warmth serves to protect the plant from cold temperatures and intensifies the odor that so many insects find appealing.

Although insects might think skunk cabbage has an appealing odor, few humans agree with them. As both the common and species names suggests, the smell of skunk cabbage is not the most pleasant. The species name, *foetidus*, means "evil smelling." The strong odor, along with the dark red coloration of the plant, is all a part of nature's plan, however. Skunk cabbage both looks and smells like spoiled meat and serves to attract the carrion flies who then pollinate it.

You can't judge a flower by its smell, and it is worth a trip into the swamp to discover the small and subtle flowers found in

93

skunk cabbage. Some folks find these tiny flowers so attractive that they bring them home to include in floral arrangements. In his book *Using Wild and Wayside Plants,* Nelson Coon assures us that "at this stage of growth the odor is not offensive."

Early tender leaves can be eaten with great relish as a spring vegetable. Cooks should change the water several times during the cooking process. The plant's unpleasant odor is eliminated by cooking. The root, ground into a powder, can be added to batter for making bread.

Skunk cabbage has been used to treat a long and varied list of ailments. To cure a headache, one smelled the crushed leaves. Drinking a concoction made from the leaves was thought to be useful in treating venereal diseases. Many different respiratory complaints, including bronchitis, asthma, and tuberculosis, were treated by powdered root taken with a bit of honey. The root was also believed to help control fits caused by hysteria and epilepsy. The most frequent medicinal use of skunk cabbage was as a contraceptive. People even thought it could produce sterility in men or women who consumed one tablespoon of the root three times a day for three weeks. The root was also made into a salve to relieve pain and swelling from rheumatism and to stop the flow of blood from open wounds.

Name: Skunk cabbage *(Symplocarpus foetidus)*
Family: Araceae
Description: Skunk cabbage is a low-growing, rather strange-looking plant. It is composed of a large purplish brown-and-green mottled spathe, curled around in the shape of a shell. Inside this is a rounded spadix, covered with tiny starlike flowers. The leaves form after the plant blooms. They are large and look like cabbage leaves.
Blooms: February through May
Natural habitat: Swamps, bogs, and marshes south to Georgia.
Propagation and cultivation: Skunk cabbage needs rich, moist soil that is neutral to slightly acidic. Although it can tolerate sun with sufficient moisture, it will do better in a shady spot. Nursery grown plants should be put out in the fall, approximately two to three feet apart. Set the shoot at soil level and mulch well with well-rotted leaves.

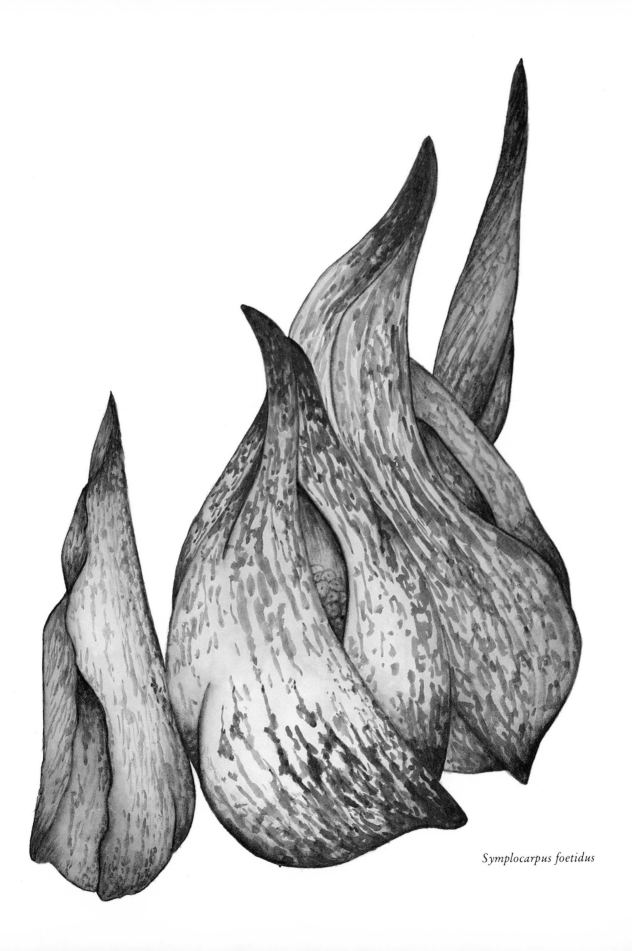

Symplocarpus foetidus

Solomon's-seal
(Polygonatum biflorum)

As regal as its name, Solomon's-seal reigns over the forest floor during late spring and early summer. Gracefully arching stems create miniature arbors under which tiny white bell-like flowers hang in pairs. As summer turns to fall, these white flowers turn to blue-black berries and the march of seasons continues.

The genus name for Solomon's-seal is *Polygonatum*, from the Latin words meaning "many jointed." Dig up the rootstock and it will be immediately obvious how the plant earned its name. The root grows horizontally just under the surface of the soil. Each spring the rootstock creates a new node and puts forth a new stem. At the end of the growing season when the stem dies back, a scar is left on the rootstock. Thus, the gnarled and twisted root holds the scars of a lifetime. Just as you can tell the age of a tree by counting the rings in its trunk, you can determine the age of a Solomon's-seal plant by counting the scars along the rootstock.

Although the Solomon's-seal that grows in our southern woods (*Polygonatum biflorum*) is not native to Europe, a similar species (*Polygonatum officinale*) can be found growing in moist woods in many parts of Europe. The two plants share very similar characteristics, including the scars along the roots.

During the Middle Ages, folk healers believed that the root scars had been placed there by King Solomon, son of David, whose powers of wisdom and healing were legendary. The seal of Solomon was thought to have been a six-pointed star, to which the scars on the rootstock hold an uncanny resemblance.

Because they believed that the plant carried the mark of Solomon himself, folk healers used Solomon's-seal extensively in various treatments. Based on the doctrine of signatures (see page 64), Solomon's-seal was used to "seal together" broken bones.

John Gerard, author of a sixteenth-century herbal, suggested that the plant was useful in treating cuts and bruises. He wrote,

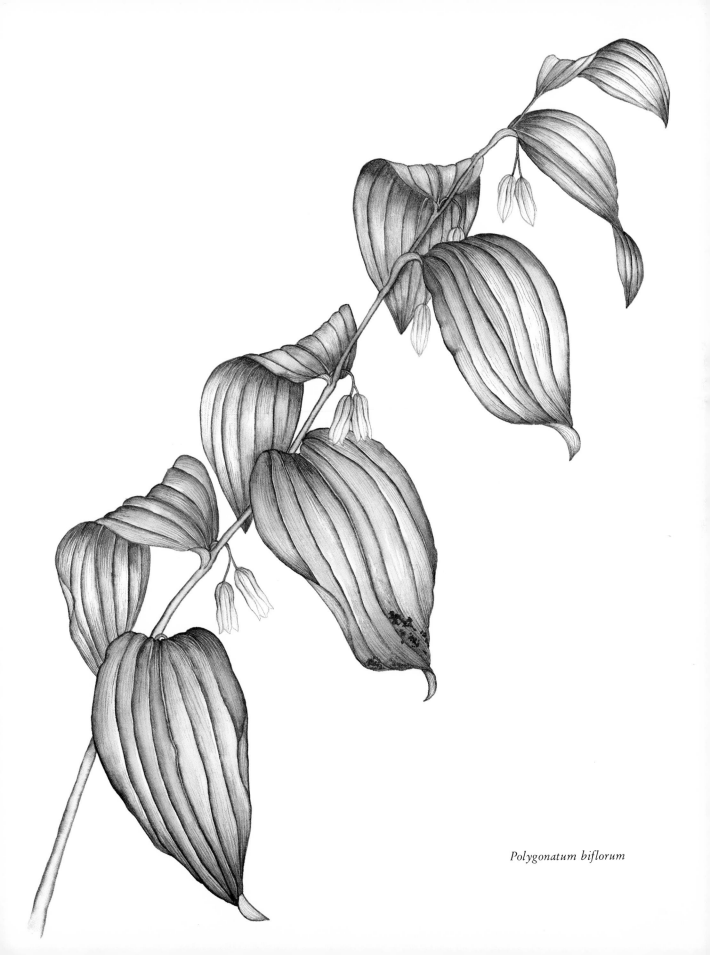

Polygonatum biflorum

"The root of Solomons Seale stamped, while it is fresh and greene, and applied, taketh away in one night, or two at the most, any bruise, black or blew spots, gotten by falls or women's willfulness in stumbling on their hasty husbands' fists."

A drawing of Solomon's-seal was found on the border of a page in a sixteenth-century herbal. The plant was referred to as *Sigillum benedictae virginis*, or seal of the Blessed Virgin.

European and American species of Solomon's-seal share more than a physical resemblance. Their medicinal virtues seem to be similar as well. Although separated by time and distance, American Indian medicine men and European folk healers have used these plants for similar purposes.

Indian healers created a concoction from the crushed root that they used to treat bruised skin, believing that the plant would help take out the discoloration of the wound. In addition, a tea made from the plant was used as a contraceptive. Extending their use of Solomon's-seal, American Indians found the plant to have culinary value as well. Both the roots and shoots are edible, and the roots can be ground to make flour.

Modern-day laboratory tests have found that Solomon's-seal contains a substance called allantoin, which has been found useful in treating external wounds and skin ulcers.

Name: Solomon's-seal *(Polygonatum biflorum)*
Family: Liliaceae
Description: The flowering stem of Solomon's-seal arches gracefully, and the flowers occur in pairs underneath the stem. Each blossom is small (one-half to two-thirds of an inch across), white, and bell-shaped. The height of the plant is eight to thirty-six inches.
Blooms: May through June
Natural habitat: Found in woods and shady clearings throughout the region.
Propagation and cultivation: The shape of Solomon's-seal lends attractive texture to the wildflower garden. It should be planted in deep shade in soil that is rich and moist. Plants should be set out in spring or fall and spaced a foot apart.

Spring beauty
(Claytonia virginica)

The Quarry Garden behind the Tullie Smith House at the Atlanta Historical Society is an exciting place in early spring. Long paths wind their way through a great depression in the ground, the site of an ancient quarry worked by convicts at the turn of the century.

The sound of picks and shovels is now merely a sound of the past. Several years ago the old quarry was adopted by one of Atlanta's leading garden clubs and transformed into a wild flower garden of exquisite beauty. Today, the garden is a quiet haven in the center of Atlanta's busy Buckhead district. Tall, stately trees form a canopy, blocking out not only the sight of skyscrapers but also the incessant sounds of city life.

As the path climbs steeply out of the quarry, visitors come eye-to-eye with myriad plants growing on the hillside. In early spring, this hillside comes alive with the delicate splendor of the small wildflower aptly named spring beauty.

This small plant is the epitome of a spring wildflower. It is small, sweet-smelling and dainty. The elegant blossoms look fragile and vulnerable to a hundred forest tragedies, but somehow the plant manages to live and bloom. Its tiny petals coyly attract pollinators, and spring beauty sets seed so that yet another generation of plants can grace the woods with their quiet beauty.

From a distance spring beauty blossoms look pink. Close inspection will prove, however, that the petals are not pink, but white, closely lined with dark pink veins. The pink theme is carried through by the stamen, which are also of this same hue.

Spring beauty has long been a favorite of wild food enthusiasts. The small corms, or small bulb-like structures, closely resemble a miniature baked potato, but with a distinctive nutty flavor. This is the reason for one of the common names given this plant, fairy spuds.

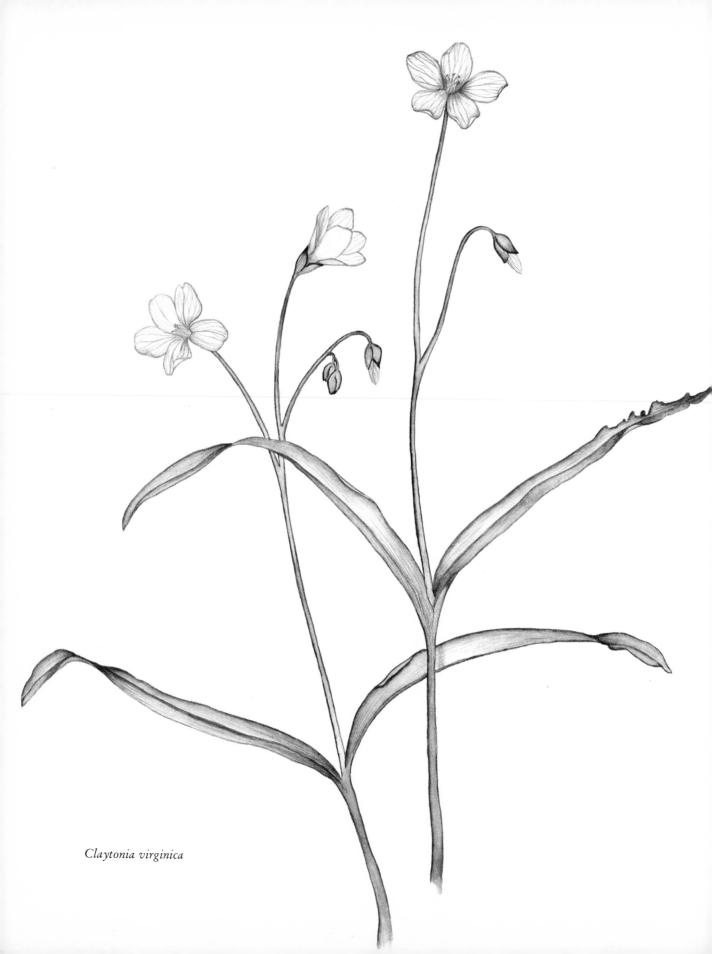

Claytonia virginica

The corms can be eaten raw (in which case they have the biting taste of a radish) or cooked. To cook spring beauty corms, wash and boil them in water until they are tender. These can be served with a cream sauce or with melted cheese and herbs.

Be sure to dig these corms cautiously. Dig only in areas where there is a great profusion of the plants, and then dig only sparingly. In these circumstances, however, no harm is done. Digging a few corms tends to help thin the plant population and often serves to stimulate more vigorous growth.

The most unusual use for spring beauty is in the study of genetics. Almost all living species have a set number of chromosomes, that is, a certain number that will determine the genetic makeup of that particular organism. Any variation from this number usually results in an aberration of the organism. Research has proven, however, that spring beauty plants have an unstable number, resulting in the possibility of numerous chromosomal combinations. Perhaps study of this plant may help us better understand the role of chromosomes within an organism and, thus, further unravel the mystery of genetics.

Name: Spring beauty *(Claytonia virginica)*
Family: Portulacaceae
Description: Tiny white flowers are lined with deep pink or red veins, giving the overall appearance of a pink blossom. The flower is only one-half of an inch wide and has five petals and five stamen with pink anthers. Generally the flower is accompanied by a single pair of long, narrow dark green leaves. The height of the plant is six to twelve inches.
Blooms: March through May
Natural habitat: Commonly found in rich, moist woods or along stream banks. In the Southeast it grows naturally from Virginia and Maryland south to Georgia and west to Louisiana and Texas.
Propagation and cultivation: This plant needs ample moisture and rich woodland soil. The corms should be planted two to three inches deep in the fall in an area that receives filtered sunlight.

Wild strawberry
(Fragaria virginiana)

*(Adapted from **Myths of the Cherokee**, by James Mooney)*

When the world was first created, there were a man and a woman who lived peacefully together. Eventually, however, they began to argue and to bicker with one another. The man would complain and shout, and the woman would whine and sulk. Finally, the woman decided to leave, and early one morning she began to walk towards the sun, promising never to look back.

After she had gone, the man was very sad and wished that she would return. He began to follow her, but she never looked back to see him. They walked for many days and not once did the woman turn to look behind her. Finally, Unehlanvhi (the Sun) took pity on the man and asked if he was still angry with his wife. He answered no. Then Unehlanvhi asked if he would like her to come back, to which he eagerly answered yes.

Unehlanvhi then caused a patch of wonderful huckleberries to appear before the woman, but she walked by without stopping. Then he sent blackberries, but these also she walked by. He sent many different kinds of trees and shrubs, all laden with fruit to tempt her and cause her to stop and look back at her husband. But she showed no interest in any of them.

Finally Unehlanvhi sent a small patch of strawberries. These had never before been seen on earth, and when they appeared, the woman stopped to look at them and then tasted one of the small red berries. They were so

102

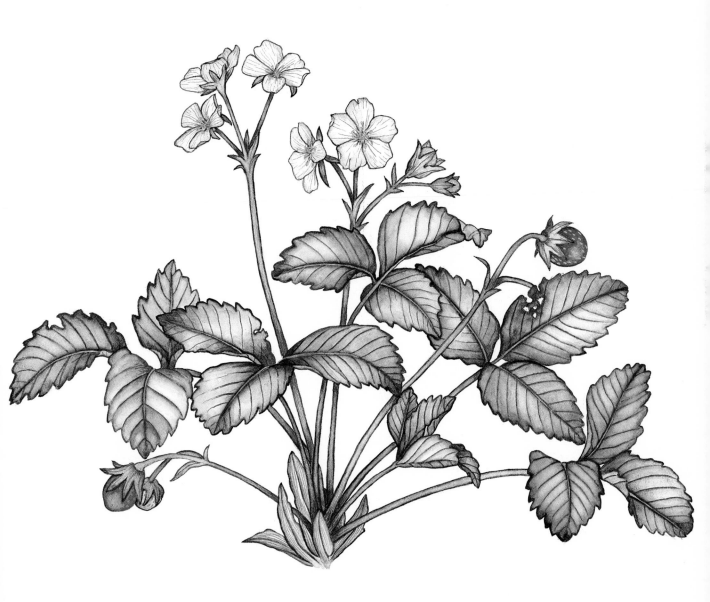

Fragaria virginia

delicious that she sat down and ate all of the berries and, in so doing, glanced back and saw her husband behind her.

She sat for a long time, eating strawberries, and the longer she sat there, the more she desired her husband. At last, she gathered the last of the strawberries and, turning back, walked to her husband and gave them to him. He accepted them, and together they returned home.

This myth of the origin of strawberries suggests that these bright red fruits may be something of an aphrodisiac. This may, in fact, be true, based on a description found in William Bartram's journal in 1776. He wrote:

We enjoyed a most enchanting view — a vast expanse of green meadows and strawberry fields, a meandering river gliding through . . . companies of young, innocent Cherokee virgins, some busy gathering the rich, fragrant fruit. Others, having already filled their baskets, lay reclined under the shade of floriferous and fragrant bowers . . . disclosing their beauties to the fluttering breeze and bathing their limbs in the cool, fleeting streams whilst other parties, more gay and libertine, were yet collecting strawberries, or wantonly chasing their companions, tantalizing them, staining their lips and cheeks with the rich fruit.

Wild strawberries were valued for their medicinal attributes as well. They were recommended for many different ailments and were said to revive one after a fainting spell and also quench thirst. A seventeenth-century herbal suggested that "They are good for inflammations, but it is best to refrain from them in a fever, lest they petrify in the stomach and increase the fits."

Strawberry tea was used as a general tonic and as a mouthwash and was used to treat diarrhea. Strawberry juice, an ancient toothpaste, was smeared on the teeth and left for five minutes. Then the mouth was rinsed with warm water and a pinch of bicarbonate of soda.

The name *strawberry* does not come from using straw as a mulch between the plants, but instead refers to the growing habit of the plant. Small runners appear from each parent plant, and

these run every whichway and look as if they have been "strewn" over the ground. Thus, the name was originally "strewberry," which later evolved to strawberry.

Though smaller than the domesticated fruit, wild strawberries are thought to be far superior. Izaak Walton said, "Doubtless God could have made a better berry, but doubtless He never did."

Name: Wild strawberry *(Fragaria virginiana)*
Family: Rosaceae
Description: The small white flowers of the true wild strawberry are three-quarters of an inch across and have five petals and five sepals. Numerous pistils in the center of the flower create a small dome. The leaves are on long stalks and are in three parts, each part being a rounded lobe, notched on the edges. It is a low-growing plant, reaching a height of only three to six inches.
Blooms: April through June
Natural habitat: Found in rich soils in wood edges throughout the region.
Propagation and cultivation: As desirable for its attractive foliage as for its delicious fruit, wild strawberry makes a good ground cover. It needs full or filtered sun and rich garden soil.

Trailing arbutus
(Epigaea repens)

Martha Johnston was glad to slip away for a few minutes. Life had been hard during the first winter at Plymouth Rock, and sometimes it was difficult not to let her spirits sag. Cold weather and hunger had taken their toll on the first Pilgrims, and they were all feeling very homesick. Whenever Martha found a few moments to herself, she walked through the woods to help relieve her spirits.

Winter on the New England coast had been quite harsh, and Martha was delighted to find that finally there was a bit of warmth in the air. The snow had begun to melt, and in many places large patches of the forest floor lay wet and brown, soaking up the early spring sunshine.

Martha watched the forest floor carefully, always on the lookout for a bit of green that she might find to spice up their bland fare.

Martha suddenly smelled the most delightful scent that had met her nose since she left England. As sweet as perfume and as delicate as warm spring air, the fragrance filled her with delight. Quickly, she bent down to the ground, hoping to find the source of this wonderful smell. She pushed aside a few leaves and uncovered several small whitish pink blossoms. Picking one and holding it to her nose, Martha was thrilled to have found the origin of the fragrance.

Happily, she searched the area and found many of these small, deliciously flavored blossoms. These she carried back to the settlement. The effect of the blossoms on the Pilgrims was great. Finally, after months of hardship they had found a sign that the cold, barren land was waking once again and putting forth beauty and fragrance. The Pilgrims felt joy at finding this sign of spring and renewed their determination to create a civilized world in their new land. They referred to the plant as a sacred flower, full of faith and hope.

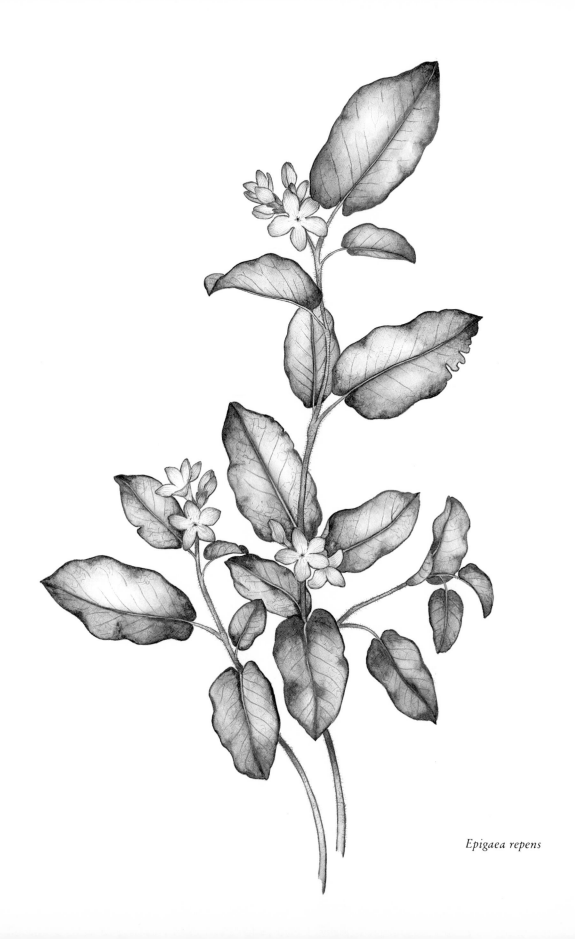

Epigaea repens

The Pilgrims named the plant mayflower, in honor of the ship which had brought them to this New World. The plant also showed a close similarity to the English hawthorn, which is also called mayflower.

Mayflower, or trailing arbutus, as it is most often called, remained a favorite wildflower for many, many years. Its popularity, however, eventually led to its decline. Because the blossoms are so sweetly scented, they were very often picked for bouquets and were frequently sold on city streets. All too soon, natural populations were greatly depleted, and the plant is now considered threatened in many states.

Trailing arbutus is a member of the heath family and considered a subshrub, for it bears small, woody stems. It grows so close to the ground, however, that it is also sometimes referred to as a vine. The leaves are thick and leathery and covered with rust-covered hairs. New leaves will not appear on the plant until after the blossoms have disappeared.

Both the botanical and common names for the plant refer to the growing habit of trailing arbutus. *Epigaea*, the genus name, is from Greek words meaning "upon the earth," and *repens* is translated as "trailing" or "creeping." The name *trailing arbutus* was given to this plant because of its similarity to a common English shrub called arbutus.

Indian medicine men sometimes used trailing arbutus as treatment for urinary infections, particularly among children. The leaves were added to boiling water and allowed to steep for three to five minutes. The resulting infusion was said to be gentle and effective.

Name: Trailing arbutus *(Epigaea repens)*
Family: Ericaceae
Description: White or pinkish flowers are borne in clusters on this low-growing creeping plant. Each individual flower is about one-third of an inch long and bell-shaped. The stem is woody, the leaves oval, hairy, and somewhat leathery.
Blooms: April through May
Natural habitat: Found in oak-pine woods in the Southeast from Virginia and Maryland south to Georgia and west to Alabama.
Propagation and cultivation: This plant will do well in a cool, rich woods. It needs protection from the hot afternoon sun but will bloom better if exposed to the gentle morning sun. Set out small nursery-grown plants in early spring and mulch with decaying leaf mold.

Trillium

(Trillium grandiflorum)

*T*here once lived a young Indian woman named Moon-flower. Moonflower was, unfortunately, a rather plain young woman. Her nose was a little large and she was a bit plump, but her heart was good and her voice was filled with laughter.

Because she did not possess great beauty, Moonflower had not attracted the attention of any young man in her tribe. She would, however, have made an excellent wife for any of the young braves. She knew how to tan animal hides until they were as soft as a baby's cheek, and she could cook better than any of the women in the tribe. Still, she had no brave to call her own.

Because of this, Moonflower soon became discouraged and depressed, but she was determined to do something about it. One night she went secretly to visit the old medicine woman and told her of her problem. The old woman was sympathetic and gave Moonflower some trillium roots, telling her that if she could get the man of her choice to eat these roots, he would fall in love with her.

The next night Moonflower carefully prepared a delicious stew made from wild onion roots and venison. At the last minute she slipped in the trillium roots. Looking around, she found the handsome son of the chief of the tribe, and, trembling a little, she began walking towards him.

Poor Moonflower. She didn't even see the tree branch lying in her path until she had tripped and fallen flat on her face. Amazingly, the stew did not spill and she set it down beside her as she checked for injuries.

Nearly the entire tribe was laughing at her awkward-ness, and Moonflower wished that the earth would swallow

her up and forever hide her from the mocking faces. As she began to cry, a strong hand wiped away her tears. She looked up and saw the only face in the tribe that was plainer than her own.

He was a tall, strong man, but with a craggy face and large ears. He bent down and helped her up, gently asking if she was hurt. She shook her head no and happened to glance at the chief's son, who was still laughing at her fall.

Looking back at the ugly but kind face of the man next to her, Moonflower made up her mind. She bent down and offered him the stew that still held the magical trillium roots. He quickly ate it, praising her cooking.

They married, of course, and for many generations stories were told of this couple who found such joy and happiness with each other—all because of the trillium roots.

In addition to being used as a love potion, trilliums were used for a variety of other medicinal needs. Often called birthroot, trilliums were made into a tea and given to mothers, after the birth of children. Juice from the plant was dropped into the eyes to relieve them from various irritations. Certain Indian tribes made a poultice from the leaves and blossoms, using it to treat skin sores and insect bites.

The most common trillium in the southern woods is *Trillium sessile*, also called toad trillium. Red trillium is often called stinking Benjamin because the plant has a most disagreeable odor.

Many different trillium species can be found in the southeastern United States. Catesby, painted, nodding, pink, yellow, red, white, and purple trilliums all grace the forest floor with their three-part beauty. Each species bears three leaves, three petals, and three sepals.

One of the most interesting southern trilliums is *Trillium persistens*, first found in 1950 by Dr. Wilbur Duncan of the University of Georgia. The plant was found in fruit in the Tallulah Gorge area of the Chattahoochee National Forest in northern Georgia.

Name: Large-flowered trillium *(Trillium grandiflorum)*
Family: Liliaceae

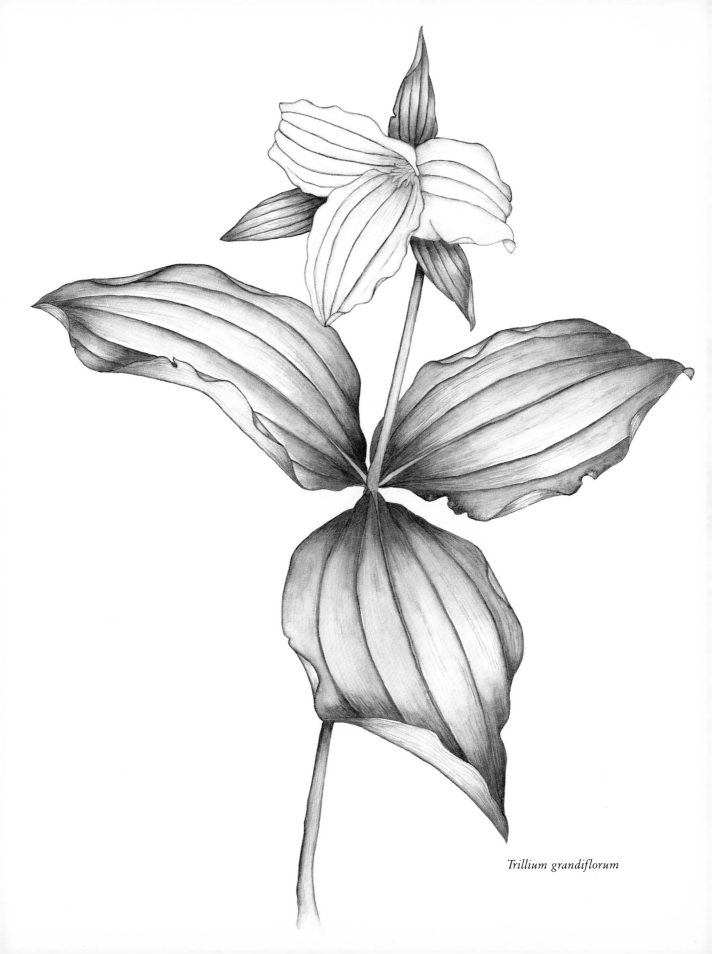

Trillium grandiflorum

Description: Trilliums are easy to identify because all plant parts occur in threes. Three petals, three sepals, three leaves, and generally six stamen characterize all species of trilliums. The large-flowered trillium has white flowers that turn pink with age and stands eight to eighteen inches tall.

Blooms: April through June

Natural habitat: Found in rich, moist woods from Virginia south to Georgia.

Propagation and cultivation: Trilliums are very difficult to propagate and, for this reason, are often dug from the wild and sold to the unsuspecting consumer. Great care must be taken to make sure that the plants purchased are propagated and not dug from the wild. Often plants can be obtained by "rescue operations" in which plants are dug from an area destined to be cleared by bulldozers. Trilliums need moist soil, rich in organic matter, dappled shade in early spring, and full shade during the hot summer months.

Trout lily
(Erythronium americanum)

Spring in the Appalachian mountains is unforgettable. It is like an early morning sunrise. Just as the first morning rays slowly glimmer in the blackness of night, then explode into the brilliance of morning, spring in Appalachia nudges away the bleakness of winter before it finally bursts into glorious bloom.

It doesn't happen all at once, of course. Small plants peek and poke their way above ground, the hardier ones staying to defy the weather. Forest animals sleepily wander out of their winter homes to test the air, then perhaps scurry back for another few days of sleep.

But the stirring of spring is undeniable, and soon the forest comes to life. New life can be seen everywhere. Tiny birds create a chorus of hungry voices, baby rabbits stay close to their warm mothers. The trees put forth succulent light green buds, and underground the flowers are queuing up for their entrance into spring.

Appalachian spring is clothed in dainty splendor. The wildflowers are ephemeral jewels, flaunting their beauty only briefly before disappearing until the next spring calls them forth.

Of all these springtime jewels, one of the loveliest is yellow trout lily. Walking through the Smoky Mountains in late April, hikers will round a bend in the trail and stop in amazement for the mountainside in front of them has been transformed into gold.

Trout lilies are rarely found underneath evergreens, for they need the early spring sunshine that pours forth between the bare branches of deciduous trees. Hundreds of small yellow lily-like blossoms cover the steep slopes, and each blossom is escorted by a pair of brownish mottled leaves. The petals are arched back, showing off attractive stamen in the center of the plant.

This species responds to many different common names. Trout lily was chosen, presumably because the mottled leaves suggest the markings on a trout. Fawn lily evolved because the twin

leaves of the plant "stand up like fawn's ears, and this feature, with its recurved petals, gives it an alert, wide-awake look," as John Burroughs wrote a century ago.

Dogtooth violet is a name that developed perhaps because of the large white tooth-shaped bulb from which the plant grows. Adder's tongue, yet another popular name, refers to the long, protruding stamen. The genus name, *Erythronium*, is from the Greek and means red, in reference to the deep red mottled leaves.

New, succulent leaves are considered quite a delicacy, particularly if cooked and seasoned with butter and herbs. The root, although not as tasty as the leaves, can be stored in a root cellar for winter fare.

Both bulbs and leaves have been used medicinally. Roman soldiers were said to have used an ointment made from the plant to treat foot sores and corns. Combined with horsetail grass and made into a tea, trout lily was thought to be effective in treating tumors or inflammations of the breast. Cooked in milk, the plant was used to cure hiccoughs and vomiting.

Name: Trout lily *(Erythronium americanum)*
Family: Liliaceae
Description: Attractive brown-and-green mottled leaves occur singly or in pairs. Plants with a single leaf are too young or crowded to bear a flower. Blossoms can be found only on plants with two leaves. The nodding blossom is composed of sepals and petals, referred to as tepals. The petals are all yellow; the sepals are yellow on the inside and a pleasing bronze color on the outside. The flowering stalk is eight inches tall.
Blooms: March through April
Natural habitat: Occurs in moist mountain coves, rich woods, and meadows in the region from Virginia south to Georgia and west to Tennessee.
Propagation and cultivation: From seed, this plant rarely blooms before its fourth growing season. A faster means of propagation is by division of mature plants. The bulb will produce offsets that can be replanted immediately. Even by this method, it usually takes two to three years for the plant to bloom.

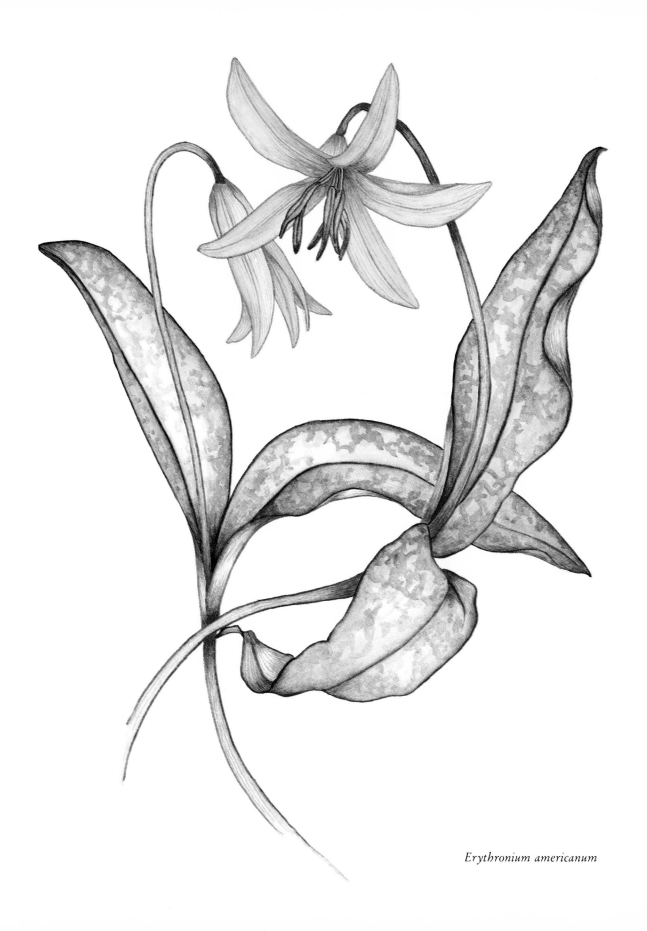

Erythronium americanum

Violet
(Viola pedata)

Io was a beautiful young nymph who loved to play in the woods near her home. Carefree and happy, Io spent her days singing and playing with the forest animals. She was beloved by all who met her, and soon word of her beauty and charms made its way to Zeus, king of all the gods.

Zeus decided to investigate and determine for himself whether or not this young nymph was as beautiful as her reputation indicated. He descended from Mt. Olympus and searched for Io. It was not difficult to find her, for the forest animals followed her everywhere and they frolicked together, painting a very pretty picture.

As soon as Zeus saw Io, he was struck by her beauty and immediately fell in love with her. He approached Io, and she, in turn, fell in love with him.

Hera, Zeus's wife, watched all of this happen and flew into a jealous rage. She swept into the woods, determined to do harm to Io. Zeus saw her in time and quickly changed Io into a white heifer.

Hera was satisfied, but poor Io, unhappy with her fate and unused to the rough grass that she was forced to eat, began to cry. In the magical ways of Greek mythology, where her tears fell, beautiful flowers began to grow. Today, we call these flowers violets.

Life was not over for Io, however. Zeus demanded that Argus, a giant with a hundred eyes, watch over Io and drive her to Egypt where, far from the watchful eye of Hera, Io was changed back into her human form.

Some flowers are so universally beloved that they transcend time and distance. The violet is such a flower. A field in Alabama turns purple every March with the advent of violet season. This

116

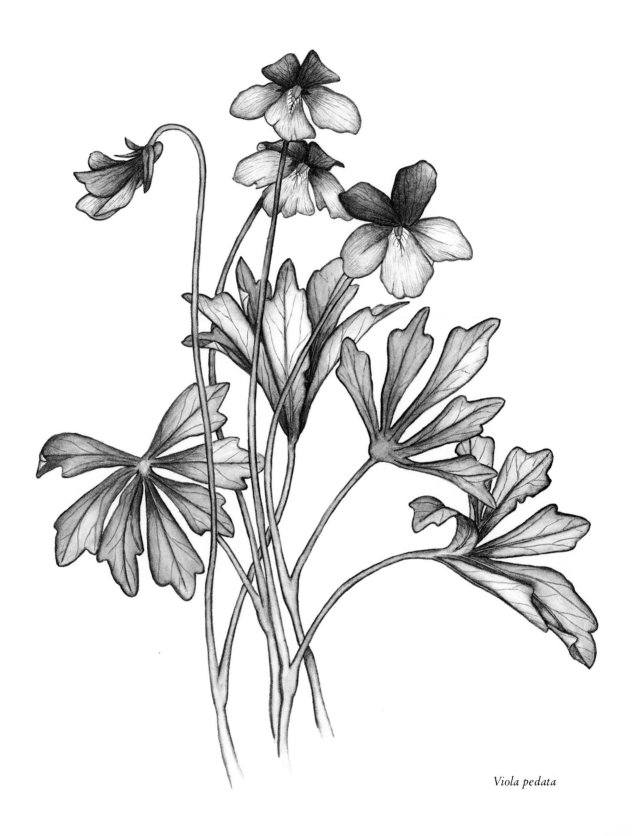

Viola pedata

same flower colors fields and mountain slopes all over the world. Children in America today gather the blossoms for tiny bouquets for their mothers, just as Greek children did two thousand years ago.

Children can pick violet blossoms with cheerful abandon, for, like pansies, the more the blossoms are picked, the more freely they bloom. Most violet species produce two kinds of blossoms. Bright showy flowers appear in the spring, and small, inconspicuous blossoms, called blind flowers, appear during summer and fall. These can be found at the base of the leaves and give the violet plant twice as many chances to be pollinated.

Of the fifty species of violets native to the southeastern United States, the most common is the little blue violet, *Viola papilionacea.* The flower is not blue at all, but a lovely dark lilac color or sometimes white with dark violet veins on the petals. The white-and-purple variety of this violet grows so commonly around the doorsteps of southern homes that it has long been known as Confederate violet.

Even more beautiful than the common violet is the birdfoot violet, *Viola pedata.* The blossoms are often bicolored, sporting both light and dark purple petals. Stamen are conspicuously orange or yellow. The leaves, which give the plant its name, are deeply segmented and resemble the claws of certain birds.

In Japan, violets are considered a "returner," a plant given to a traveler to assure his safe return home. They grow so hardily under adverse growing conditions that they are sometimes called the "little savage."

Greeks found violets to be uncommonly useful. Greek men believed that wearing a garland of violet blossoms would dispel the odors of wine and allow one to imbibe without becoming drunk. This superstition probably resulted from the fact that violets cause a temporary loss of smell. Their reasoning: if you can't smell it, it won't hurt you.

Greek women, not to be outdone by the menfolk, also used violet blossoms. They would mix the blossoms with goat's milk and apply the mixture to their faces to improve their complexions.

The Roman statesmen and writer Pliny suggested that eating violets would induce sleep, strengthen the heart, and soothe raw nerves.

Although today we cannot support all the claims about what violets will do for you, certain aspects of eating violets have proven very beneficial.

Euell Gibbons, author of *Stalking the Healthful Herbs*, calls violets "nature's vitamin pill." He had the blossoms and leaves of violets analyzed and found that both are very high in vitamins A and C. Pound for pound, violet blossoms contain more vitamin C than oranges.

Both the leaves and blossoms can be eaten raw, and the leaves can be cooked like other spring greens. The blossoms can also be candied or made into an indescribably lovely jelly.

To make violet jelly, pick a bucketful of violet blossoms. Wash them thoroughly and remove the stems. Place the blossoms in a saucepan and barely cover with water. Simmer for fifteen minutes and strain out the blossoms, leaving the dark purple juice. Measure the juice, and for every cup of juice you have, add a cup of sugar. Return juice and sugar to the saucepan and cook until a jelly stage is reached. Pour into prepared jars and process as you would any jelly. The color of this jelly is marvelous.

Name: Violets (*Viola* species)
Family: Violaceae
Description: Many different kinds of violets grace the southern woods. The following are descriptions of some of the more common or beautiful:

Viola blanda: The leaves and flowers of the white violet occur on separate stalks. The flowers are white, the lower petal often found with a purple vein. The plant grows to a height of three to five inches. It blooms during April and May and can be found in rich woods from Virginia south to Georgia and west to Tennessee.

Viola papilionacea: The blue violet has flowers and leaves on separate stalks. This is the most common violet in the South. The blossoms are violet-blue or white streaked with purple and are approximately one-half inch long. It grows three to eight inches tall. The leaves are five inches wide and heart-shaped. It grows in grassy lawns and along roadsides throughout the South, blooming March through April.

Viola pedata: Bird's-foot violet has flowers that are deep blue-violet. Sometimes the lower petals are white veined with purple. Anthers

are bright orange and quite conspicuous. The leaves are fan-shaped but deeply divided into linear segments, thus explaining the bird's-foot name. The height of the plant is four to ten inches. It grows well in dry, sandy areas throughout the South and blooms March through May.

Viola pubescens: This browny yellow violet has leaves and flowers on the same stem. The blossoms are three-quarters of an inch across and are a lovely yellow, veined with dark purple. It grows six to sixteen inches tall in rich woods in the northern part of the region and blooms during May and June.

Propagation and cultivation: One of the most beautiful of all the violets to grow in the home landscape is the bird's-foot violet. Seeds can be collected from the plants a couple of weeks after the flowers fade. The seeds should be allowed to darken a bit before they are collected and then should be sown immediately. Unlike many other kinds of violets, bird's-foot violets need full sun and very well-drained soil. A rock garden or sandy slope makes an excellent place to grow this lovely violet.

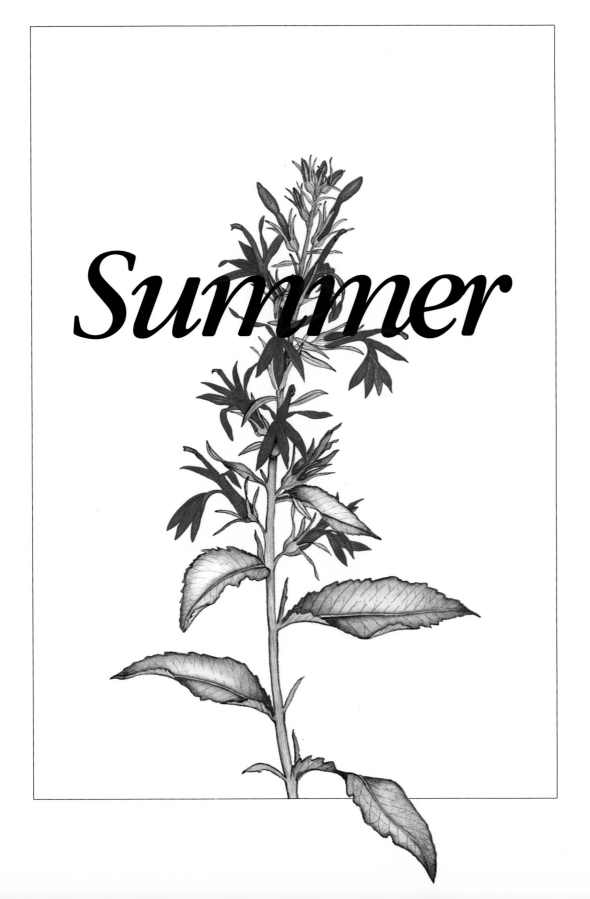

Summer

Bee balm
(Monarda didyma)

*"He is called the Hum-bird or Humming-Bird, because some say he makes a noise like a Spinning Wheel when he flies." —Nehemiah Grew, M.D., **Philosophical Transactions***

I froze in my tracks as I heard the familiar whirring sound. Too low for a bumblebee, too fast for most birds, I knew that the humming behind my head was caused by one of God's most astounding creatures.

I turned slowly and carefully but soon lost my caution as the tiny ruby-throated hummingbird darted, dove, and spiraled around me. Surprisingly aggressive for its diminutive size, this wisp of a winged creature quickly became accustomed to my presence and proceeded to ignore me completely to devote full attention to the bee balm blossoms in front of me.

The hummingbird is able to fly forwards and backwards, hover or go from zero to thirty miles per hour in nothing flat. More than 30 percent of its tiny body weight is made up of breast muscle that enables it to perform such amazing acrobatics.

Just such aerial antics allow the hummingbird to compete with other pollinators so successfully. Because the hummingbird can eat in flight or while hovering, it does not need a broad, flat petal to land on. For this reason, hummers usually search for long tubular flowers where there is little competition.

Like other birds, hummers have a poor sense of smell. While insects might be attracted to heavily scented flowers, hummingbirds bypass these perfumed ladies and search for less crowded unscented blossoms.

Hummingbirds seem to prefer red flowers, either all red, as is the case of trumpet creeper, or at least partially red, such as

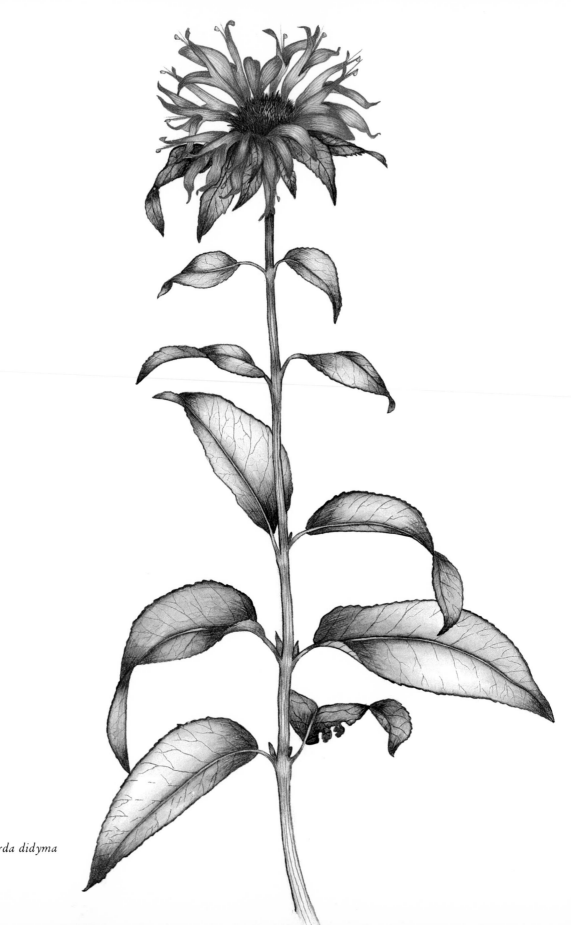

Monarda didyma

columbine. Bee balm, with its bright red tubular flowers, is a perfect example of a hummingbird plant and provides many a hummer with a delightful picnic.

The hummingbird does not have a tubular tongue and does not suck up the sweet nectar. Instead, he licks it up at the incredible rate of eighteen licks per second.

Hummingbirds are not the only species that enjoy the citrusy flavor of bee balm. Herbalists suggest that both leaves and blossoms of this plant be used fresh in salads or in flavoring for meat or poultry. Dried, the plant can be used to make a tasty tea. Dried petals and leaves can also be used in potpourris, adding both aroma and color.

This plant is called bee balm not because it is pollinated by bees, but because it was at one time used to soothe the sting from a bee or wasp.

The genus, *Monarda*, was named for Nicholas Monardes (1493–1588), a Spanish botanist. The species name, *didyma*, is from the Greek word meaning "paired" and refers to the two stamen found in each flower.

Another common name for bee balm is Oswego tea, because this plant was commonly found growing in the Northeast in Oswego Indian territory, and the Indians often made tea from the leaves. Settlers in the area adopted this recipe and made a delicious tea that was particularly popular during the Revolutionary War.

Name: Bee balm *(Monarda didyma)*
Family: Labiatae
Description: This showy plant bears round clusters of bright red tubular flowers. Red or purplish bracts can be found underneath the flowers. As in most members of the family, the stem is square, and the dark green leaves are opposite. The plant grows to a height of two to five feet.
Blooms: June through August
Natural habitat: Found in the Southeast from Virginia south to upland areas in Georgia and Tennessee. It is most often found growing in the wild along stream banks or in moist meadows.
Propagation and cultivation: Bee balm needs ample moisture and is best grown along a stream or lake. The easiest means of propagation is by dividing the plants in early spring. Planted from seed, bee balm should bloom the second year.

Black-eyed Susan
(Rudbeckia hirta)

My grandfather was the quintessential earthman. A farmer by choice rather than necessity, Grandpa retired early from his city job to take up his true vocation of raising cattle and a few vegetables. By the time I was able to follow around in my grandpa's gigantic footsteps, he had snow-white hair and walked at a pace that was easy for me to keep up with.

Though there were a thousand things to do to keep up his farm near Jeffersontown, Kentucky, Grandpa always had time for me. An inquisitive child on a farm is probably one of the most time-consuming creatures on earth, but Grandpa handled my unending questions with true grace.

Grandpa and I snuck off to go fishing as often as we could. The fishing pond was located a few fields away from the farmhouse, and to a child who was only slightly taller than the grass itself, this was an adventurous trek, full of wonder and magic. When the going got rough, Grandpa would scoop me up, and we would survey our grassy kingdom together.

Grandpa loved all flowers, but perhaps his favorite was the black-eyed Susan. He would bend to pick a few blossoms, his gnarled and weathered hands gently snapping off the stem at just the right point. And then he would weave the most marvelous tales about this dark-eyed lady who filled his fields.

Some days black-eyed Susan was a runaway princess; other days she would be a gypsy girl, but always in the end he would rename the plant brown-eyed Laura in my honor.

We were generally much more successful at picking black-eyed Susans than we were at fishing, and we would take armfuls of the flowers back to the house. My grandmother would shake her head at our "weeds" but would gracefully arrange them in a china vase so that they looked as elegant as roses.

126

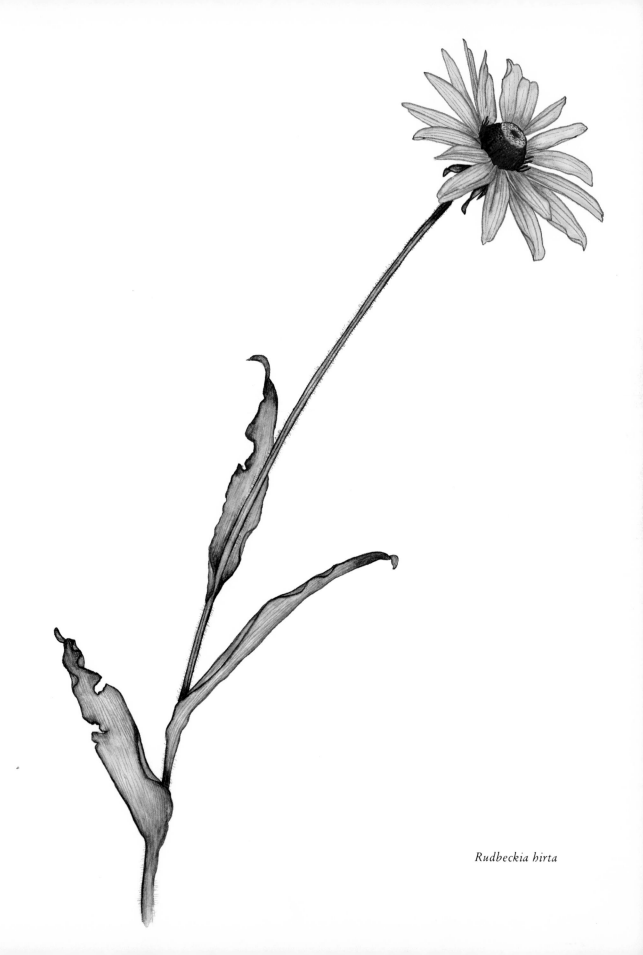

Rudbeckia hirta

The black-eyed Susans of our southern fields are vagabonds from prairie states. Indigenous to the Midwest, these brown-eyed darlings have traveled in the footsteps of progress.

The old National Geographic Society *Book of Wild Flowers*, printed in 1924, was caught up in the jargon of a world just recovering from war. The description of black-eyed Susan reads:

"Fighting her way across the American continent, black-eyed Susan has proved the master of the allied forces of man and Nature. In the competition of life she has been able to make a home wherever she sets her foot, and neither the rivalries of the field nor the laws and labors of man have been able to hold her in check."

In 1918 the black-eyed Susan was chosen as the state flower of Maryland. Some people say that it was picked because it carries the colors of Lord Baltimore, black and orange.

Mary Frances Davidson, in her book *The Dye Pot*, says that black-eyed Susan is the source of many shades of dye, and that each part of the plant is useful. The heads, used with an alum mordant, produce an attractive green color. Using chrome creates a green-gold. The petals, used alone with a chrome mordant, give a butter-yellow color.

Black-eyed Susan was used to treat skin infections, and laboratory testing has found that the plant does indeed contain appreciable amounts of antibodies.

Name: Black-eyed Susan *(Rudbeckia hirta)*
Family: Compositae
Description: Bright yellow ray flowers surround dark brown disc flowers. Color variations can occasionally be found in the wild. Ray flowers are often colored with deep reddish tints toward the center of the blossom. The flowering stem is covered with hairs, and the leaves are fuzzy. It grows one to two feet high.
Blooms: June through July
Natural habitat: A native of the prairies, has spread eastward and can now be found in abundance in the region. They are most commonly found along roadsides and in dry fields.
Propagation and cultivation: Adaptable to rich or sterile soils, these plants need full sun and regular watering to perform best. They are sometimes considered biennials, sometimes short-lived

perennials. They grow easily from seeds sown in spring or fall, and seeds should germinate in ten to fifteen days. When the seed heads turn a grayish color, this is an indication that the seeds are mature and ready to collect. Store the seeds in a plastic bag in the refrigerator until ready to use.

Butterfly weed
(Asclepias tuberosa)

A small rust-colored monarch butterfly stirs slightly as the gentle spring sun slowly warms his body. He is only one of millions of monarchs who have spent the winter resting in the high area in the Sierra Madre near Mexico City.

As the sun grows even warmer, these butterflies shake off their winter sleep and prepare to return to the northeastern homes that they left in September. During the fall, many of them flew over two thousand miles to reach the warm safety of their winter home.

As they begin their journey back north, the butterflies keep an eye out for nectar sources. A monarch can fly hundreds of miles on a "tankful" of flower nectar, but, even so, they stop frequently to refuel.

Of all the flowers that they feed off of, butterfly weed seems to be the favorite. Bright reddish orange flowers polka-dot the landscape, signaling that food is near and abundant. Butterfly weed benefits from these winged visitors. While they collect nectar, they also collect pollen, which they take from flower to flower, thus cross-pollinating the plants.

Butterfly weed not only supplies nectar for the adult monarch; it also supplies food for the newly emerged caterpillar. The female butterfly lays an egg underneath the leaf. As soon as the caterpillars emerge, they first eat the eggshell and then the leaf to which it was attached.

Because butterflies have such long tongues, they are wonderfully adapted to collecting nectar from the butterfly weed. Monarchs are not the only butterflies that find this plant irresistible. Swallowtail, tiger, spicebush, black, parsnip, white cabbage, pearl crescent, fritillary, and several kinds of sulphur butterflies also frequent this plant when it is in bloom.

Butterfly weed was also called pleurisy root, for the root (which is rather tough and bitter) was chewed by early settlers to treat pleurisy and other respiratory complaints. Pioneers and Indians ground the root into a powder and added water to make a

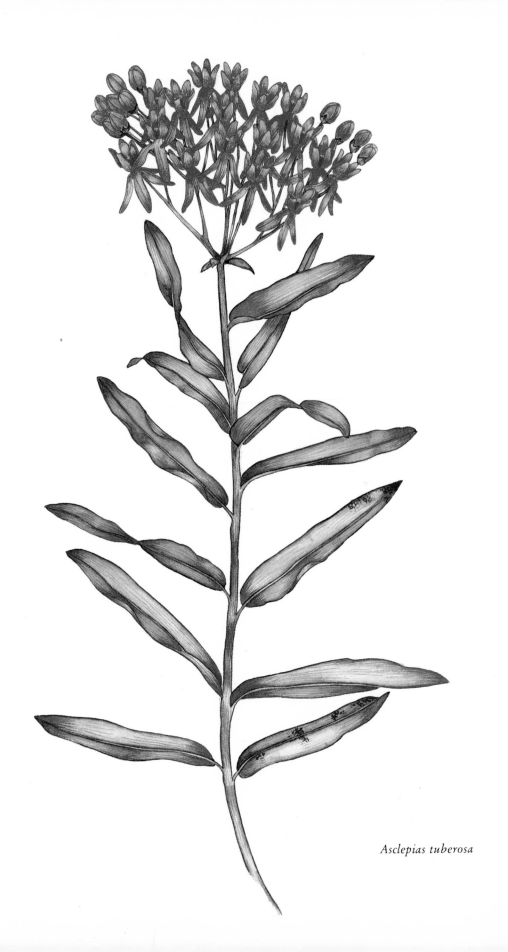

Asclepias tuberosa

paste, which they applied to skin sores to aid in the healing process. Tea made from the roots was used as an expectorant. Too large a dose is poisonous and will cause vomiting. Because of its poisonous properties, the plant is no longer used for medicinal purposes.

Unlike other members of the milkweed family, butterfly weed does not have a milky sap within the stem. It does, however, produce the long, warty seed pods characteristic of the family. These pods are filled with seeds attached to soft, silky down. The down was used instead of feathers as stuffing in beds and cushions. Some folks (with enormous patience) tied the silky seeds one by one onto woven cloth, giving the cloth the appearance of fur. The downy seeds were also sometimes used on hats in place of feathers.

In 1887 Dr. Charles Millspaugh wrote in *American Medicinal Plants*, ". . . the gorgeous butterfly-weed, whose vivid flowers flame from dry sandy meadows with such luxuriance of growth as to seem almost tropical. Even in the tropics one hardly sees anything more brilliant."

Name: Butterfly weed *(Asclepias tuberosa)*
Family: Asclepiadaceae
Description: The bright orange blossoms vary in shade from yellowish orange to almost red. The flowers are borne in terminal clusters on several branches. The stems are rough and hairy and do not exude the milky sap so often found in this family. The leaves are lance-shaped and entire, measuring two to six inches long. The plant grows twelve to thirty inches tall.
Blooms: June through September
Natural habitat: Found throughout the region along roadsides and in dry fields and disturbed areas.
Propagation and cultivation: This plant comes easily from seed and usually blooms the third year from sowing. Collect the seeds just as the pods begin to split open. If you wait too long, the pods will burst open, releasing hundreds of seeds—each attached to a silken parachute. At this stage it is very difficult to separate the chaff from the seed. Butterfly weed is also quite easy to propagate by means of root cuttings. It needs plenty of sunshine and well-drained soil. Soil that is sandy or gritty and neutral or slightly acidic is perfect.

Cardinal flower
(Lobelia cardinalis)

A small stream meanders through a dry field in western North Carolina. Two feet to either side of the stream, grass lies brown and brittle. But hugging close to the precious water, myriad ferns and wildflowers create a swath of lush, rich growth. By late summer the stream banks are covered with foliage from dozens of different plants, and a riot of ferns creates a dark green carpet. From amongst this bed of green, cardinal flower stands out boldly.

Tall and brilliantly colored, cardinal flower is ostentatious in its beauty. The stem is covered with bright red tubular flowers, and hummingbirds hover nearby, waiting their chance to gather the sweet nectar.

Justice, an early American botanical writer, said of the cardinal flower, "A flower of the most handsome appearance, which should not be wanting in curious Gardens, as it excells all other flowers I ever knew, in the Richness of its colour."

Not only should it be included in "curious" gardens, but in all other gardens as well. In spite of its height, cardinal flower adds spectacular color to a perennial bed. Tests at the University of North Carolina Botanical Garden have found the plant to be surprisingly adaptable to a number of environmental conditions. Although it is found in the wild growing in very damp places, in cultivation it can survive (with frequent watering) even in a pot.

Cardinal flower grows all over the eastern United States. It was first discovered growing in the French colony of Canada. Plant explorers collected it and sent it to their queen, Henrietta Maria. The story is told that when this queen saw it, she began to laugh excessively and said that the color of the flower reminded her of the scarlet stockings worn by the cardinals in the church. The name stuck, and today we know this bright red flower as cardinal flower.

The genus, *Lobelia*, was named for a French botanist, Mathias de L'Obel.

Cherokee Indians used the cardinal flower as a cure for syphilis. Both Indians and early settlers used a decoction made from the root as an expectorant and an emetic. Today, though, the plant is thought to have no medicinal value.

Cardinal flower was, perhaps, most cherished for its use as a love charm. Taken out of the ground with much ceremony, the root was then touched to all parts of a woman's body. The power of the root was such that the woman would supposedly become irresistible. Cardinal flower was thought to be useful in this manner for all ages of women, but was considered particularly effective for older women.

Blue lobelia is also very common in the Southeast, but the two species never seem to interbreed in the wild. To test the possibility of hybridizing the two species, Dr. A. B. Stout (most famous for his work with daylilies) tied flowering stalks of the two kinds of lobelias together. The combined flowering stalk then had the blue flowers on the bottom and the red ones on top, each still attached to its parent plant.

Dr. Stout then carefully watched bees as they came to collect nectar from the flowering stalks. The bees began collecting the nectar at the bottom of the stalk, quickly making their way upwards. This was fine as long as they were working the blue flowers. As soon as they got to the red flowers, however, they refused to go any further and flew off to another plant. Dr. Stout watched this happen time and time again and came to the conclusion that in the wild, at least for some species, bees will not go from one species to another.

Name: Cardinal flower *(Lobelia cardinalis)*
Family: Campanulaceae
Description: Tall spires of bright red blossoms make cardinal flower easy to spot in the landscape. Each individual blossom is long and tubular, made up of a split-lipped petal. The anthers occur at the end of a narrow red filament tube. The plant grows two to five feet tall.
Blooms: August through September
Natural habitat: Occurs naturally in swampy or wet areas throughout the Southeast.

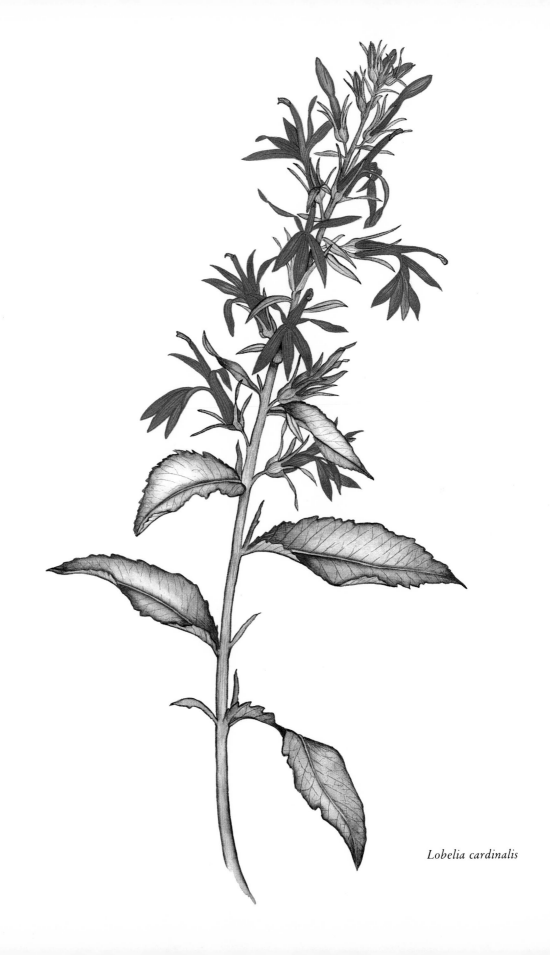

Lobelia cardinalis

Propagation and cultivation: This plant is adaptable in cultivation and can be used in a variety of locations. It can grow in sun or shade and needs average soil with ample moisture. If grown in light, rich soil, it often blooms more profusely than it does in the wild. If grown from seeds, the seeds should be stored in the refrigerator for two months for better germination. If sown into warm (70°F) soil, seeds should germinate within a week.

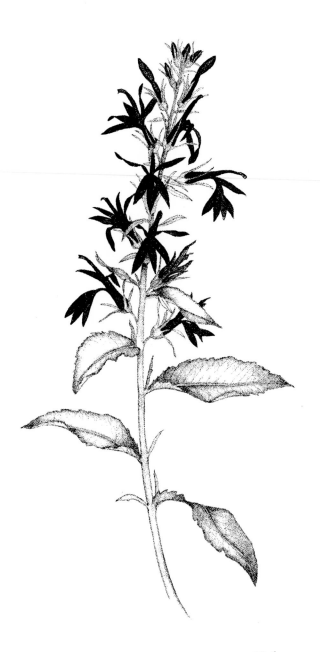

Chicory
(Cichorium intybus)

*(Adapted from **Song of the Seven Herbs**, by Walking Night Bear and Stan Padilla)*

Wanatu checked the provisions once more as he waited for the rest of the tribe to join him. This was not a happy journey, but it was a necessary one. Wanatu and his people were quiet and peaceful, but neighboring tribes had recently moved in closer, taking the best hunting grounds.

Rather than fight, Wanatu's tribe had decided to move further west to find new hunting grounds. Wanatu was the leader and medicine man of this small tribe, and it would be up to him to find food and shelter along the way.

At first the journey was easy, and there was plenty of game and wild plants. But soon the landscape changed, and the forest gave way to a hot, dry plain. Food was scarce, and Wanatu became worried. The people and animals suffered greatly from lack of food. Many of the very young and the elderly became ill. Wanatu was a great medicine man, but even he could not make food come when there were no plants and no animals. Finally, the people could go no further, and they simply stopped. They had no hope and no spirit left, and they lay down to die in the hot and unforgiving sun.

Wanatu slowly walked away from his people and sat down on a rock and prayed to the Great Spirit for help. Suddenly, a large eagle swept down from the sky and sat beside him. This eagle said: "The Great Spirit has heard your prayers. Tomorrow you will find a new plant growing all around you. The root is not sweet but bitter, but it will

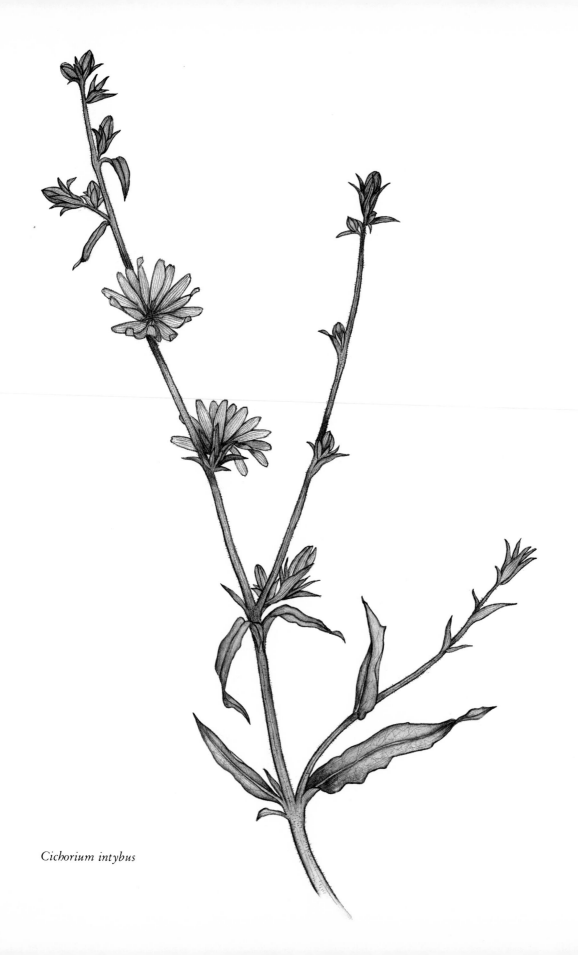

Cichorium intybus

make you strong. To give you hope and happiness again, I will cut tiny pieces of the blue sky and put them on the plants. These you must pick very carefully because the sky doesn't like to be handled roughly. And you must leave behind many blue flowers so that others may find hope and happiness."

With that the eagle flew back into the sky. Wanatu returned to his people, and the next morning when they awoke, the earth was filled with a sturdy plant topped with sky-blue flowers. Each flower had a jagged edge, though, because the eagle could not cut smoothly as he borrowed pieces of the sky.

The people carefully dug the root and ate it, and this gave them strength. Then they carefully picked some of the blossoms and made a tea from them. This they drank, and it filled them with happiness and hope. They continued their journey until they found rich and fertile lands where they made a new home. But always this plant called chicory, with its pieces of blue sky, filled them with hope and happiness.

Like many American Indian legends, this one was probably fabricated by the white man, for chicory is not native to the United States but was introduced here by the colonists.

Chicory has been cultivated for centuries. Egyptians grew it in the Nile River Valley five thousand years ago, and the Greek physician and writer Discorides mentions it in his herbal written in the first century A.D.

Chicory is most often grown as an additive to coffee. Chicory coffee is an acquired taste, for it is rich and bitter. The Cajun folks in southern Louisiana are particularly fond of chicory. It has been suggested that the addition of chicory to coffee diminishes the effects of caffeine.

Although they are quite bitter, the young leaves can be eaten like spinach or collard greens. Medicinally, the plant has been used for quite a variety of ailments, including soothing swollen and inflamed tissue and liver ailments, and as a laxative, diuretic, and tonic.

The sky-blue flowers open and close at approximately the same time every day, a fact that encouraged Linnaeus to include it

139

in his floral clock. This "clock" was composed of flowers that opened and closed during different hours of the day and evening.

Chicory has many common names, such as blue sailors and ragged sailors, which refer to its striking blue color. The German name is "watcher of the road" and refers to the German legend that says a young girl sent her lover off to war and sat by the road to await his return. She waited for years and years and finally died of a broken heart. Where she died, this flower began to grow.

Name: Chicory *(Cichorium intybus)*
Family: Compositae
Description: Although a rather ragged-looking plant up close, the sky-blue flowers of chicory make it appear quite beautiful from a distance. Each flower is one to two inches across, and each ray flower is deeply notched on the end. The leaves look somewhat like those of dandelion. They are deeply toothed and taper towards the ends. The height of the plant is one to four feet.
Blooms: July through September
Natural habitat: Common in fields and along roadsides throughout the region.
Propagation and cultivation: Chicory needs full sun and somewhat infertile soil. If the soil is too acidic, the color of the blossoms will be very light and inferior. Once established, chicory is drought tolerant. This plant comes very easily from seeds sown in spring or fall.

Cinquefoil
(Potentilla recta)

I strolled through my meadow on an early summer morning. It was pleasant there in my miniature wilderness, and I began to take silent inventory of my wildflowers, mentally checking off the ones I knew should be there. Yes, there was Queen Anne's lace and coreopsis, plenty of black-eyed Susan and—but then I saw a plant I had not invited to my meadow. A party crasher? There were plenty of those, but this particular uninvited guest I allowed to stay.

Close inspection told me that my new guest was a rough, fruited cinquefoil. A weed, you might say with a shrug. And you would be correct. But what a lovely little weed it is. Pale flowers cover the rough erect stem, each one looking like a tiny yellow rose. Roses in my meadow? The idea held a certain appeal for me.

In some states cinquefoil is a terribly aggressive weed, pushing and shoving more desirable plants out of the way. In my Georgia meadow, however, the tall cinquefoil is a reasonable guest and adds a bit of pastel beauty to my early summer meadow.

Even if cinquefoil added no beauty to my landscape, I probably would allow it to stay because of its rich and diverse history. A magical plant, cinquefoil was once used extensively as protection against witchcraft. If, however, you were a witch yourself, you could also use cinquefoil to your own advantage. Witches were said to rub the plant all over their bodies while chanting dark and secret oaths. The result was a trance-like state. Cinquefoil also went into witch's brew along with poison hemlock, deadly nightshade, thorn apple, and spider's legs.

The magical use of cinquefoil was not limited to witches. The plant was also used as a love potion and to make predictions about matters of the heart. During medieval times, only those knights who had achieved self-mastery were allowed to use the emblem of cinquefoil in their coats of arm. The five leaves on the plant symbolized the five senses of man.

The name *cinquefoil* is French, meaning "five leaves." The common name *potentilla*, which this plant often goes by, is from the Latin and refers to the potent medicinal power attributed to it.

Cinquefoil has been used medicinally since the time of the Golden Age of Greece, but was held in particular esteem during the Middle Ages. A decoction made from the roots was used to treat fever and toothaches and was gargled to help cure mouth sores. Because of the tannin content in the root, it was effectively used as an astringent to stop bleeding. Drinking tea made from the leaves or root helped stop diarrhea. Pliny, a Roman statesman and writer, suggested that honey, cinquefoil, and axle grease mixed together was a wonderful ointment for scrofula.

Cinquefoil mixed with corn is said to be an excellent fish bait.

During a heavy storm cinquefoil leaves bend over to protect the blossom from the rain. Because of this interesting bit of natural history, cinquefoil is a symbol of the beloved daughter, for the leaves remind one of a mother protecting her child.

Name: Cinquefoil *(Potentilla recta)*
Family: Rosaceae
Description: Cinquefoil is an open, airy plant with pale yellow blossoms. The flowers have five petals and five large sepals. The stem is hairy, the leaves divided into five to seven leaflets.
Blooms: May through August
Natural habitat: Although quite a pest in the Midwest, not as aggressive in our area. Grows south to Georgia and along roadsides and in abandoned fields.
Propagation and cultivation: Most of the species of this genus are really too weedy to be useful in the garden. Some species are prized horticulturally, however. One of the best native species to cultivate is silverweed, *Potentilla anserina*. It needs neutral to slightly acidic soil, full sun and well-drained soil.

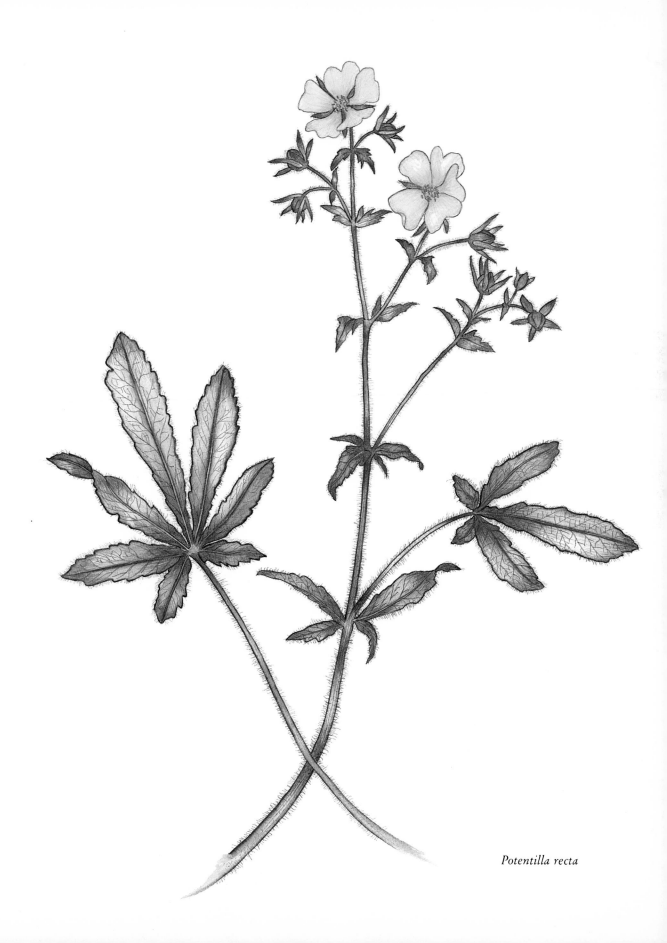

Potentilla recta

Purple coneflower
(Echinacea purpurea)

By the middle of June my meadow is usually a sea of color. The daisies are long gone, and coreopsis is holding on by a thread. Summer flowers are in full force, and, except for a mass of Queen Anne's lace, the landscape belongs to the composite family.

Composites make up the largest plant family on earth. Nineteen million years ago only one or two species were in existence. Today, between fifteen and twenty thousand species can be found in this enormous family.

Not only characterized by huge numbers, the family is also full of diversity. Its members include such garden favorites as dahlias, marigolds, and zinnias, as well as pests such as dandelions, ragweed, and thistles. Many glorious and beautiful wildflowers are also found in this family. These include daisies, black-eyed Susans, goldenrods, and asters.

The outstanding characteristic of the family is its seed production. Thousands of seeds are often crammed into a single seed head. Many of these, as in the case of dandelion, are attached to silken parachutes, allowing for quick and easy dispersal.

Donald Peattie in his book *Flowering Earth* writes: "When you try to visualize this flowering society, when you call up all the flowers you can remember, and their tints and shapes and scents, the climates they like, the scenery they adorn, the memories they bring back, your mind begins to riot with flowering, and of all this color and perfume and delight there seems no end or order. Yet never was beauty so exactly organized. . . . The culmination of this line is probably the mighty composite family where, as in the sunflower, hundreds of florets are united into a single head, like a city full of houses laid out in regular streets, enclosed in the walls of the green bracts underneath."

Most of the summer composites are yellow. Coreopsis, sunflowers, black-eyed Susans, calliopsis, sneezeweed, Jerusalem

144

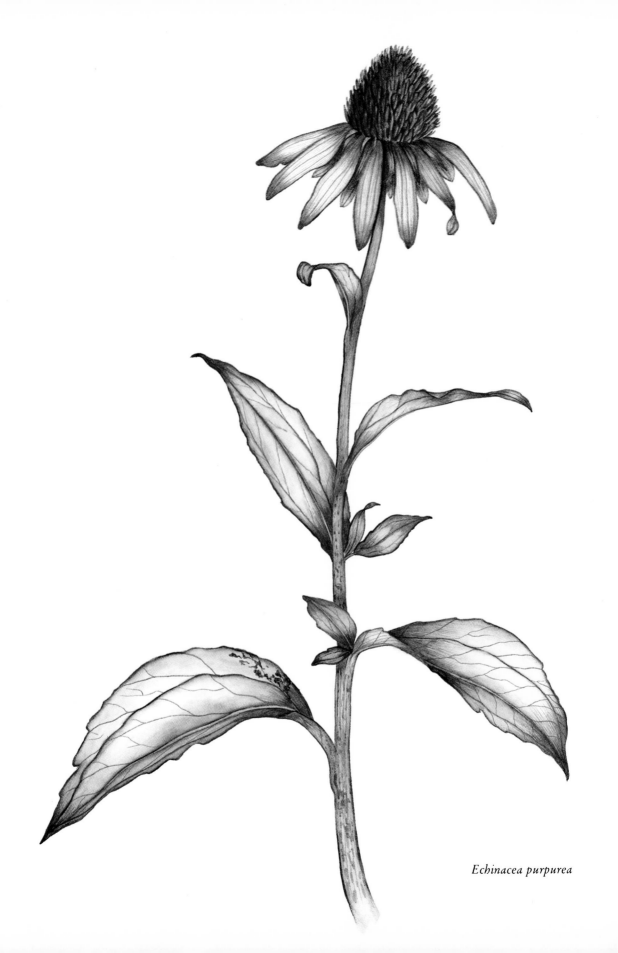

Echinacea purpurea

artichoke, and ragweed are all variations on the same theme. They all have daisy-like flowers, and all are shades of yellow. Into this maze of yellow bursts the purple coneflower. The shape and configuration are the same—narrow ray flowers surrounding short disc flowers—but the difference in color is a marvelous change.

Although they are called purple, the blossoms are better described as dark pink. When first opening, the ray petals are often very light pink, turning darker as they mature. The entire blossom has a wonderfully sweet smell that is attractive to humans and wild creatures alike. Butterflies flock to the flower when it is in bloom.

The genus name, *Echinacea,* is from the Greek word *echinos,* meaning "hedgehog," for the bristly center disc flowers reminded early botanists of this prickly animal. Once the flowers have gone to seed, the center part becomes even more stiff, and Indians used the seed heads as combs.

Purple coneflower was often used as medicine. Indians used it to treat snakebite and the sting from poisonous insects. They also felt that it was useful in reducing the swelling of glands and in relieving toothache. Smoke from the burning plant was inhaled to cure a headache. Physicians in the nineteenth century used the root of purple coneflower as a blood purifier. The dried root was used as an antibiotic and an antiseptic. Tea made from the plant was thought to be a good general health tonic.

Name: Purple coneflower *(Echinacea purpurea)*
Family: Compositae
Description: A long-lived sturdy plant, purple coneflower generally grows one to three feet tall. It has rough-toothed basal leaves that measure three to six inches long. The blossom is distinctly daisy-like. Ray flowers vary from pale pink to deep purplish pink. The center disc flowers are dark purple and form something of a cone shape.
Blooms: June through August
Natural habitat: Although more abundant in the Midwest than in the Southeast, can occasionally be found growing in mountainous areas of the region. It prefers roadsides or open woods.
Propagation and cultivation: This plant can be easily cultivated within the region. It comes easily from seed, making it a favorite plant to include within a wildflower meadow. The seeds mature

four to five weeks after the blossoms fade. For ease in collecting, allow the seed heads to dry thoroughly before gathering the seeds. For best germination results, the seeds need to go through a period of cold. They can either be sown immediately after being collected or be placed in a clean plastic bag in the refrigerator until the following spring. The plant may be divided in early spring or late fall. Divisions should be placed twelve to fifteen inches apart. Purple coneflower prefers fertile, well-drained soil and full or filtered sunlight.

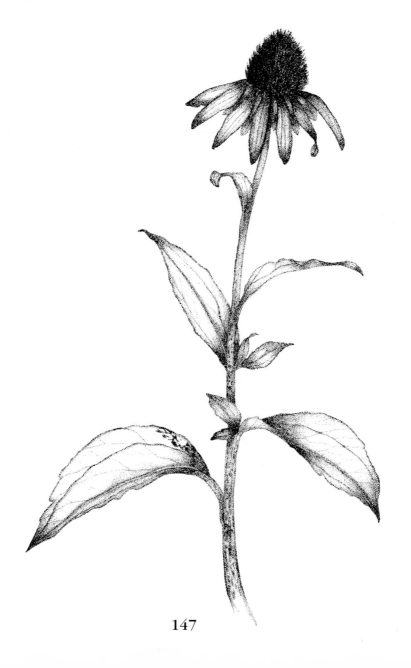

Coreopsis
(Coreopsis lanceolata)

Lady Bird Johnson easily earns the title of America's most enthusiastic wildflower lover. Although this love of our native plants has blossomed during the past several years, she has always loved nature and been keenly interested in the beautification of America. During her years in the White House, Mrs. Johnson spent considerable time and effort on many different civic beautification projects. A needy nation was grateful for her very successful efforts.

Now that she has time to spend on her own favorite projects, Mrs. Johnson has turned to wildflowers and in 1982 established the National Wildflower Research Center. The goal of the Center is to learn as much as possible about the native plants of our country and to disseminate this information to interested organizations and individuals throughout the nation.

When asked what her favorite wildflower is, Mrs. Johnson is hard put to give an answer. In her book, *Wildflowers Across America*, she writes: "It would be impossible for me to talk about my favorite wildflowers without mentioning coreopsis (*Coreopsis tinctoria*). In the Texas hill country, it is a brilliant yellow with a sort of dark brown, dubonnet center, and it grows on a slender, fragile stem with very little foliage, in masses—just a whole field of golden color."

Coreopsis tinctoria, or calliopsis, as it is commonly called, is a flower of prairies and meadows, swaying in time to the wind that undulates over the grasses and wildflowers. As this annual plant germinates and grows, it quickly forms a dark brown flower bud. At this point in development, it seems to freeze, and the plant remains poised on the brink of maturity for many weeks.

Then suddenly the buds burst open, and an explosion of color transforms the plants. Yellow and maroon in every combination imaginable are found on the blossoms. Often the petals are all yellow—or all maroon. Sometimes the tops of the petals are yellow

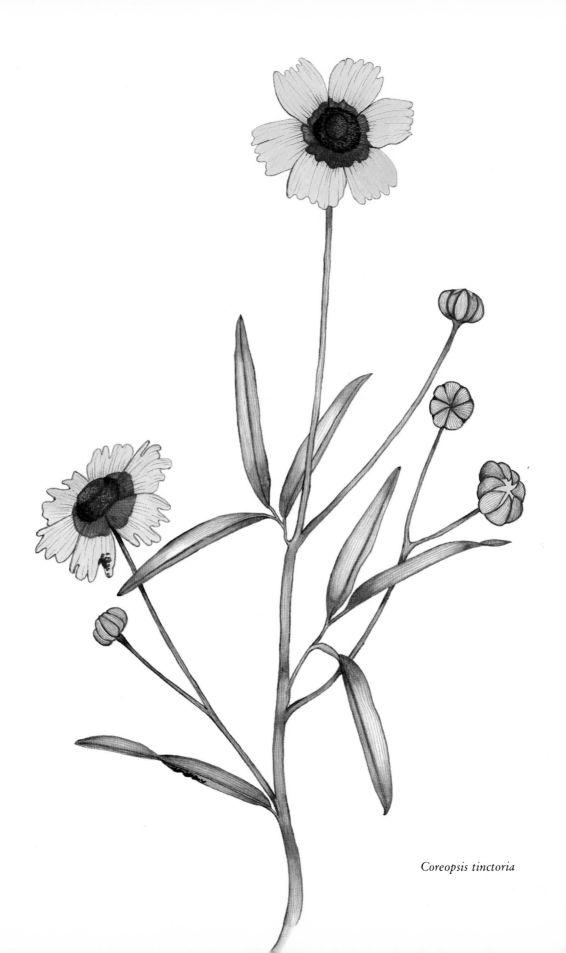

Coreopsis tinctoria

and the undersides all dark maroon; sometimes just the opposite.

The name *tinctoria* indicates that the plant was used as a dye, for it comes from the Latin *tinctura*, meaning "to dye."

Today, seeds from calliopsis are almost always included in a wildflower meadow mixture. They seem to grow well in almost every region of the country and germinate easily from seed. In the southeastern United States calliopsis creates a splendid display of color during the first year of a meadow planting.

No less beautiful than calliopsis is the perennial species, *Coreopsis lanceolata*. Bright yellow petals sport characteristic notches on petal ends. The seed of this coreopsis is small and black and has two tiny hooks on one end. At first glance the seeds resemble small bugs, and for this reason the plant was sometimes called tickseed.

The genus name, *Coreopsis*, also refers to the similarity of the seeds to a bug, for it is based on two Greek words, *koris*, meaning "bedbug" and *opsis*, meaning "similar to." Early pioneers believed that the seeds helped repel bedbugs and fleas and used them to stuff their mattresses.

Name: Coreopsis *(Coreopsis lanceolata)*
Family: Compositae
Description: Bright yellow ray flowers and somewhat darker yellow disc flowers make up the blossom of coreopsis. Each ray flower (usually eight to a blossom) is notched at the end. The blossoms measure two to two and one-half inches across. Basal leaves are three to six inches long and are lance-shaped. Annual coreopsis *(Coreopsis tinctoria)* is taller and more slender than its perennial cousin. It is an airy plant with soft, fernlike foliage. The blossoms are small and are yellow and maroon.
Blooms: May through July
Natural habitat: Commonly found along roadsides or in fields or disturbed areas throughout the Southeast.
Propagation and cultivation: Both annual and perennial coreopsis prefer soils that are not too rich. They need regular watering, well-drained soils and full sun to light shade. Both species come easily from seed. *Coreopsis lanceolata* can be divided in spring or fall and the divisions should be replanted and watered immediately.

Oxeye daisy
(Chrysanthemum leucanthemum)

The soft summer-evening breeze curled the hair gently around my face. Moonlight was everywhere, and my meadow was magically transformed. Daisies caught moonbeams and tossed them back and forth softly lighting the summer night by their white petals, eerily iridescent in the moonlight.

"One moon shows in every pool; in every pool, the one moon," wrote a Chinese poet thousands of years ago. I looked at my daisies and knew that the moon shone in every one.

Perhaps the city of Atlanta is a strange place to find a flood of daisies. But perhaps the city is where daisies are most needed. I worked hard to change a corner of our suburban lot into a meadow, and this swath of white-petaled brilliance rewarded my efforts ten times over. My meadow has proven to be my salvation. It is my taste of wilderness, a whiff of the wild to keep things in perspective when traffic and crowds tend to skew my outlook on life.

Aldo Leopold wrote that there are those who can live without wild things and those who cannot. I fall into the latter category, and while reality ties me to the city, my spirit soars in the wilderness.

Ancient flowers of medieval monks, daisies are full of magic and medicine. Along the Rhine River in western Europe, daisies were called *Johanniskraut*, or St. John's Day flower, and, if hung indoors, the yellow centers were thought to hold the power to ward off thunder and lightning.

Gypsies used daisies to tell fortunes of love. Plucking the petals off one by one, they would chant, "He loves thee, he loves thee not," until all the petals were gone.

Daisies have been known and loved for thousands of years. A design resembling a daisy was found on artifacts from the Minoan civilization on Crete, dating back four thousand years. However, our common oxeye daisy is a relative newcomer to North America. It

151

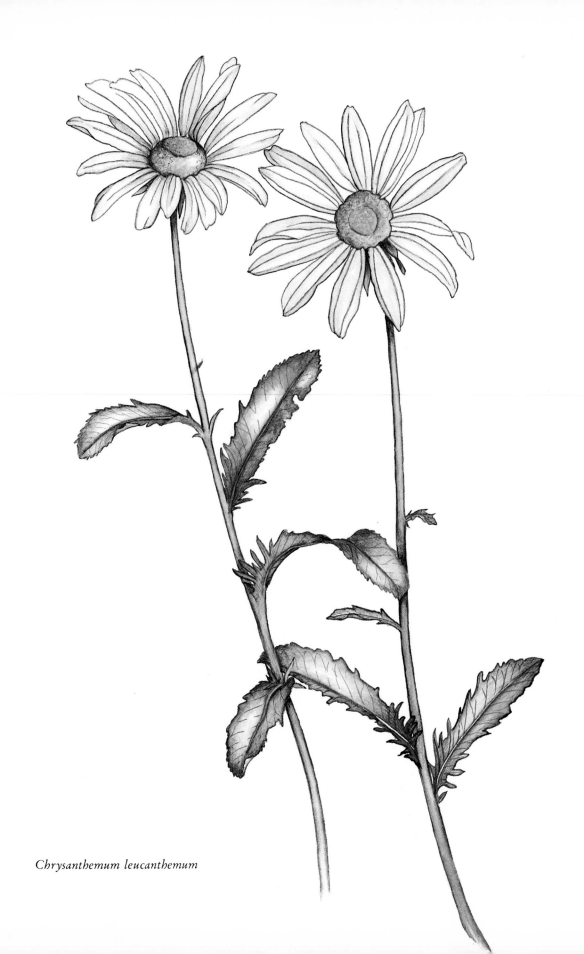

Chrysanthemum leucanthemum

wasn't until immigrants began settling this country that the daisy showed its face in the New World. Seeds from the daisy probably caught a ride in packing material, or perhaps were tucked in with fodder for the animals. However daisies got here, they liked it once they arrived, and in a very short time oxeye daisies spread across the countryside.

Early British settlers tried growing the little English daisy in their new land but had little success. *Bellis perennis* did not adapt well to growing conditions in this country. Determined to grow daisies that would remind them of home, the settlers turned to the oxeye daisy, and soon these bright white flowers filled flower gardens in all the early settlements.

Daisies brought more than just beauty. Though modern testing has found few medicinally effective substances within the plant, it was still used in herbal remedies for many years. During the Middle Ages daisies were used to treat smallpox, tumors, jaundice, boils, and skin rashes. Made into a salve, daisies were used to treat broken bones, a fact that earned the plant the name banewort, from the words *bane*, meaning "bone," and *wort*, meaning "food or medicine."

Superstition played a big part in these daisy cures. If taken while chanting proper oaths, daisies were thought to cure insanity. Another superstition suggested that if you ate three daisies after having a tooth pulled, you would never again be troubled with a toothache. Some people believed that eating the daisy root would stunt your growth. Others believed that feeding daisies to puppies when they were born would keep the puppies from getting too large.

The American Herbal, written in 1801, suggested that "The leaves and flowers [of the daisy] loosen the belly and are good for diseases arising from the drinking of cold liquors when the body is hot."

Known by Chaucer, who wrote of the "ee of the daie," and Ben Jonson, who wrote of "day's eye," daisies have always been beloved by poets and children. In Germany the plant is called *tausendschön*, meaning "one thousand times beautiful," or *massliebchen*, "love's measure."

A shadow passes over the moon, and for a moment the daisies are lost in the darkness. But as the breeze persists, causing the

clouds to scurry across the sky, a thousand white petals glow in the moonlight. If each is a thousand times beautiful, that means my meadow is worth a million.

Name: Oxeye daisy *(Chrysanthemum leucanthemum)*
Family: Compositae
Description: Each daisy blossom occurs on a separate stem. The blossoms are composed of white ray flowers surrounding the center yellow disc flowers. The flowers measure about one inch across. The height of the plant is two to three feet. Leaves are deeply lobed and four to eight inches long.
Blooms: May through July
Natural habitat: Found along roadsides and in fields and waste places throughout the region.
Propagation and cultivation: Oxeye daisy can be grown easily from seed. A perennial, the plant will probably not bloom until the second year of growth. Daisies like full sun and average to infertile soils.

Fire pink
(Silene virginica)

Drought has turned the landscape brown. What is normally a hillside bursting with rich hues of vibrantly colored wildflowers is now barren and dusty. Only kudzu and honeysuckle seem able to survive the dry heat, and even these look a little wilted.

But from this depressingly brown landscape there suddenly bursts forth a flower of such a vibrant red that the entire hillside seems transformed. It is not a very large flower, only an inch or two wide, but what fire pink lacks in size it more than makes up for in color. Its bright red face creates myriad freckles across the landscape.

Up close, fire pink assumes an entirely different personality. What appeared to be a freckle from a distance turns out to be a highly prized beauty mark upon close inspection. Each individual flower is composed of five deeply segmented petals, adorned in the center with ten stamen. The stems are slender and delicate.

Upon first seeing this flower, one thinks that the plant is grossly misnamed. Or perhaps that in other areas the flower is pink instead of red. Neither is true. The flower is always red, and it is very appropriately named, for it is not named for the color but for the verb *to pink*, which means to cut with a jagged or notched edge. Thus, your pinking shears cut a jagged line.

Fire pink is a member of the Caryophyllaceae, or pink family that also includes such garden favorites as sweet William, carnations, and garden pinks, all of which have petals with notched edges, though none are as deeply segmented as those of fire pink.

Fire pink and several other members of this family exude a sticky sap from the stem. Ants crawling up the stem are caught in this sap and prevented from stealing the nectar without pollinating the flower. Thus, these plants are often called catchfly.

This sticky sap resulted in the plant's association with Silenus, foster father of Bacchus, Greek god of wine and revelry. Silenus was

often caught with foam from beer all over his face. Some folks thought that the plant resembled the appearance of this happy-go-lucky fellow and so named it after him, the genus name being *Silene*.

Another possible origin of the name is from the Greek word for saliva, *sialon*.

Name: Fire pink *(Silene virginica)*
Family: Caryophyllaceae
Description: Five bright red petals make up the blossom of this plant. The flowers are one and one-half inch across, and each petal is usually deeply notched. Often many flowers will be found in a loose cluster at the top of the stem. Stem leaves are opposite and six inches long. The plant grows six to twenty-four inches tall.
Blooms: April through June
Natural habitat: Found in the region from Virginia south to Georgia in open wooded areas or on rocky slopes. It is more common in mountainous areas.
Propagation and cultivation: Fire pink is a short-lived perennial, and it is best to introduce a few new plants annually to keep the colony attractive. It performs best in average, well-drained garden soil. If the soil is too rich, it will produce long, leggy plants. Although it benefits from several hours of morning sun, it needs protection from the hot afternoon heat. The plant will benefit from mulch and regular watering.

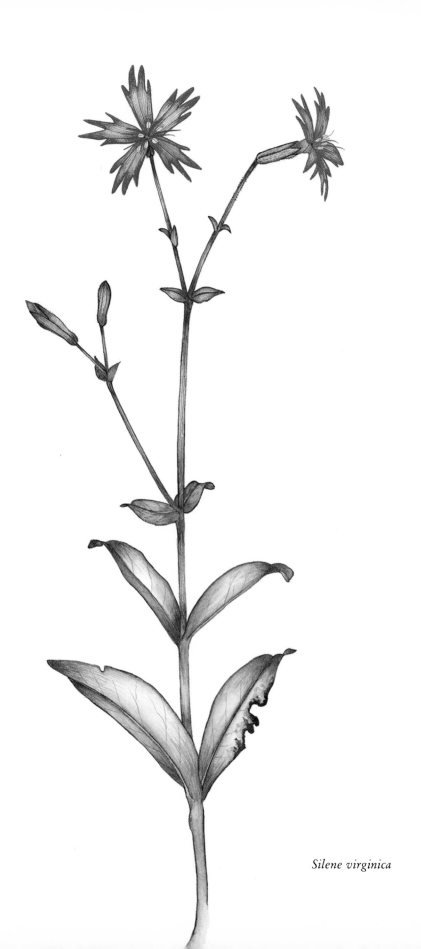

Silene virginica

Fireweed
(Epilobium angustifolium)

Plants all over the earth exhibit an incredible will to live. In every nook and cranny, plants put forth an effort which at times seems unbelievable. Against amazing odds, plants live and thrive, often creating breathtaking beauty at the same time.

Plants are remarkably adaptable, and through the eons have developed means of surviving even the most inhospitable conditions. In arctic areas where temperatures often stay below freezing throughout the year, plants have adapted by growing close to the ground. No large leaves can be found here, but small evergreen needles that lose moisture slowly and take advantage of every ray of sunshine that creeps into the cold, desolate area can be.

Desert plants are separated from their arctic counterparts by thousands of miles, and the conditions are distinctly different—but surprisingly similar. Lack of moisture and temperature extremes challenge all of these plants. In response to this environment, desert plants have also given up on the idea of leaves, leaving the job of photosynthesis to the stem.

Plants defy cold and heat, drought and floods, and seem to shout "Life will go on!" Perhaps nowhere has this been more dramatically shown than in May of 1980. On May 18, Mount St. Helens erupted, blowing down trees up to fifteen miles away and leaving a layer of ash and debris that measured as much as six hundred feet deep in places.

After the volcanic eruption, the area around Mount St. Helens was reduced to a bleak and desolate landscape. No trees lent their shade; no green leaves brightened the gloomy gray land. Scientists rushed to the area to determine how the landscape would recover, how Mother Nature would heal her wounds.

They did not have long to wait. Just a month after the blast, a fireweed blossom was found high on a ridge. The roots were buried under several layers of hot ash, and the top of the plant had been

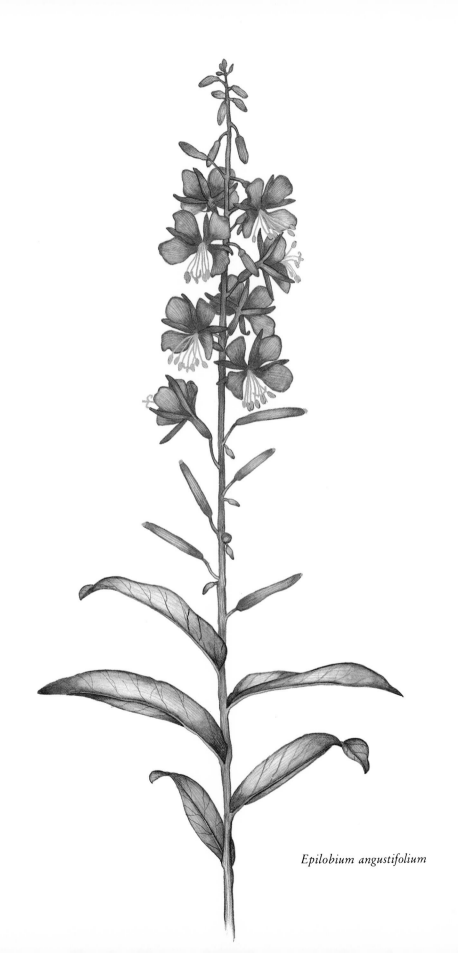

Epilobium angustifolium

burned off. But the will to live was so strong, the plant managed to bloom anyway.

Soon this lone little blossom was joined by hundreds of other fireweed blossoms, each adding a spot of hope to a cheerless scene. But the presence of the fireweed was more than just a bit of color in a gray world. Its emergence signaled the beginning of rejuvenation for the entire area. Animals soon wandered onto the mountain and browsed on the tender young shoots of fireweed. Excrement from these animals, combined with fallen vegetative matter from the plants, gradually added nutrients to the barren soil. These nutrients allowed other plants to begin to grow once again.

Although a volcanic eruption is not necessary to spur the growth of fireweed, the plant is intolerant of shade and is most conspicuous after an area has been burned. During World War II after London was bombed, acres and acres of the plant turned the earth a brilliant reddish pink.

Fireweed is an exceptionally tasty wild treat. Young shoots are tender and are frequently eaten like asparagus. French Canadians think so highly of the plant that they call it wild asparagus. Tender new leaves can be cooked and eaten as greens, and tea made from the dried leaves is particularly soothing and good.

As medicine, fireweed was used most often as an antispasmodic in treating asthma, whooping cough, and hiccoughs.

The genus name, *Epilobium*, is from the Greek meaning "upon the pod" and refers to the blooming pattern of the plant. Buds low on the stem open first, then the higher ones. The leaf, which is similar in shape to that of the willow tree, has given rise to several other common names, including great willow-herb and willow-weed. Still another popular common name is blooming Sally.

Name: Fireweed *(Epilobium angustifolium)*
Family: Onagraceae
Description: Bright pink flowers occur in terminal clusters. Each four-petaled flower is about an inch across. The leaves are long (eight inches), linear, and willow-like. The height of the plant is two to six feet.
Blooms: July through September
Natural habitat: Found in recently cleared or burned areas in our region from Virginia south to the mountains of North Carolina and Tennessee.

Propagation and cultivation: This plant can be propagated by seed or by plant division. It will not tolerate any shade and needs relatively moist soil to do well. It should spread by reseeding or by means of an underground creeping root.

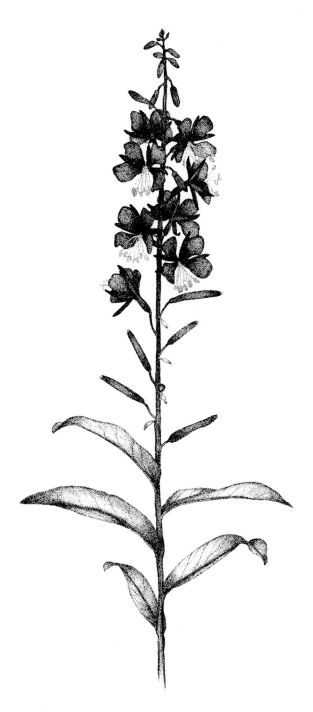

Forget-me-not
(Myosotis scorpioides)

At the beginning of the world, when God created each creature, He also gave a name to each living thing. All the plants of the fields and forests and all the animals, small and large, waited their turn to receive their name. Among these creatures was a small blue flower with a golden center.

This small flower waited patiently as each creature received a name until, finally, he was the only one left. But he was so small that God did not see him. So, in a very small voice, he cried out, "What about me?" God at once turned and looked down to find the small voice.

When he saw the tiny blue flower, He bent and picked him up, whispering softly in his ear, "I forgot you once, but will not forget you again. From now on you will be known as forget-me-not."

There are many legends about the origin of the forget-me-not. This little plant is a native of Europe and grows quite abundantly there. In England the story is told of two young lovers walking beside a great lake. As they walked, the young woman noticed a lovely blue flower growing on the banks of an island some distance into the lake. She cried out with delight, and the young man, full of chivalrous thoughts, immediately plunged into the water to pluck this blue blossom for his love.

He easily retrieved the blossoms, but as he was returning to shore, a great storm came up, pulling him under the water. Just as the waves covered him for the last time, he threw the flowers to his lady love, crying out "Forget me not!" Because of this legend, the forget-me-not has become a symbol of friendship and fidelity.

Germany favors the following legend: A young man was walking through the mountains in search of treasure. He had been told of a wonderful storehouse of gold and jewels in a cave in the

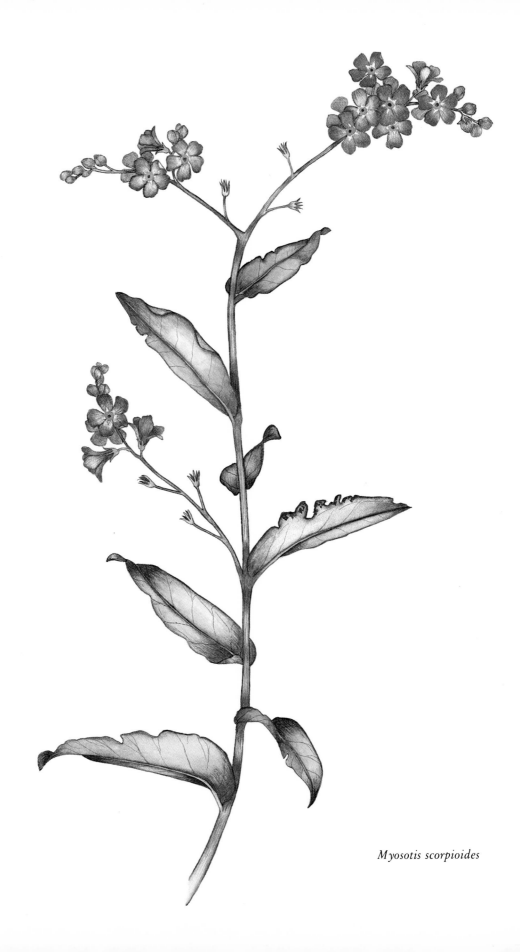

Myosotis scorpioides

mountains. After a great search, he found the cave, and it was indeed full of treasure. Around the cave grew a thousand small blue flowers.

The man was filled with delight at finding the treasure and quickly began filling bags and sacks with gold and jewels. Suddenly, a lovely lady appeared to him and said, "Remember the humble and forget not the best." Then she disappeared as quickly as she had come.

The man thought for a moment, trying to figure out what she meant, but so great was his greed that he soon forgot the lovely lady and her warning. When his sacks were full and he could carry no more, the man carefully covered up the entrance to the cave, marking it carefully so he could find it again. In doing so, he trampled on the small blue flowers.

As he was leaving, the beautiful lady appeared once again.

"You did not heed my warning," she cried out. "This little flower and all of nature are worth more than all the treasure in the world." Suddenly a great avalanche came down, burying the man and the treasure he sought so desperately.

Forget-me-not also played a small role in English history. In 1398 King Richard II, fearing the power shown by his cousin Henry of Lancaster, banned him from England. Henry and his followers adopted the forget-me-not blossom as their symbol, promising to come back and take over the throne. Eventually, Henry was able to do this and became Henry IV.

The genus name *Myosotis* is from two Greek words meaning "mouse ears" and refers to the small, round wooly leaves on the plant. The species name *scorpioides* is from the Latin for "resembling a scorpion" and was given because of the plant's growth habit. As the flower buds form, they can be found on a tightly coiled stalk, which looks something like the curled tail of a scorpion. Because of this, the plant was extensively used as an antidote for the poisonous sting of scorpions and spiders.

According to Reader's Digest *Magic and Medicine of Plants*, ingestion of the plant over a long period of time can result in liver cancer.

Name: Forget-me-not *(Myosotis scorpioides)*
Family: Boraginaceae

Description: Sky-blue flowers with bright yellow centers are found at the ends of several prostrate stems. The leaves are light green and lance-shaped. Stems are curled until the flowers open and then they gradually unfurl. The height of the plant is six to twenty-four inches.

Blooms: May through October

Natural habitat: Found in very moist places, stream or lake banks throughout the area.

Propagation and cultivation: Although only found in very wet places in the wild, forget-me-not has proven to be quite adaptable in cultivation and can grow in relatively dry areas. If it gets too dry, the plant will go dormant until sufficient moisture is available. It will grow in full sun or partial shade. Plant in spring in clumps two feet apart. Established plants can be divided in spring, and stem cuttings can be taken during the summer months.

Red hibiscus
(Hibiscus coccineus)

The red hibiscus is considered one of the most beautiful of all our native wildflowers. Tall and commanding, it lords over the rich swamps where it is most often found.

Wildflower enthusiasts for over two hundred years have enjoyed the breathtaking sight of red hibiscus in bloom. In 1773 William Bartram, son of the famous plant collector John Bartram, found the plant growing in Florida. He wrote:

> There are some rich swamps on the shores of the island, and these are verged on the outside with large marshes, covered entirely with tall grass, rushes, and herbaceous plants; amongst these are several species of Hibiscus, particularly the *Hibiscus coccineus*. This most stately of all herbaceous plants grows ten or twelve feet high, branching regularly, so as to form a sharp cone. These branches also divide again, and are embellished with large expanded crimson flowers. I have seen this plant of the size and figure of a beautiful little tree, having at once several hundred of these splendid flowers, which may be then seen at a great distance. They continue to flower in succession all summer and autumn, when the stems wither and decay; but the perennial root sends forth new stems the next spring, and so on for many years.

William Bartram, an accomplished naturalist and artist in his own right, never attained the fame and prestige that his father did.

John Bartram, born in 1699, was a Quaker farmer living in Philadelphia. The story is told that Bartram's interest in and passion for plants came upon him instantaneously. Apparently, John Bartram was plowing his fields one day and stopped his plow to pick a daisy. As William Darlington, his biographer, put it, he "viewed it with more curiosity than common country farmers are wont to do."

166

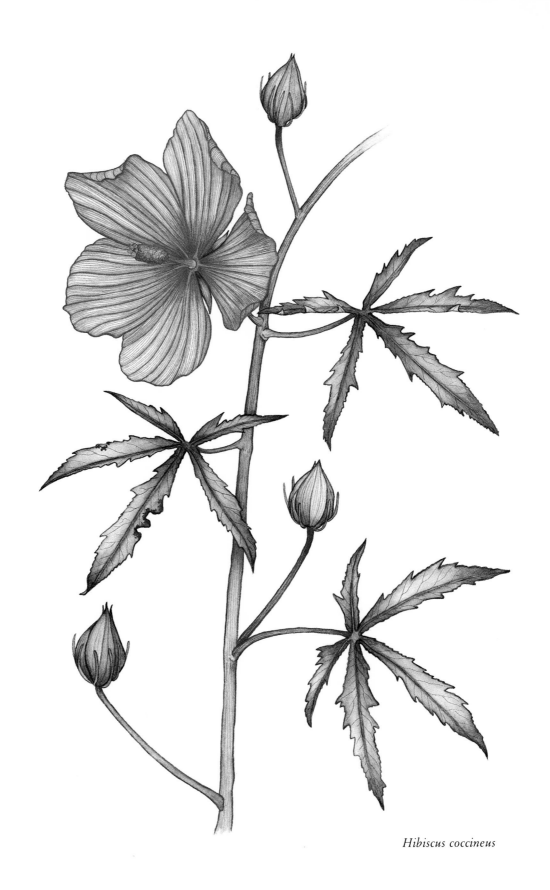

Hibiscus coccineus

There are variations on this story, of course. Some versions say that Farmer Bartram saw a colony of birdfoot violets growing in his meadow. He admired these and dreamed of them that night. In the morning he awoke an impassioned enthusiast of botany.

Whatever caused his conversion, it was complete, and Mr. Bartram soon gave up farming. For the next forty years he pursued his newfound love of plant collecting. He was considered quite reckless, for he often went into dangerous Indian territories.

Bartram was not alone in his reckless passion for collecting plants. Linnaeus in his 1737 book *The Glory of the Scientist* wrote, "Good God! When I consider the melancholy fate of so many of [botany's] votaries I am tempted to ask whether men are in their right minds who so desperately risk life and everything else through their love of collecting plants."

It has been to our great benefit that these early plant explorers did risk "life and everything else" to help us understand the rich flora of our country.

The red hibiscus that William Bartram wrote of is but one of many hibiscus species found in the southeastern United States. Many of these are cultivated alongside other members of the mallow family, including hollyhocks and okra.

In the South Sea islands superstition holds that if a young girl places a red hibiscus blossom behind her left ear, it signifies her desire for a lover. If the flower is placed over the right ear, the girl is announcing that she already has a lover. Flowers over both ears mean "I have a lover and desire another."

Name: Red hibiscus *(Hibiscus coccineus)*
Family: Malvaceae
Description: A tall plant, red hibiscus often reaches a height of almost ten feet. The flowers are large and spectacular. They measure six to eight inches across and are a bright crimson color. The leaves are palmately divided and are two to ten inches long.
Blooms: June through September
Natural habitat: Found in fresh and brackish swamps of Georgia, Alabama, and Florida.
Propagation and cultivation: Because of its great beauty, red hibiscus is often cultivated. Place it in a sunny area where it will get plenty of moisture.

Indian paintbrush
(Castilleja coccinea)

(Adapted from a Navajo Indian legend)

A young Indian boy stepped out from his hiding place and looked around the village. The women, including his mother and grandmother, were chatting as they ground corn into meal for flour. A dozen small brown children ran past him, involved in their game of sticks. The men and older boys of the tribe were all out hunting.

The boy smiled softly to himself and silently crept into the woods behind him. It wasn't easy to find a few hours to himself, but whenever he did, he painted. He loved to paint more than anything in the world. Colors were magic to him, and to capture these colors on bleached animal hides or transform a plain woven basket into a piece of colorful art was his greatest pleasure.

Not many of the men or boys in the tribe shared this pleasure, and many did not understand or appreciate the gift that this young boy possessed. They often teased him, taunting him because he would rather sit in camp with the women and paint than go out and hunt with the men.

He really did not mind. When he began to paint, he forgot all else.

On this particular day, the boy gathered his paints together and sat at the edge of the woods painting. As evening drew near, a brilliant, beautiful sunset filled the sky.

He wanted more than anything else to paint this sunset. As he looked at his collection of paints and dyes, he

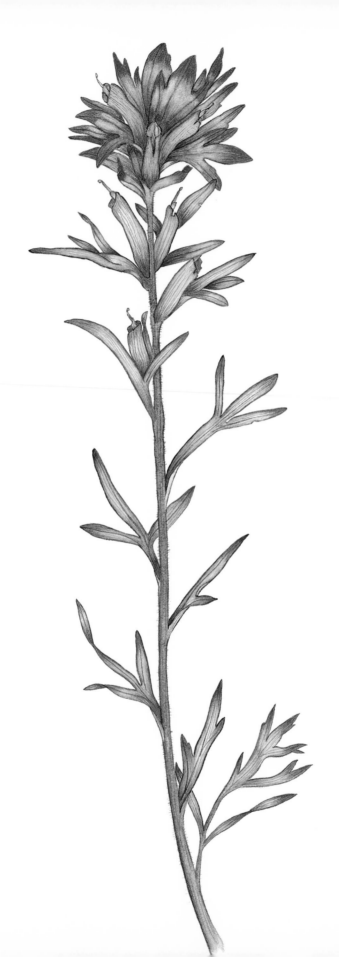

Castilleja coccinea

realized that they were all soft, muted colors and in no way resembled the vibrant hues that were in the sunset. He sat for a while, frustrated and disappointed, then opened his heart and prayed to the Great Spirit, asking him to give him the colors that he needed.

Suddenly all around him were paint brushes dripping with brilliant reds and oranges and yellows. He took them up, one by one, and painted his sunset. As he finished with a brush, he tossed it out onto the plains in front of him.

The next morning the boy woke to great shouts and much excitement. He dressed quickly and ran to see what had caused the commotion. There in front of him was a living sunset. The brushes that he had so casually discarded the night before had become beautiful flowers, turning the dry plains into a picture of colorful beauty. These flowers were thereafter called Indian paintbrush, and their blooms on the dry, rocky soil, remind us of the love and generosity of the Great Spirit.

The brilliant colors of Indian paintbrush create a summer spectacle of unparalleled beauty. Standing alone or complemented by bluebonnets or coreopsis, Indian paintbrush is an unusual flower of great beauty. The bright colors are not from the blossoms, which are small, greenish yellow, and rather inconspicuous, but from the brightly tipped bracts.

Indian paintbrush is but one of several similar southern species that include purple painted cup *(Castilleja purpurea)* and downy painted cup *(C. sessiflora)*. The genus, *Castilleja*, was named for Domingo Castillejo, a Spanish botanist. Indians used the root, mixed with iron minerals, to dye deer skins black. The stems, leaves, and flowers were mixed with alum to develop a rust-colored dye.

Based on the doctrine of signatures (see page 64), a concoction made from Indian paintbrush was used to soothe burned, red skin. It was also used to treat the sting of a centipede.

Name: Indian paintbrush *(Castilleja coccinea)*
Family: Scrophulariaceae

Description: Flowers of this plant are actually tiny and inconspicuous. It is the brightly colored bracts that give it its true beauty. These bracts are scarlet and fan-shaped and occur in a dense spike. The height of the plant varies from one to four feet.

Blooms: June through August

Natural habitat: Indian paintbrush is abundant in the western part of the country but can be found in nearly every state in our region as well. It prefers dry, open wooded areas.

Propagation and cultivation: This plant is difficult to establish, but once it is, it will tolerate a wide variety of cultural conditions. Some experts say that Indian paintbrush is partially parasitic on the roots of sagebrush, but there is some controversy about this.

Indian pink
(Spigelia marilandica)

Bill and Lydia Fontenot live just outside the little town of Carencro, Louisiana. Both nature lovers, they have worked hard to create a partnership with the land. They love and care for it, and it yields to them herbs and native plants that they sell to gardeners throughout the area.

The woods and gardens surrounding their home are full of special plants, many of which carry a story. Here and there are particularly meaningful flowers from relatives who have since passed away. Under the native azaleas are a few cherished wild petunias brought to them by a friend who now lives hundreds of miles away. Growing beside the swamp, dogwood are prized specimens given to them by former botany professors.

All of these plants grow happily beside flowers that were there when they moved to these woods; to these the Fontenots have added many new species of wildflowers. The result is a magical patchwork quilt of their lives. Past and present grow side by side as Papa's pawpaw tree provides shade for the zigzag iris from Mom's garden.

Not all of the gift plants they have received have lived, of course, but the majority have grown and spread, reminding them of the bounty of the earth and the miraculous continuity of life.

Beginning in late April, center stage of the Fontenots' garden is colored brilliant red and yellow as Indian pink comes into bloom. Trumpet-shaped flowers are bright red on the outside and golden yellow on the inside.

The beauty of the plant is in stiff competition with its usefulness, for Indian pink can be particularly effective in curing intestinal worms. The demand for the root of Indian pink was great during the early 1800s and provided much needed income for several Indian tribes, including the Creeks and the Cherokees.

Indian pink, which is also called Carolina pink, Maryland pink, pink root and worm grass, was often mixed with equal

173

parts of senna leaves, anise seeds, male fern, and turtlehead bloom. Indian superstition held that the treatment was more effective if administered during a full moon when intestinal worms were very active and vulnerable.

So much of the plant was used that it was grossly overharvested and by 1830 was considered rare and close to extinction in the southern United States. Fortunately, for the sake of the plant, severe side effects often accompanied the use of Indian pink root. Patients complained of dizziness, rapid heartbeat, and convulsions.

Laboratory testing found that the root contained the poisonous alkaloid, spigeline. By 1920 the plant was no longer used for medicinal purposes and, without pressure from herb and plant hunters, slowly began to reproduce and prosper in the wild.

Name: Indian pink *(Spigelia marilandica)*
Family: Loganiaceae
Description: Inch-long trumpet-shaped flowers are red on the outside and strikingly yellow on the inside. They are grouped into a narrow, one-sided terminal cluster. Each blossom has five protruding stamen. The leaves are ovate, opposite, and two to four inches long. The plant grows one to two feet high.
Blooms: March through June
Natural habitat: Found in wooded areas from South Carolina south to Georgia and Florida and west to Texas, Louisiana, and Mississippi.
Propagation and cultivation: Indian pink needs rich, well-drained soil and full to partial shade.

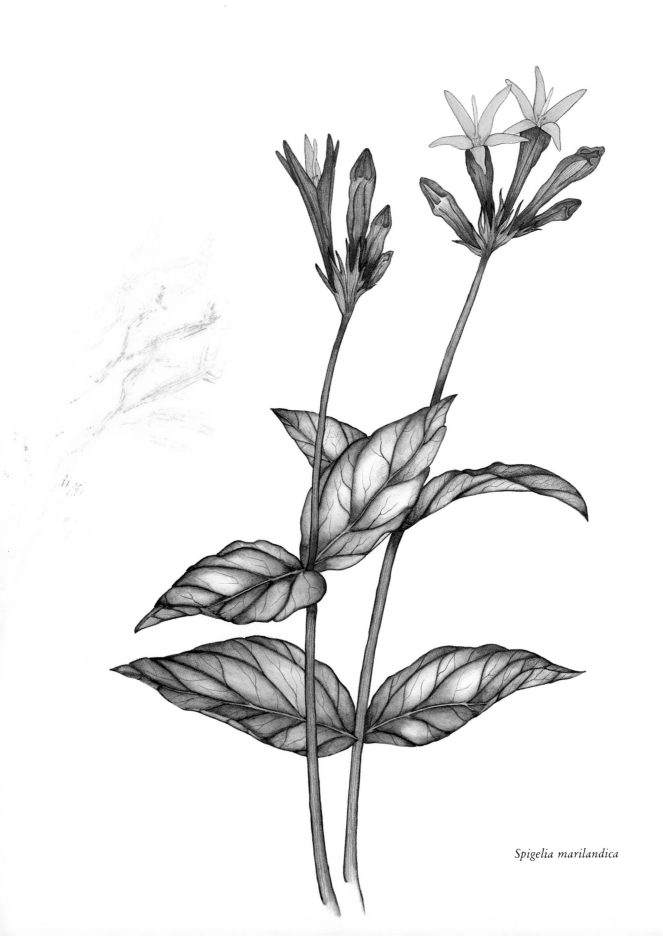

Spigelia marilandica

Indian pipe
(Monotropa uniflora)

I was always a child of the woods, running to wander among the trees at every opportunity. I grew up only a few miles from the city limits of Atlanta, Georgia, but my parents, who had lived there for many years, had managed to accumulate six acres of woods, which served as a buffer for us. Our trees physically insulated us from the noise and sights of suburbia and also provided a psychological barrier, allowing us the freedom of wilderness in the bustle of the city.

Thus, it seemed natural to me that when my childhood friends would talk of softball games in the parking lot and riding bicycles in the street, I would tell them of the new rabbit's nest I had found or of the swallowtail butterfly that I had seen sipping nectar from the apple tree.

I was not a particularly good child, and when there were chores to be done, I usually read the signs ahead of time and slipped out the back door to the freedom of my woods.

The moss-covered ravines covered with ferns were my playground and backdrop for my vivid imagination. Though I sometimes imagined myself a pioneer, I most often pretended to be an Indian. And always, as can happen only in the imagination, I was the one who saved my people from sickness and hunger for I knew the magic of the plants. I made stew from pine straw and bits of bark, salad from grass and ferns. My "medicine bag" held such treasures as dandelion blossoms and acorns.

Though I loved all the plants that I found in the woods, there was one that always made me feel a little uncomfortable. Indian pipe, white and eerie and cold to the touch, always turned black when I touched it, and this inevitably sent shivers up my spine. To my childhood eyes it seemed unreal, a plant that grew but was not green, that was cold instead of warm—the contradictions were too numerous, and I shied away from it in distrust.

176

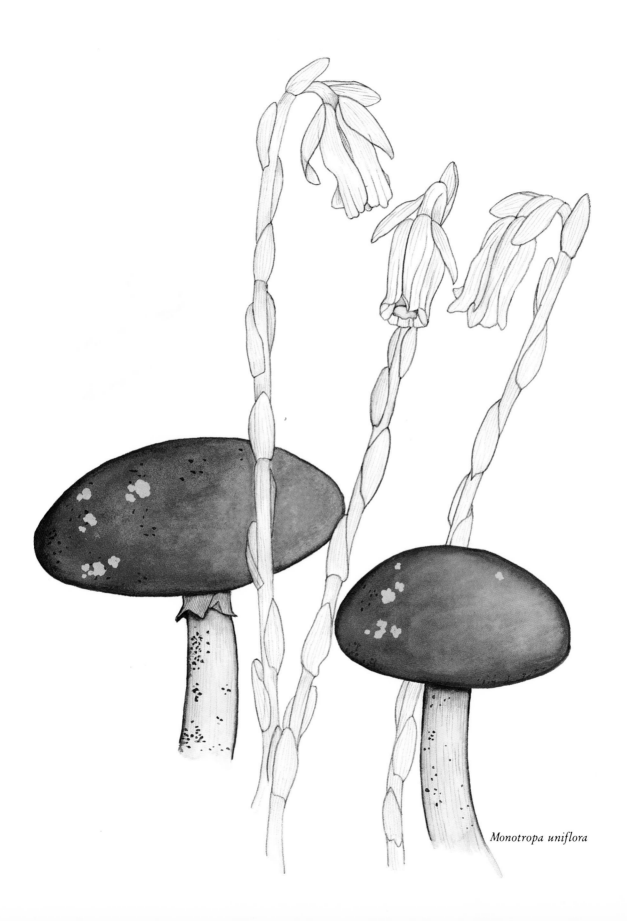

Monotropa uniflora

I was not alone in this dislike and distrust of Indian pipe. The Indians themselves called it corpse plant or life-in-death. But, in spite of their dislike, the Indians also found great uses for this unusual plant. Clear juice extracted from the stems soothed sore eyes. A decoction made from the plant was considered an excellent treatment for children prone to fits. It was considered effective in soothing restlessness, pain, and nervous irritability without having any dulling effects. It was used as a feminine douche and in treating gonorrhoea as well.

Indian pipe, also called bird's nest, ghost flower, and ice plant, contains no chlorophyll and is thus unable to photosynthesize and create nutrients. Instead, it is parasitic on myzorrhiza, tiny fungi often found on the forest floor.

The single flower generally droops to one side (thus the genus name, which means "one turn") and is shaped like a pipe. This has given rise not only to the common name Indian pipe but also to the less often used name of peace pipe.

After the flower has set seed, it stands upright and turns a very light pink color.

Name: Indian pipe *(Monotropa uniflora)*
Family: Monotropaceae
Description: Indian pipe looks unlike any other common southern wildflower. Lacking chlorophyll, the plant is translucent and appears white. The thick stem is covered with scaly bracts and ends in a single nodding flower that is one-half to one inch long. There are four to five petals and a dozen stamen. The height of the plant is three to nine inches. There are no true leaves.
Blooms: June through September
Natural habitat: Found throughout the region in rich woodland humus.
Propagation and cultivation: Indian pipe grows in rich, shady woodlands.

Jewelweed
(Impatiens capensis)

Self-pity welled up inside me as I looked at my ankles. They were red and swollen and itched like crazy, the unfortunate result of a walk through poison-ivy-infested woods.

Cameron, my eight-year-old, came up and peered down at my ankles. I looked up expectantly. "Why didn't you wear socks?" It wasn't exactly the sympathetic remark that I was looking for.

She continued, "You always make us wear socks. But I'm sorry, Mom." The note of sympathy in her voice was minimal and did little to hide her obvious secret pleasure that Mom was paying for not practicing what she preached.

"I should have," I admitted grimly. I had tried everything I knew of to relieve the itching. A heap of bottles and tubes containing lotions to "stop the discomfort caused by poison ivy" littered the bathroom shelf. It looked more like a pharmacy than a bathroom.

I stood up and grabbed Cameron's hand. "Come on— there's just one thing left to do. Let's go find Aunt Bessie."

Aunt Bessie isn't really my aunt, but she is one of those wonderful people everyone loves and calls "Aunt." She is old and wise and gentle, but, more to the point, she knows more about home remedies than anyone else I know.

If anyone could help my ankles, I figured, Aunt Bessie could.

After a short drive through the country, we arrived at Aunt Bessie's house. I stopped the car and ran to the front porch, where she sat in a rocking chair shelling peas.

"Hi! Do you know anything to do for poison ivy?" I balanced on one foot and held out an angry red ankle. I knew that this kind and gentle soul would give me the sympathy I sought so desperately.

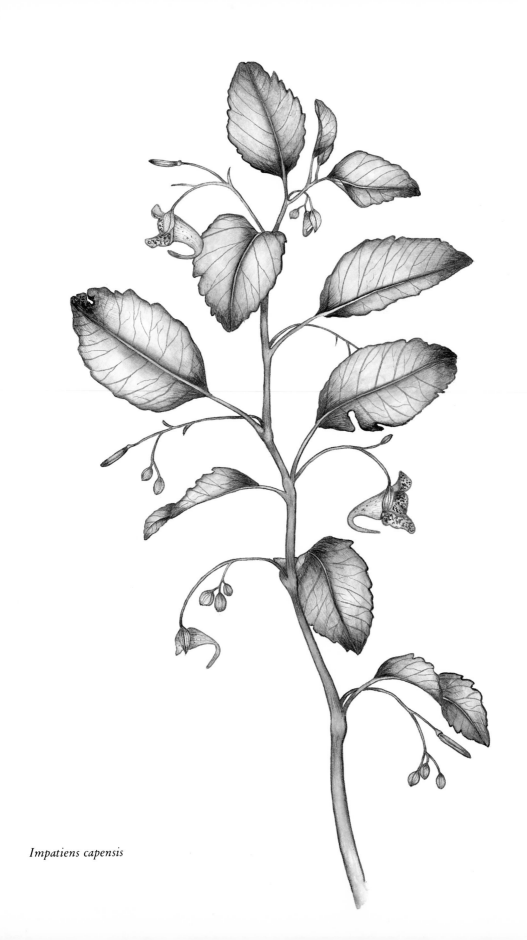

Impatiens capensis

Aunt Bessie looked at my ankle.

"Why didn't you wear socks?" she asked innocently and winked at Cameron. They exchanged amused looks.

I was not amused. "You two might think that this is funny, but this stuff is driving me nuts. Don't you have anything that will help?" I pleaded with Aunt Bessie.

She chuckled as she stood up and went into the kitchen. I heard her mumble something else about socks, but I tried to ignore any further comments.

From the freezer she pulled out an ice tray full of cloudy orange-tinted ice cubes. She removed several and bent down to hold them on my ankles. As the ice began to melt, the itching immediately subsided. Soon much of the redness was gone as well.

"That feels wonderful!" I was purring with delight. "What is it?"

Aunt Bessie answered, "Jewelweed, of course. It often grows right next to poison ivy. It helps if you just rub the leaves and blossoms over the rash, but it's more effective if you gather the plant and extract the juice. Put the leaves and blossoms in a big saucepan and cover them with water. Let it stew and simmer for about a half-hour, then strain off all the juice.

"The juice isn't any good unless you use it right away or put it in the freezer. I try to keep a supply handy. It's good for preventing the rash—or curing it either one."

I wanted to ask Aunt Bessie if there was some sort of scientific basis for using jewelweed, but I decided not to look a gift horse in the mouth. My ankles no longer itched, and I felt wonderful. At this point I didn't even care if this cure had been "scientifically proven." I knew that jewelweed contained no hidden toxins and would do me no harm, and it had already done a lot of good.

The three of us sat chatting about this and that until finally it was time to leave.

"Aunt Bessie, you've done it again. How can I thank you?"

Aunt Bessie looked at Cameron, and they both grinned wicked grins.

"Next time, practice what you preach. Wear socks."

In addition to relieving the rash caused by poison ivy, jewelweed has also been known to help athlete's foot. Laboratory tests have proven that substances within the plant are effective fungicides.

The blossom of jewelweed hangs down like a pendant on a lady's necklace, thus the common name. Another possible reason for this name is that water droplets on the surface of the plant reflect sunlight and look like jewels. It is also known as lady's-eardrops, snapweed, or spotted touch-me-not because when the ripe seed pods are disturbed, they burst open, spewing the seeds long distances.

The blossom seems to be particularly attractive to hummingbirds.

Name: Jewelweed *(Impatiens capensis)*
Family: Balsaminaceae
Description: Jewelweed grows to be two to five feet tall. It is multibranched and has many long, thin leaves. The stems are succulent. The blossoms are long tubular pendants of orange splotched with brown.
Blooms: July through October
Natural habitat: Grows in the Southeast from Virginia south to Georgia and westward. It can most often be found growing in lightly shaded wet meadows or on stream banks.
Propagation and cultivation: Jewelweed is an annual, and the seeds should be collected and sown when ripe. When the seed pod is mature, it will burst open, spewing seeds a great distance. It is a very delicate plant and in the garden should be planted in a protected location.

Milkweed
(Asclepias syriaca)

How about a bit of *pee-too-can-oh-uk* for dinner tonight? Sound exotic? It is. This is the name of a Delaware Indian dish that consists of milkweed pods boiled with dumplings.

Modern wild food advocates have found milkweed to be just as delicious as their native American cousins did. Billy Joe Tatum's *Wild Foods Field Guide and Cookbook* lists milkweed pods as being "unsurpassed as a wild food." Ms. Tatum goes on to say that the early flower buds and unripe seed pods cannot be topped by any other vegetable for taste.

Milkweed must be carefully prepared to obtain the optimum taste. This involves gathering the plant parts at the correct time. Flower buds can be found in late spring or early summer on the tips of two- to six-foot plants. The buds are tightly clustered and look a bit like broccoli. Seed pods should be picked while they still feel solid to the touch and before they mature. If they feel soft or rubbery, the downy seeds have probably already formed and the pods will not be edible.

In its natural state, milkweed is somewhat bitter. To remove this bitterness, plant parts need to be blanched for several minutes, changing the water several times. Usually it takes three to four water changes to remove all the bitterness. Once the plant has been blanched, it can be used in a variety of recipes. The following is from the *Wild Foods Field Guide and Cookbook*:

Milkweed Pods with Black Walnuts

2 cups black walnut meats
1 cup fine dry breadcrumbs
1 stick butter
1/2 tsp. salt
1/4 tsp. dried thyme

¹/₂ tsp. dried basil
Fresh ground pepper
3 cups milkweed pods (blanched to remove bitterness)

Toast nuts in a shallow pan in the oven for 30 minutes at 300°. Mix the breadcrumbs with the herbs. Put into a buttered 1¹/₂-quart casserole dish a layer of milkweed pods, a layer of nuts, and a sprinkling of the herbed crumbs. Continue layering the dish in this manner, ending with the remaining crumbs. Sprinkle with ¹/₄ cup water. Cover and bake for 30 minutes at 350°, removing the cover during the last 10 minutes to allow browning. Serve hot.

If you are eating milkweed be sure to eat the correct part, for the roots are considered poisonous. The sap within these roots was used to treat a variety of ailments and was thought to be particularly effective in treating warts, ringworm, poison ivy, and other skin disorders. During the early nineteenth century, physicians used milkweed roots to treat respiratory conditions such as asthma and coughs from colds. The Quebec Indians used the roots as a contraceptive.

The healing powers of milkweed were so highly regarded that the plant is named for the Greek god of medicine, Asclepias.

The common name, milkweed, is from the milky white sap that is present in many species of this genus. This sap contains small amounts of rubber, but investigation proved that the extraction process was too expensive to make milkweed a viable source of rubber.

It has been discovered, however, that milkweed may be a good source of hydrocarbons, and testing in Alabama and Texas has proven that a surprising amount of oil can be obtained from milkweed plants. Young plants (two to three months old) are harvested and the leaves and stems ground to a pulp from which is extracted an oil that can be refined in a conventional manner. It could be that in the not-too-distant future you just might be running your car on fuel made from milkweed.

Name: Milkweed *(Asclepias syriaca)*

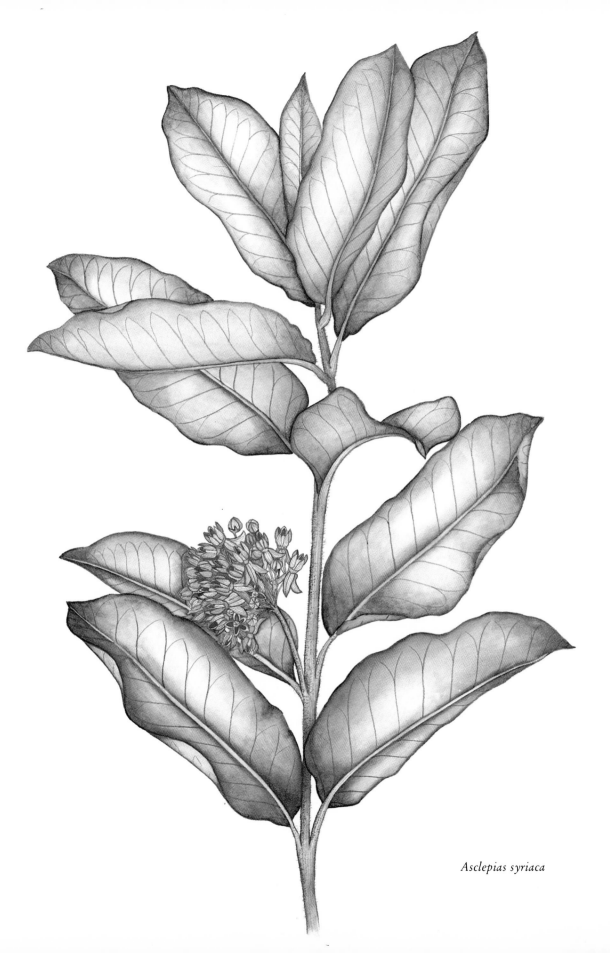

Asclepias syriaca

Family: Asclepiadaceae

Description: Deep brownish pink blossoms occur in terminal racemes. The leaves are opposite and about four inches long. Light green on top, they are grey down underneath. Attractive seed pods are elongated and measure two to four inches long. They are rough and warty on the outside. The height of the plant is two to six feet.

Blooms: June through August

Natural habitat: Commonly found in fields and disturbed areas and along roadsides in the Southeast from Virginia south to Georgia.

Propagation and cultivation: There are over nineteen hundred species of milkweeds, only a few of which are truly worthy of cultivating. Of these, the outstanding species include swamp milkweed and sand milkweed. These perennial plants can easily be grown from seed or from plant division. They like well-drained soil and full sun.

Wild morning glory
(Ipomoea purpurea)

A wildflower or a weed? Ask a hundred people about a hundred different plants growing across America, and you will get a hundred different answers to that question. The definition of a wildflower is "the flower of a plant not in cultivation," and under this broad heading could conceivably come a multitude of plants we might never have considered as wildflowers.

What is one man's orchid is another man's weed is an axiom that is true all over the world. A friend who did botanical research in the tropics told me of watching native gardeners weed the rose gardens of wealthy landowners. They yanked and pulled, fumed and fussed over the pesky weeds that had made their way into the rose garden. And what were those despicable weeds? The native orchids, of course.

Although there are some plants that few of us would classify as anything but a weed, the difference between a weed and a wildflower is generally one of taste and preference. According to Webster, a weed usually grows in profusion and crowds out more desirable plants. The poets tell us that a weed is simply a wildflower growing where you don't want it to grow.

As we drive down a rural highway, often the breathtaking beauty of the wildflowers along the roadsides will cause us to stop in wonder and amazement. A field of mustard glows bright yellow in the sun. A thousand daisies catch the early morning sun. To us they are beautiful wildflowers and a sight to be cherished. To the farmer in whose field they are growing, though, they are probably merely weeds and a detriment to a good field of hay.

A white fence covered with bright blue wild morning glories is truly a glorious sight only to the roadside traveller. To the farmer who has to repair and repaint the fence annually because of the damage done by this aggressive vine, wild morning glories are probably not so appealing.

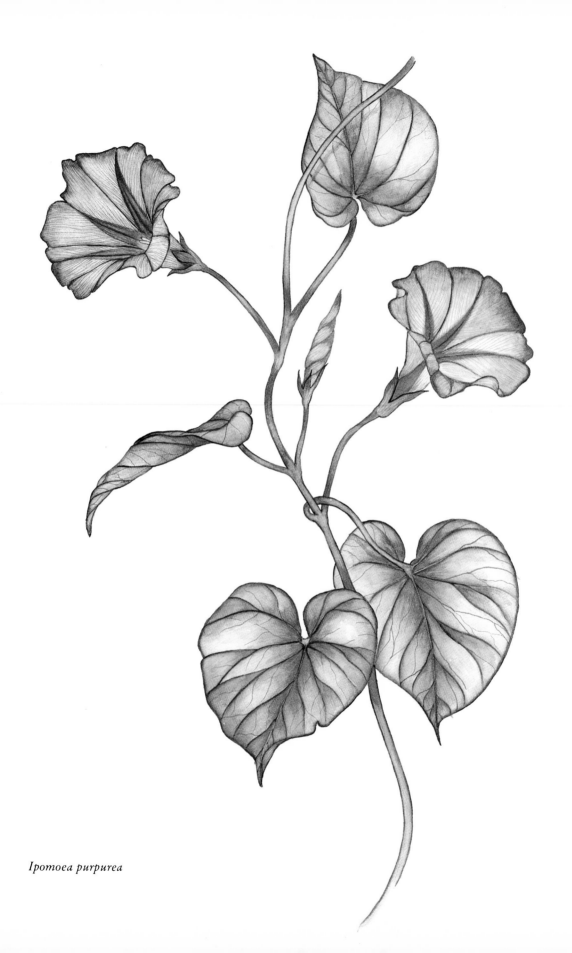

Ipomoea purpurea

It's true that the wild varieties of this early riser are not so beautiful as their cultivated cousins. The colors are not so vibrant and the blossoms not so large, but the sheer vitality of these wild vines more than makes up for their lack of sophistication.

The vines can grow to a height of ten feet or more, and care little for whatever comes in their way. A fence is nice, when handy, but the vine will use anything it can for support. The wild morning glory was originally brought to this country from its native haunt of tropical America. It liked growing conditions here so well, however, that it soon escaped from cultivation and spread throughout the countryside.

The first morning glories were found in Mexico and were sent to Spanish monasteries. The monks must have considered these exotic new vines quite beautiful, for designs employing the morning glory have been found on the borders of many of their manuscripts.

The monks also must have found this flowering vine to be frustratingly useless. All parts of the plant are somewhat poisonous; some substances within the plant even cause hallucinations. Necklaces made from the seeds caused a painful rash.

Morning glory was soon sent to England as an ornamental plant and, true to its adaptive nature, quickly made itself at home inside the garden and along the roadsides. Rural English folks were fascinated with the blooming habits of the plant and nicknamed it "life of man," for it is a bud in the morning, opens fully by noon, and wilts by evening.

Witches thought that the plant was full of magic. They considered it useful in casting spells and thought it particularly effective if it was collected and used three days before a full moon.

Name: Wild morning glory *(Ipomoea coccinea)*
Family: Convolvulaceae
Description: This aggressive vine has lovely little bright red tubular flowers that measure three-quarters of an inch wide. The heart-shaped leaves are one and one-half inches long.
Blooms: July through October
Natural habitat: Common along roadsides and in fields and open spaces throughout the region.
Propagation and cultivation: Wild morning glory vine is really too aggressive to be useful in cultivation. Hybrids developed from this and other wild species are much more satisfactory in the home garden. Generally, these hybrids will thrive in full sun and rich, fertile soil.

Mullein
(Verbascum thapsus)

My mother has always been something of an esoteric gardener. She grew wildflowers in the front yard back when people still called them weeds. She grew old-fashioned flowers when modern gardeners still scoffed at those "old outdated things." It wasn't always easy to explain my mother's garden to my friends, particularly the years she grew cotton around the sundial by the front door.

"Mom, why cotton? People will think that we're dirt farmers!" I wailed at a time in my life when peer pressure was everything. I wanted my mother to grow yellow marigolds just like everyone else's mother.

She smiled with a twinkle in her eye, unaffected by my desire for conformity. "It's so interesting," she exclaimed, "and the seed pods are great for dried arrangements." She continued to prune her cotton, and I groaned and went to buy yellow marigolds.

However, not even the cotton could compete for attention when Mom's mullein was in bloom. She had a big old iron pot that she had carried with her from her parent's Kentucky farm. Planted in this pot were her current favorite flowers. I liked it planted in good old normal red geraniums. She liked it planted in common mullein. Mullein? Yes, that roadside plant with the big old fuzzy leaves.

Even I had to admit that the silvery green leaves against the black iron pot looked attractive. And when the tall spike of yellow flowers began to appear, it became quite a conversation piece. Neighbors from all around dropped by to see our mullein. They would feel the soft leaves and exclaim over the small yellow flowers just as if we were growing orchids or something. And they would all, every last one of them, shake their heads and say, "Mullein, who ever would have thought of growing mullein in a pot?"

190

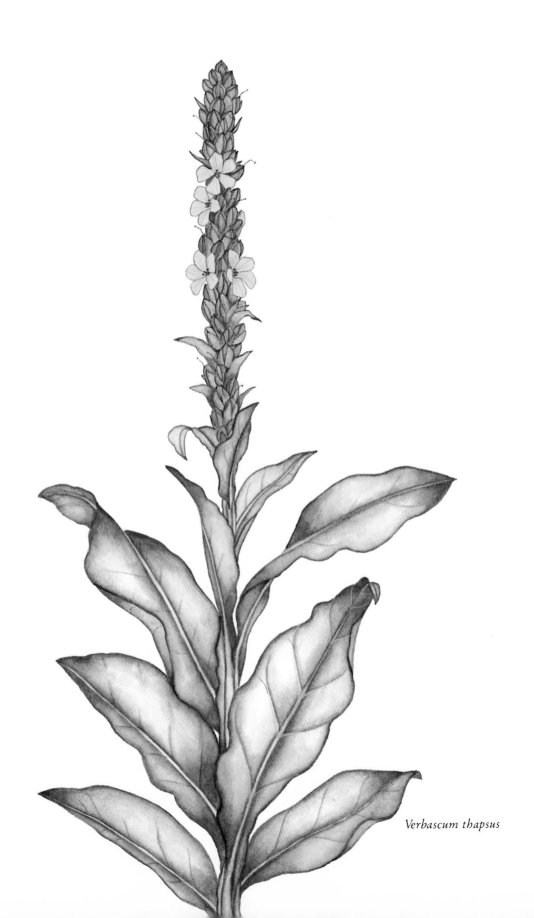

Verbascum thapsus

My mother purred with delight. I groaned in exasperation.

But now, decades later and something of an esoteric gardener myself, I have a fabulous mullein patch of my own. I just can't figure out why my children don't bring their friends by to see it.

Although mullein is not normally cultivated, it has been used a great deal throughout the centuries. Roman soldiers used the long, thick flowering stems as torches. Roman ladies used the yellow flowers to dye their hair blonde.

Much superstition is connected with mullein. It was thought that people who had dealings with the devil used a mullein torch to light their way. Also called witch's candle, mullein was thought to be potent protection against witches and warlocks and was thus sometimes called hagtaper (hag being another name for a witch).

During colonial times in America, Quaker women found a use for the plant. Prohibited by their religion from using cosmetics, they would take the downy mullein leaves and rub them on their cheeks, causing them to turn red. This practice resulted in the plant's being called Quaker's rouge.

The name mullein comes from the Latin word *mollis*, which means "soft." The genus name *verbascum* is a corruption of another Latin word, *barbascum*, which means "with beard."

The soft, thick leaves were used by European peasants during the winter months to line their shoes for protection from the cold.

As medicine, mullein has been quite useful, too. Farmers often refer to it as cow's lungwort because it was used in an old remedy for pulmonary congestion in cattle. American Indians dried the leaves and smoked them for relief from respiratory ailments. Choctaw Indians applied them directly to the head to relieve a headache.

Early pioneer doctors used mullein in cough syrup. Research has found that mullein contains chemicals that soften skin or soothe inflamed tissue.

Name: Mullein *(Verbascum thapsus)*
Family: Scrophulariaceae

Description: A tall, downy spike of small yellow flowers characterizes this plant. It grows to a height of two to six feet. Blossoms are three-quarters of an inch across and have five petals and five stamen. The basal leaves are large and thick and velvet-soft to the touch.

Blooms: June through September

Natural habitat: Commonly found in fields and disturbed areas and along roadsides throughout the region.

Propagation and cultivation: Mullein creates an interesting backdrop for colorful perennial or annual plants. A biennial, mullein forms a basal rosette of wooly light green leaves the first year. The second year, the spike of yellow flowers is produced. Seeds are easily collected from the plants and should be sown in the fall.

Passionflower
(Passiflora incarnata)

Philip Georg Friedrich von Reck was considered a young man with a future. Described as "idealistic, well educated, enthusiastic, [with a] great artistic gift," Von Reck came to Georgia with the Salzburgers in 1736. Not only was he an amiable and popular leader, young Von Reck soon became well known for his artistic talents as well. He kept a complete diary of life in this strange New World and often accompanied the text with exquisite paintings and drawings of plants and animals that he encountered.

Unfortunately, Von Reck was lured by possible fortunes, was unable to hold the trust of his followers, and quickly lost the support of his benefactors. He was said to have "retired from Georgia in disgrace after only a few months."

After Von Reck's death in 1790, his diary and drawings were given to the King of Denmark. We are fortunate to have a record of what was found in this southern colony during the first three years after its establishment. Von Reck's writings and diary have been collected in a delightful little book published by Beehive Press in Savannah, Georgia.

One of the loveliest drawings in this book is of the passionflower vine. Von Reck seems to have been much taken with this exotic-looking flower that produced such a sweet fruit. He writes:

The May apple is the fruit of certain . . . lianes [vines], which are creeping and very fast-growing. . . . The fruits are very healthy for the breast, refreshing and good-smelling. Their shell is green in the beginning but it gets yellow when the fruit ripens. It is neither thicker than a coin nor stronger than parchment. It is filled with a greyish liquid thick as rubber and full of small, grey seeds rather hard and very sticky. For eating this fruit you make a little hole in one of

194

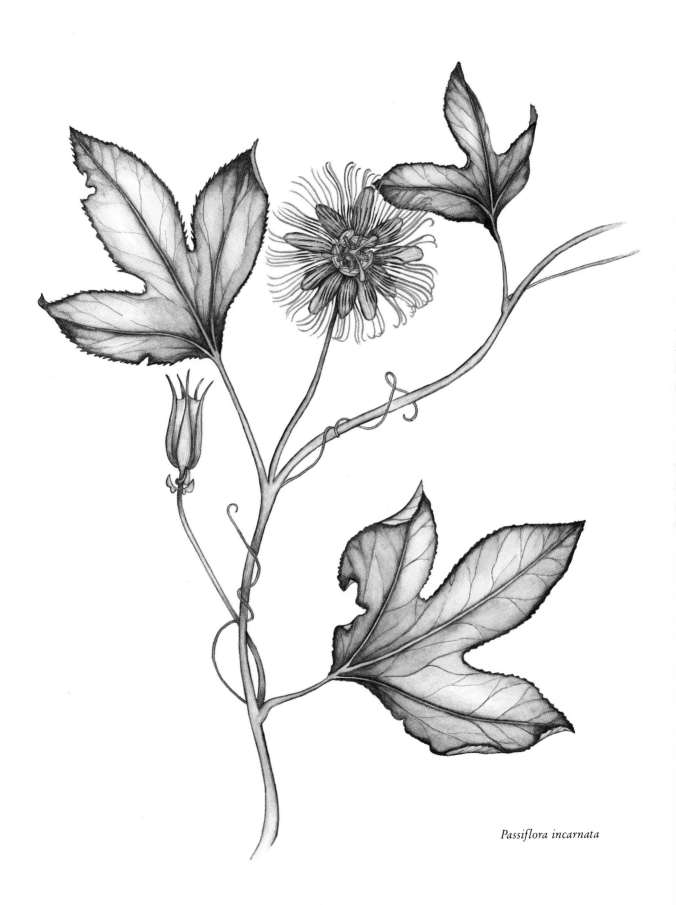

Passiflora incarnata

the ends and suck through it all the contents, a sweet jelly to which is added a taste of grenadine.

The fruit of passionflower is called a maypop, and since the time of Von Reck, Southerners have enjoyed the sweet and exotic flavor of the maypop. Usually the juice is extracted and made into a tasty drink with the addition of white wine. The juice is also useful in making punch or marmalade.

The flower is so unusual that it has attracted much attention and has been the focus of much superstition and folklore. Passionflower is thought to be the plant growing on the crucifix as seen in the vision of Saint Francis of Assissi. Each part of the blossom then attained some symbolism.

Five petals and five sepals, taken together, represent the ten faithful apostles. They form a backdrop for thin, threadlike segments, which are symbolic of the crown of thorns. Five stamen represent the five wounds, the ovary is symbolic of the hammer, and the three styles represent the nails. Spaniards exploring the southeastern United States called this plant *flor de las cinco llagas*, or flower of the five wounds. Passionflower is thought to be a symbol of faith and piety.

Indians traditionally used leaves from passionflower to make a poultice to help heal bruises and other external afflictions. Early pioneers used the juice from the fruit to soothe sore eyes. Later, in the nineteenth century, it was found that passionflower contained substances that were useful as a gentle sedative. These substances were thought to be particularly useful in controlling spasms and convulsions in young children.

Very large doses of passionflower may prove to be toxic. Taken in small quantities, passionflower tea can be quite relaxing. The tea is made by boiling one-half to one teaspoon of dried leaves to a cup of water.

A dose of passionflower was said to cause one to have a more restful sleep and to experience a feeling of freshness on awakening. The flowers, added to a warm bath, are also said to be quite soothing. It has even been reported that passionflower was used infrequently as an aphrodisiac.

Passionflower is the state flower of Tennessee. Although most of the four hundred species found within this genus grow in more

tropical areas, the southern passionflower is able to withstand winter temperatures down to zero degrees.

Name: Passionflower *(Passiflora incarnata)*
Family: Passifloraceae
Description: The flowers of the passionflower vine are difficult to misidentify, for they are strikingly beautiful and distinctly different. The blossom is made up of five sepals and five petals, all a light purple color. On top of this wheel of purple lie two to three layers of long fringed segments. There are five drooping stamen and a large three-part pistil. The leaves are dark green and have three lobes.
Blooms: June through September
Natural habitat: Grows in open areas and along roadsides throughout the Southeast.
Propagation and cultivation: The problem is usually not in getting this vine established but in controlling it once you do have it growing. Although seed germination is low, sometimes taking two years, the plant can easily be propagated by taking stem cuttings any time during late spring or early summer. The plants prefer rich, well-drained soil and full sun.

Pitcher plant
(Sarracenia minor)

Legends about man-eating plants are, fortunately, just that. Although it makes wonderful stuff for horror movies, the fact is that there are truly no terrifying plants on earth, unless of course you happen to be a small insect.

In North America insectivorous plants live primarily in bogs or other nitrogen-poor soils because there is little competition from other plants that need that essential nitrogen. Many insectivorous plants are able to withstand these conditions because they obtain nitrogen from a different source, namely the bodies of small insects.

In the Southeast, the most common insectivorous plants are the pitcher plants. Of the ten species native to the eastern United States, the most abundant species are the so-called trumpets, *Sarracenia flava* and *S. alata*. The rarest species include the green pitcher plant, *S. oreophila*, which is found only in a small area in northeastern Alabama and a single site in north Georgia. It was declared a federally endangered species in 1979. Equally as rare is *S. alabamensis*, or canebrake pitcher plant, found only in a few counties in central Alabama. It, too, is on the federal endangered species list.

Although some pitcher plants are so particular in their environmental needs that they can grow only within a very small geographic range, others are quite adaptable and can be found in a bog or a savannah. *Sarracenia purpurea* can be found as far north as British Columbia and as far south as Florida.

Pitcher plants do not actually reach out and grab their prey, but creatively lure them to their parlor instead. It is the leaf, not the flower, that means the end to an unsuspecting insect. The leaves are long, hollow, and pitcher-shaped and have a hood at the opening. Hairs on the inside of the leaf secrete a sweet substance that attracts insects.

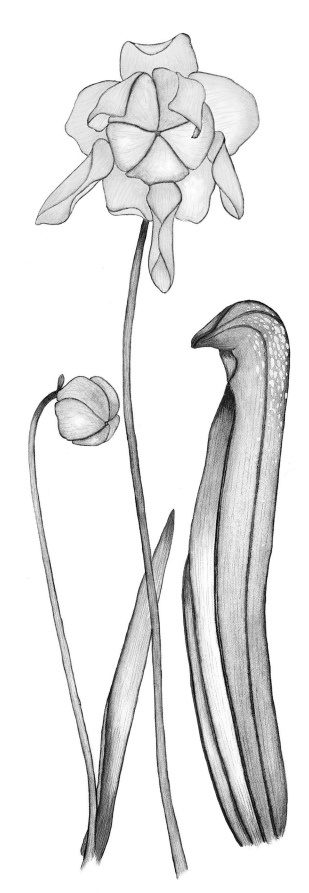

Sarracenia minor

The internal leaf hairs all point downward so that insects landing on the substance find themselves slowly slipping toward the bottom of the leaf. Because of the position of these hairs, insects are unable to crawl out of the leaf and eventually fall to the bottom of the pitcher into a pool of rain water and enzymes secreted by the plant. This fluid quickly breaks down the body of the insects so that the plant can easily absorb the needed nutrients.

The flowers of pitcher plants are on separate stalks from the leaves. Blossoms on most species measure two to three inches across and have five broad petals. They look like giant buttercups, and many rural folks call them just that. The leaves are so unusual that the uninitiated often think that they are the flowers of a different species.

Dr. Howard Miles at the University of Central Florida has researched the possible medicinal uses of pitcher plants. At least one quite toxic chemical has been isolated; it is one of the substances that kills the insects as they fall into the pitcher. This same chemical is found in hemlock, the infamous poison that killed Socrates.

In folk medicine the plants have been used sparingly. The most common use by the Indians was as a treatment for smallpox and as prevention against disfiguring smallpox scars.

Pitcher plant was thought to have certain magical powers. Cherokee Indians believed so strongly in these powers that they often carried it with them when they went hunting. Superstition held that the plant would attract game to the hunter and fish to the fisherman. Likewise, it was thought to attract girls when carried by an eligible young brave.

Name: Pitcher plant *(Sarracenia minor)*
Family: Sarraceniaceae
Description: Flowers and leaves are found separately. The flowers grow on a leafless stalk. They are approximately two inches wide and have five petals and five sepals. The pistil bears a style resembling an umbrella. The leaves are large and interesting. They are tubular and create an arching hood at the top. Reddish veins and pale spots can be found on the leaves. The leaves are six to twenty-four inches long, one side being distinctively longer and winged.
Blooms: April through June

Natural habitat: Found in swamps and bogs from North Carolina south to Florida.

Propagation and cultivation: Pitcher plants need acidic soil and constant moisture, as found in their natural habitat. They should be grown in full sun and the crowns should be placed just at the surface of the soil, above normal water level. Fertility of the soil seems not to be important. Plants can be divided in early spring.

Queen Anne's lace
(Daucus carota)

Common as a dandelion, prolific as kudzu, what kind of royalty are you? You, with your lacy white head and frilly leaves, putting on airs when everyone knows that you're just a weed. You show up in some of the most disreputable places, along dirty highways and in vacant lots, chaperoned only by crabgrass. A queen? Ha! Perhaps a gypsy queen, for a gypsy is just what you act like, running all over the fields, leaping fences, and climbing to the sky.

You become tall and lanky and almost always outgrow your welcome in polite company. But I suppose the friends you keep don't mind. They are just as rude and pushy as you. Creeping clover and climbing vetch are not exactly my idea of elegant playmates. You'd not last very long in a proper woodland court. Prince's pine and king's cure-all wouldn't give you the time of day. Dutchman's breeches ignore your kind. Jack-in-the-pulpit might try to help you mend your ways, but I doubt that you would listen.

No, without the wide open spaces and that garish sunshine to which you are accustomed, I imagine you would just wither away.

Yet, in spite of your wild and untamed ways, there is a touch of the beautiful about you. Your blossom is full of delicate detail, and each floret is exquisitely fashioned. The dark purple floret in the center of your blossom is a nice touch, a good accessory to show off your natural beauty.

And you do know how to age gracefully. What a marvelous idea, to transform yourself into one of those dear little bird's nest things. It makes you so useful for so long.

You are an exotic queen, far from your home in Afghanistan. Perhaps you just never learned how to conduct yourself in this your adopted home.

In spite of the fact that Queen Anne's lace tries to pass itself off as royalty, the plant actually has many redeeming qualities. The

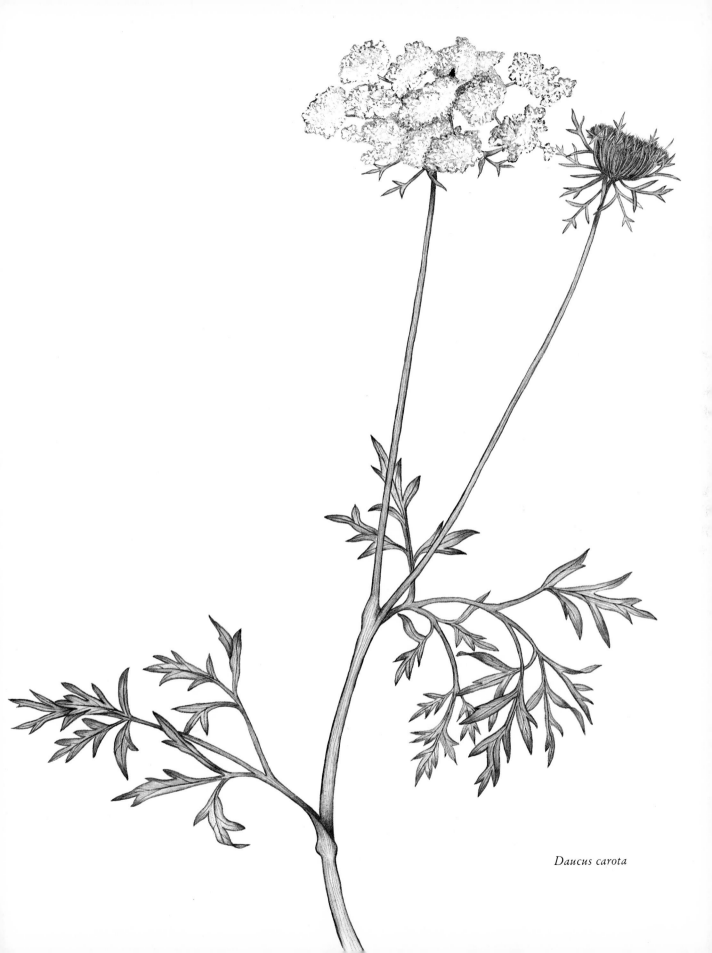

Daucus carota

blossoms make a wonderful cut flower that lasts a long time in an arrangement. The dried flower, or bird's nest, is also useful in a dried arrangement. The entire stalk, used with an alum mordant, makes a wonderful light yellow dye.

The delicate flowers press easily in a plant press, and the flat, dried flowers can be used for many purposes. They are perhaps most beautiful when made into sparkly Christmas tree ornaments. Take the pressed flower and cover it with a spray adhesive. Immediately sprinkle the blossom with gold or silver glitter. When it is dry, tie a narrow satin ribbon around the stem and hang the ornament on the Christmas tree.

Eating a bit of this plant was said to be good for "stitches in the side." The seeds, taken in wine, were said to aid conception. Queen Anne's lace root was grated, mixed with oil, and put on burned skin. The single center purple floret was eaten in hopes that it would cure epilepsy. (This single dark-colored flower is said to have appeared on the blossom when Queen Anne of England [1665–1714] pricked her finger while making lace.)

During a rainstorm, the stem supporting young blossoms becomes soft and flexible and bends, thus protecting the pollen from the rain. Stems supporting older blossoms that have already been pollinated do not exhibit this characteristic.

Queen Anne's lace is often called wild carrot because of its similarity to the cultivated carrot. The genus name, *Daucus*, is from the Greek *daukos*, which is a kind of carrot or parsnip.

Name: Queen Anne's lace *(Daucus carota)*
Family: Umbelliferae
Description: The fernlike leaves of this plant form an attractive rosette from which the multi-branched flowering stem arises. The blossoms are terminal umbels of many small white florets. The center floret is usually dark purple. After the plant blooms, the flower head curls upward and inward forming a "nest."
Blooms: June through August
Natural habitat: A native of Afghanistan naturalized throughout the region and commonly found in fields or along roadsides.
Propagation and cultivation: This is very easy to grow from seed. The seeds should be sown one-eighth of an inch deep in either spring or fall. Because it is a biennial, it probably will not bloom

until the second growing season. If frost does not come until late in the fall, however, it might bloom the first year. Although Queen Anne's lace tends to be somewhat aggressive, it can be controlled by not allowing it to go to seed. Once the plant is through blooming, pull it up or snap off the flowering heads before they set seed. Being a biennial, it will bloom only once anyway.

Spiderwort
(Tradescantia virginiana)

Spiderwort is a very ordinary looking plant. It has small purplish blue flowers and long, straight leaves. When it is found in a rich, moist environment, it grows lazy and lank, not even bothering to stand up straight. Although it has been hybridized to give us plants with slightly larger blossoms and less offensive foliage, it still remains a wallflower. It is a plant with so few outstanding characteristics that it is most often overlooked and underadmired.

There are hundreds of plants just like spiderwort. They are of no great beauty; they have no horticultural value and are generally insignificant. So of what good are they? How would the world be lessened by their disappearance? Why is it so necessary to try to preserve and maintain every species on earth?

There are a hundred spiritual and aesthetic answers to those questions. But there are also many practical reasons. Take, for example, the lowly spiderwort.

It has been discovered that spiderwort is quite sensitive to varying levels of pollution and radiation. When exposed to radiation, the plant responds by undergoing rapid mutations. These mutations cause the hairs on the stamen of the plant to change from blue to pink within just a few days. The number of cells that mutate is in direct correlation to the amount of radiation to which the plant has been exposed.

Spiderwort, then, became an efficient and speedy radiation detector and is in many ways superior to a mechanical counter, such as a dosimeter. Because spiderwort internalizes the radiation, it responds to much lower levels (around 150 millirems) than a mechanical counter can.

Spiderwort is also useful in detecting poisoning from herbicides, pesticides, and even auto exhaust fumes. Spiderwort is now being grown commercially for use as a detection device.

The importance of spiderwort, however, lies only partially in

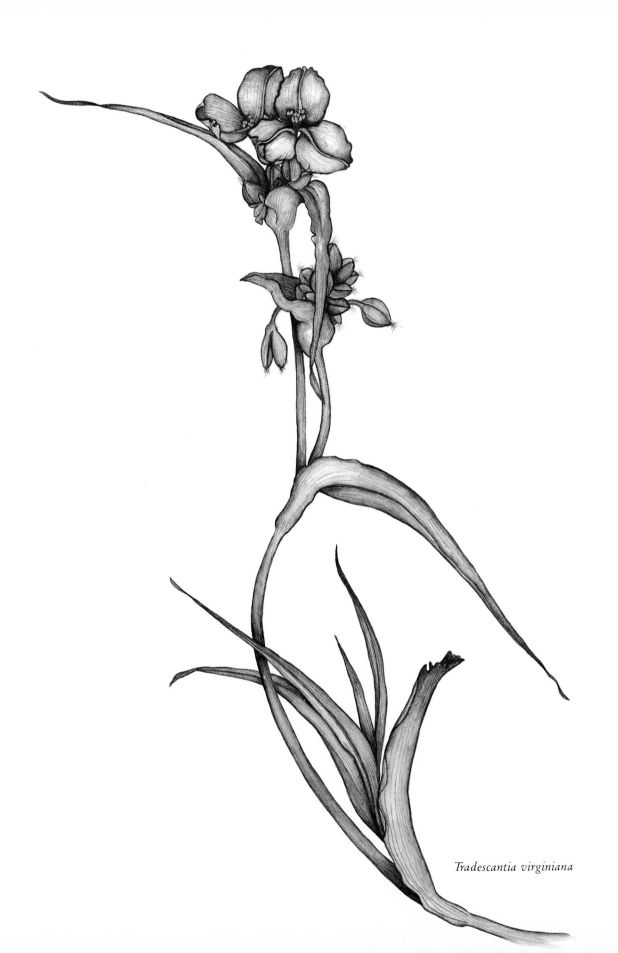

Tradescantia virginiana

its use as a detection device. Its primary importance is perhaps in the lesson that it teaches us about the potential value found in each wild species. A hundred years ago we didn't even know what radiation was, let alone predict that we would need a plant that could help us detect it.

As the world changes rapidly year after year, it is impossible for us to know what the needs of the future will be. Because of this, it is impossible for us to know which plant and animal species will be of vital importance to us. From a very practical and realistic standpoint, our very survival might be dependent on chemicals found within some unknown and obscure plant species. Already such chemicals have made tremendous differences in the fields of medicine, agriculture, and industry. It is to our own benefit, then, to fight hard to assure that we allow no species to become extinct.

In spite of its very modern usefulness, spiderwort is a very old plant. Historically, it provides a link between the ancient, simplistic plants, such as the sedges, and more complex modern plants, such as lilies.

Spiderwort received its name because the leaves are long and slender and somewhat twisted at the joints, something like spider's legs. Based on the doctrine of signatures (see page 64), spiderwort was sometimes used to treat spider bites.

Other common names, including Moses-in-the-bulrushes and widow's tears, refer to the enzymatic action within the plant. This causes the dead flowers to turn into a runny blob instead of becoming dry and brittle.

Name: Spiderwort *(Tradescantia virginiana)*
Family: Commelinaceae
Description: The plant grows to a height of twelve to twenty-four inches and has long, narrow leaves that have a lengthwise fold. The blossoms are made up of three purple petals, all the same size, and conspicuous yellow stamen. The stem is somewhat hairy.
Blooms: April through July
Natural habitat: Commonly found along roadsides and in open woods or borders from Virginia to Georgia and Tennessee.
Propagation and cultivation: Ideal growing conditions for this plant include moist, well-drained soil and full sun, but it is quite adaptable to less than perfect conditions. It will grow easily from seed or plant division.

Sunflower
(Helianthus annuus)

*(Adapted from **Song of the Seven Herbs**, by Walking Night Bear and Stan Padilla)*

*T*he Great Creator made the Earth and all the flowers and plants and people upon it. The Creator loved his people, and they in turn loved him. But they were imperfect and soon began to stray from the Path of the Good Spirit and Light. The Creator became very sad and knew that He would have to teach His people a lesson.

He filled the blue sky with thick, dark clouds so that the sun could not shine on the Earth, and then He caused it to rain. It rained for many, many days, and the Earth was full of water. The plants and animals began to drown, but still it rained. Finally, there were only a few people and animals and plants left.

During all of the rain the Sun stood still in the sky. She loved the Earth and was sad that she could not send her heat and light to help it, but she knew that the Creator was wise and good. She also knew that when it finally quit raining, she would have a tremendous job to do in drying up all the rain and making things grow again.

It finally quit raining, and the Sun shone through the clouds and the Earth began to recover. But the Earth was so wet that the Sun soon became exhausted. She became worried because she could not do her job fast enough and there was nothing for the people and animals on Earth to eat.

Her friend Bright Light saw how sad and worried the Sun was, and she wanted to help.

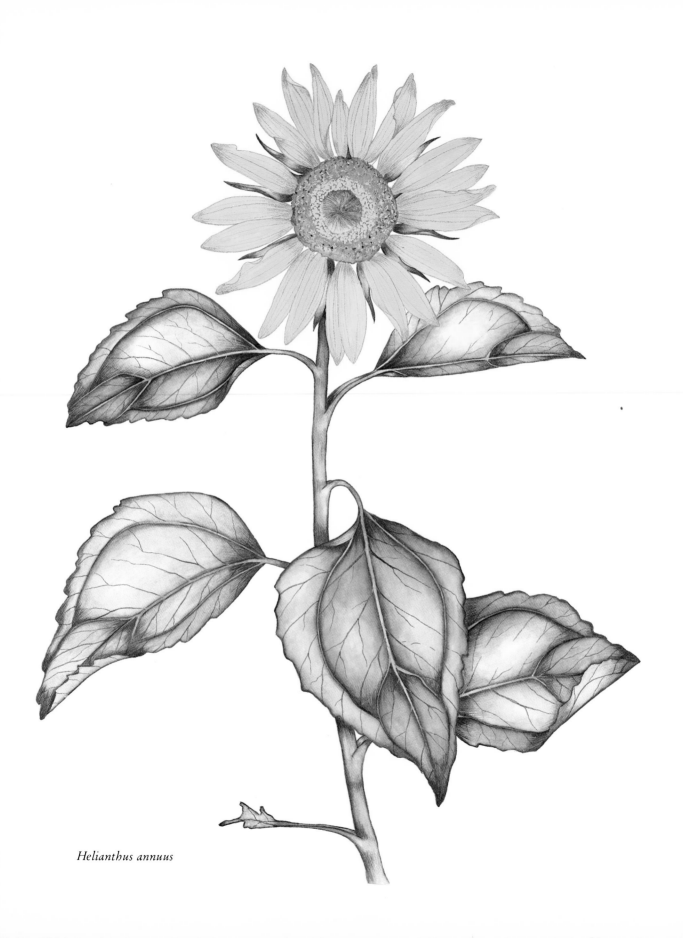

Helianthus annuus

"My light is not strong enough to reach the Earth from here," she told the Sun, "but I could go to the Earth and help from there."

The Sun shook her head. "No, if you go to the Earth, you can never come back," she told Bright Light.

But Bright Light was determined to help and begged the Sun to let her go. The Sun eventually called the Great Creator and explained the situation to Him. The Great Creator looked at little Bright Light and saw the goodness in her heart.

"You may go to Earth to help, but let me change you, for you can never come back. You will be the tallest flower on Earth so that you can always stay close to your friend the Sun."

And the Great Creator changed her into a seed that He carried to the Earth and gently buried in the ground. Soon the seed began to grow into a tall and beautiful plant, and she produced a huge flower that looked like the sun itself. The plant gave the people roots and leaves and seeds to eat, and the people were thankful. They called her Sunflower, and this made Bright Light very happy.

But still she missed her friend the Sun, and every morning when the Sun comes up in the sky, Sunflower turns her face to greet her. All during the day as the Sun makes her way across the sky, Sunflower turns with her, watching throughout the day until evening when the Sun finally goes to bed. Sometimes in the early morning you will find a few tears on the face of the Sunflower, for she misses her friend. But soon the Sun dries the tears, and Sunflower is happy once again.

Carlton B. Lees suggests in *Wildflowers Across America* that the sunflower is the "consummate American plant: tenacious, brash, bright, open, varied, optimistic, and cheerful, it might well be considered the true American flower."

Sunflowers are economically important worldwide, the only plant originating in the continental United States that is considered so. Oil from the seeds is used in cooking, canning, and making paint pigments.

Use of the sunflower dates back to North America before the white man arrived. Indians ground the seeds into meal and flour and used the seeds' oil. Leaves and stalks made good fodder, and fibers from the stalks were used to make cloth. Dried leaves were smoked like tobacco, and even the seed husks were ground and made into a coffee-like drink.

In South America the Incas worshipped the sunflower as a symbol of the sun. Priestesses from the Sun temple were adorned with large sunflower-shaped medallions made of gold. Spanish explorers brought sunflower seeds back to Europe, where they were soon hybridized and became economically important.

Name: Sunflower *(Helianthus annuus)*
Family: Compositae
Description: The outstanding characteristic of this plant is its size. It gets to be quite large, sometimes as tall as eight feet. The blossoms are also gigantic and can measure as much as twelve inches across. The leaves are three to twelve inches long and look almost triangular.
Blooms: July through November
Natural habitat: Occurs frequently along roadsides or in abandoned fields throughout the area.
Propagation and cultivation: Sunflowers grow easily from seed planted in average soil. They need full sun and ample moisture, particularly the taller hybrid plants.

Turk's-cap lily
(Lilium superbum)

Stately and royal, this lily is beloved by princes and paupers alike. Never was a brown freckled face so admired, so loved for its exquisite beauty. The lily stands proud in its swampy kingdom, lord of all it sees. Turk's-cap lily is taller by far than the surrounding plants and stands as haughty and proud as a king. Yet, the flowers themselves nod slowly in the breeze, quietly acknowledging the praise the plant is due.

Upon a single stalk, Turk's-cap lily can produce as many as forty flowers, each exquisitely detailed in its perfection. The blossom is a ballet in motion. As if in answer to a beautifully choreographed dance, each orange-red petal arches backwards to meet again behind the blossom. The strong male anthers thrust forward and for a while take center stage. Underneath the blossom at the base of each flower segment, a perfect star is formed where they come together.

We are not alone in our love and admiration for the lily. This plant and its cousins have been cultivated for over five thousand years. Evidence indicates that early civilizations in the Tigris-Euphrates Valley cherished the lily just as we do today. One of their cities, Susa, was even named for the lily.

Tiger lily grows abundantly in Korea, and there it is beloved, not only for its beauty but also for its delicate flavor. So great is the beauty of the Oriental lilies that plant collectors risked life and limb to gather them. An American plant collector, Ernest Wilson, went to China in 1910 to find, among other things, the royal lily. This plant was known to grow only in the high mountains of China, and climbing the slopes was quite treacherous. But Mr. Wilson was a determined man and, even when the climb became very dangerous, continued his quest for this exquisite flower. He did find hundreds of the plants growing in crevices along the mountainside. After he had collected many bulbs, a landslide suddenly transformed the

mountain into a swirling mayhem of dirt and rocks. Ernest Wilson was swept a hundred feet before he reached safety. He escaped with his life but had a very badly crushed leg—and several of the lily bulbs.

Native bearers fashioned a rough splint and set the leg so badly that when Mr. Wilson returned to civilization he was told the leg would have to be amputated. He refused, wanting to wait until he returned to America. When he did return home, surgeons were able to reset the leg. Although he walked with a limp the rest of his life, he was able to continue his plant explorations around the world.

According to Greek myth, lilies were created when Juno was nursing her son Hercules. Drops of milk fell from the sky. Some of these stayed in the heavens, creating the Milky Way, and some fell to earth, creating lilies. In Rome lilies were called Juno's rose, or *Rosa junonis*.

Lilies have been used a great deal as medicine. Roman soldiers carried lily bulbs with them to treat corns and sores on their feet. Lily seeds were thought to cure snakebite, and lily and yarrow, taken together, made a treatment for burned skin. Lily bulbs and honey, applied to the face, were thought to remove facial wrinkles.

Lilies are considered a symbol of motherhood. Ancient superstition suggests that if you offer a pregnant woman both a lily and a rose, her choosing a lily means the baby will be a girl, while her choosing a rose means the baby will be a boy.

People once believed growing lilies in the garden kept evil spirits away.

Name: Turk's-cap lily *(Lilum superbum)*
Family: Liliaceae
Description: This beautiful wildflower has a tall (three- to seven-foot) stem with many blossoms. Each blossom droops gracefully and has strongly reflexed orange petals and petal-like sepals. These are often spotted brown towards the center. A green star can be found at the base of each blossom. The stamen are large and have showy brown anthers. The leaves are two to six inches long and can be alternate or whorled.
Blooms: July through September

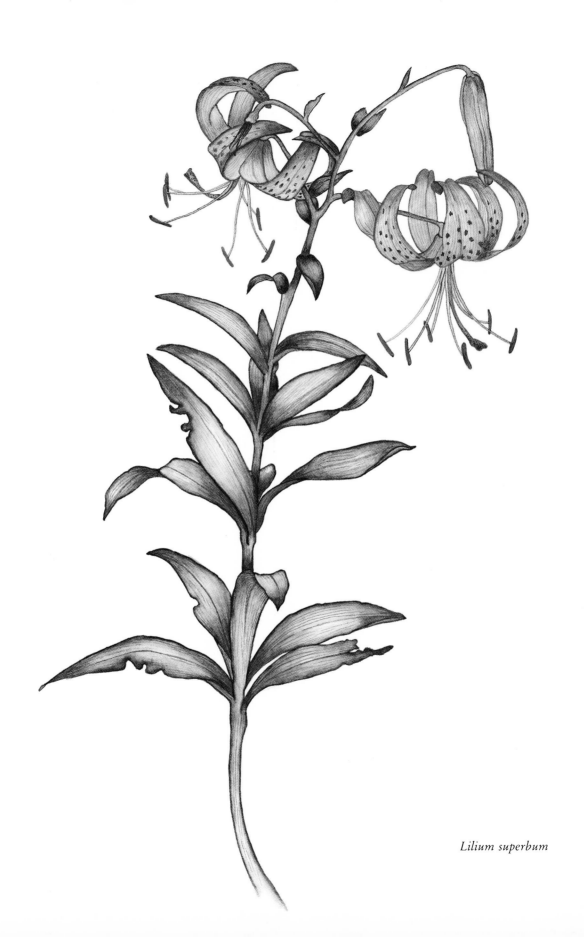

Lilium superbum

Natural habitat: Found in our range from Virginia south to Georgia and Alabama. It prefers moist areas, wet woods, swamps, or mountain coves.

Propagation and cultivation: Lilies need several hours of sunlight daily to bloom well. In addition, rich, well-drained soil is essential. The lily bed should be dug to a depth of twelve inches or more and then treated to generous amounts of organic material. The tall plants also need protection from winds so will do best if planted near shrubs or a wall. Lilies are not easy to propagate and sometimes take as long as five years to develop into a flowering plant. Consequently, they are often rather expensive. Be sure that you buy native lilies from a reputable source and that they have not been dug from the wild.

Vetch
(Vicia dasycarpa)

I am addicted to pink flowers. I've tried to kick the habit and have actually introduced different colored flowers into my garden, but to no avail. I know that pink is a little girl's color. Grownups who prefer pink are, according to psychologists, often spoiled and frivolous. They love luxury and like to be taken care of.

This hardly fits my image of myself as an independent Mother Nature type of woman. But that can't be helped. No matter what my image is, no matter what the psychologists say, I still love pink.

Whenever I have a choice, whenever the occasion presents itself, I always choose pink flowers over any other color.

I like solitary pink flowers just fine. To me, a single pink rosebud is the epitome of grace and refinement. But nothing can compare to an entire field of pink flowers.

Early in June I head north to the mountains to find my field of pink, and rarely am I disappointed. At this time of year vetch bursts into bloom and colors my world a delicious pink. Often there is a bit of purple thrown in, and sometimes the flowers look more white than pink, but no matter. The overall effect is pink, pink, pink, and I love it.

I am not alone in my love of vetch, for the bees flock to it as if it were ambrosia. Farmers also love vetch, though not for its beauty or its sweet nectar. Vetch, a member of the legume family, is often planted as a green manure crop and is tilled under before it blooms. The roots contain nitrogen-fixing bacteria and greatly increase the nutrients in the soil.

Vetch was used in Europe as a forage plant for cattle. So strong was the growth of this plant there that country folks used to say "A vetch will go through the bottom of an old shoe." It was brought to North America as a forage plant, but soon escaped from the confines of the fields and gardens and naturalized throughout the Southeast.

217

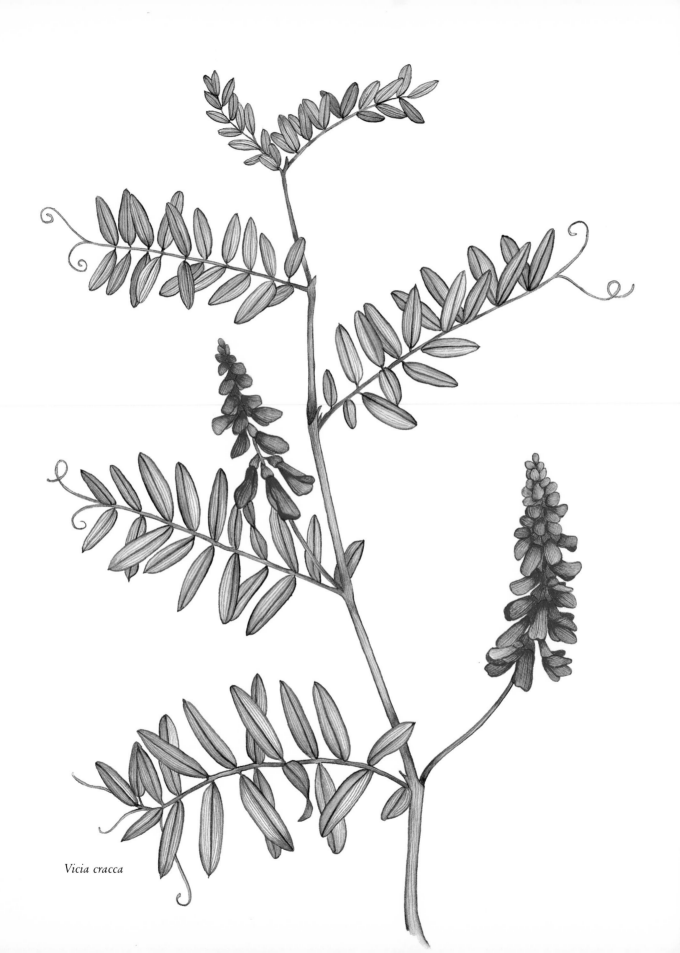

Vicia cracca

Indians quickly found various uses for the plant. They ate the tender young stems in early spring and used the seeds as flavoring for meats and soups. Cherokee Indians used vetch externally to relieve backaches and stomach cramps. It was also rubbed on the body to relieve muscular cramps and twitching. Mixed with sweet everlasting, vetch was made into a tea used to treat rheumatism. Indians mixed vetch with Virginia pine and apple juice to make a drink given to ballplayers during a game to help their wind.

Name: Vetch *(Vicia dasycarpa)*
Family: Leguminosae
Description: The leaves are pinnately divided into six to eight pairs and are characterized by tendrils or hairlike extensions at the ends of the leaves. The flowers are pinkish purple with white wings on each side.
Blooms: April through September
Natural habitat: Found in disturbed areas and roadsides throughout the region.
Propagation and cultivation: Although vetch is sometimes planted as a green manure crop, most species are considered too invasive and aggressive to be used as a satisfactory garden flower.

Water lily
(Nymphaea odorata)

The Biological Station at Highlands, North Carolina, is a favorite spot of both lay and professional plant people. Although the name is a bit forbidding, the lovely trails are full of some of the South's most beautiful wildflowers. The small nature center building is generally full of visitors, many of whom are children, crowded around the honey bee display or perhaps staring eye to eye (through a glass) with one of the resident snakes.

Paths wander through the woods, and plants near the trail's edge are all neatly labeled with the botanical and common names. Due to the concerted efforts of botanists over the course of years, many common and some quite uncommon southern wildflowers now grow in these woods.

Several of the trails lead to the lake and bog area, and as the ground becomes uncomfortably soggy, a boardwalk keeps your feet dry but still allows you a close encounter with some very unusual water-loving plants.

In spite of the fact that there are many more interesting plants growing close by, it is the common water lily that receives the most attention in the bog area during summer. Sheer numbers create a stunning visual effect. Imagine, if you can, a thousand lightly tinted perfect blossoms gracefully floating on the surface of the pond. Dragonflies dart from blossom to blossom, dancing a minuet to the slow rhythm of the swamp.

Water lilies are considered very primitive flowering plants and lack the sophisticated reproductive features characteristic of many other flowers. Water lilies are also very ancient. To date, the oldest fossil record of pollen, dating from 140 million years ago, is from the water lily.

Although its reproductive features may be primitive, the leaves of the water lily display fantastic feats of plant engineering. The underside of the leaf of a giant water lily consists of a series of ribs

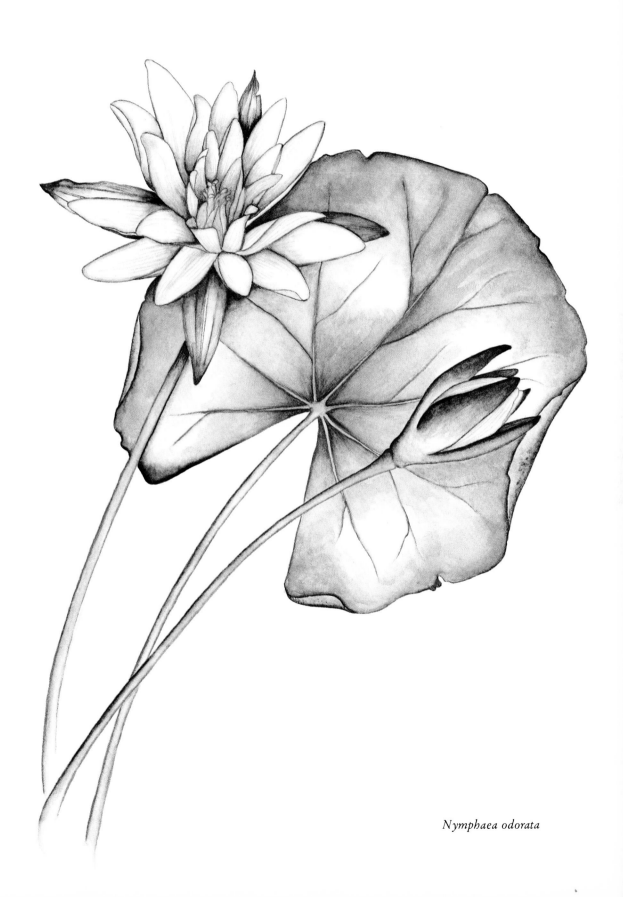

Nymphaea odorata

and air pockets that serve to keep the huge (six to seven feet across) leaf afloat. So efficient is this engineering, these gigantic leaves can support the weight of a small child. Because of its unusual strength, the lily pad has served to inspire architects of modern skyscrapers, so "Your pad or mine?" takes on new meaning.

Unlike many water-dwelling plants, water lilies are rooted in the muck at the bottom of the bog or pond. To get air to the submerged roots, the plant has developed very long stems with large channels.

Flowers of this common southern water lily are very fragrant, thus the botanical name *Nymphaea odorata*. The genus is named for the Greek nymphs, who lived in streams and ponds, the natural habitat of the water lily.

Fresh young growth from the plant is edible. The leaves and flowers, before they open, may be boiled in salted water and served with butter. North American Indians ground the seeds into flour and sometimes popped the seeds like popcorn.

A concoction made from the water lily was used to cool an overactive sexual drive. Gathered at night with great ceremony and the correct magical chants, water lilies were thought to be effective charms against witchcraft.

Water lilies, bruised and steeped in milk, have also been used to keep away beetles and cockroaches. The smoke from burning the rootstock is also thought to keep away crickets.

Medicinally, water lilies were used to "settle the brain of a frantic person," and syrup made from the flowers was thought to help one rest better. A tincture made from the blossoms and water was thought to be effective in ridding one of freckles, spots, and sunburn, and a special concoction made from the plant was thought to cure baldness.

In Holland a popular superstition said that a child who fell into the water with his arms full of water lily blossoms would be prone to fits.

Name: Water lily *(Nymphaea odorata)*
Family: Nymphaeaceae
Description: Large white or pink flowers are three to five inches across and have many narrow petals and numerous yellow stamen.

The plant floats on water and has large leaves that are shiny on top and purplish red underneath.

Blooms: June through September

Natural habitat: Commonly found on ponds and lakes throughout our region.

Propagation and cultivation: Water lilies can be grown in deep, fertile mud in slow-moving water. Divide the rootstocks in late September and replant divisions immediately. It might be helpful to protect the young plants from muskrats by placing screening around them.

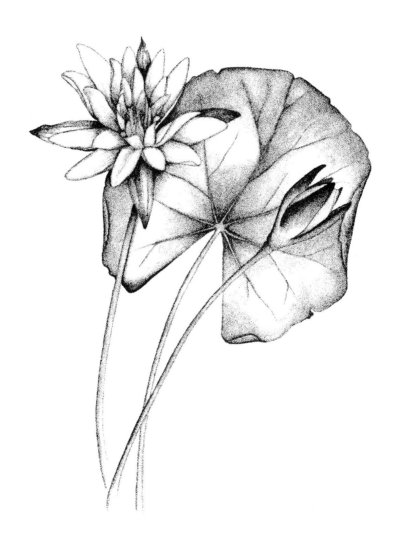

Yarrow
(Achillea millefolium)

*(Adapted from **The Song of the Seven Herbs**, by Walking Night Bear and Stan Padilla)*

*T*here once lived a very peaceful tribe of Indians. Plenty of game filled their bellies, and good, clean water quenched their thirst. They were seldom sick, and they were a very happy people. Because they were so healthy and happy, the medicine man had very little to do and spent much of his time with his young grandson, teaching him about the healing herbs.

The time came, however, when a strange sickness came upon these good people. Some said that the sickness was caused by a neighboring medicine man who was jealous of their happiness. Others said the Great Spirit was angry with them. Whatever the reason, however, all of the people became very sick.

The old medicine man became so weak that he was unable to collect the plants he needed to cure his people. He called his young grandson to him and told him to go high on the mountain to find the ferny leafed plant that would cure them all.

The young boy was ill himself but knew that the tribe was depending on him. Slowly, he walked up the mountain, but by the time he was at the top where the plant grew, the sun had set and darkness was all around. The young boy knew that if he waited for the morning that his grandfather might die, so he began looking for the plant in the dark.

But the darkness was too black, and he could not see anything.

He knelt in the darkness and called to the Great Spirit for help. When he rose from his knees, the stars became brighter and brighter until they seemed to explode. Suddenly, tiny star lights were all around him. These lights did not fall all the way to the ground, however, but landed on the ferny leaved plant that would cure his people.

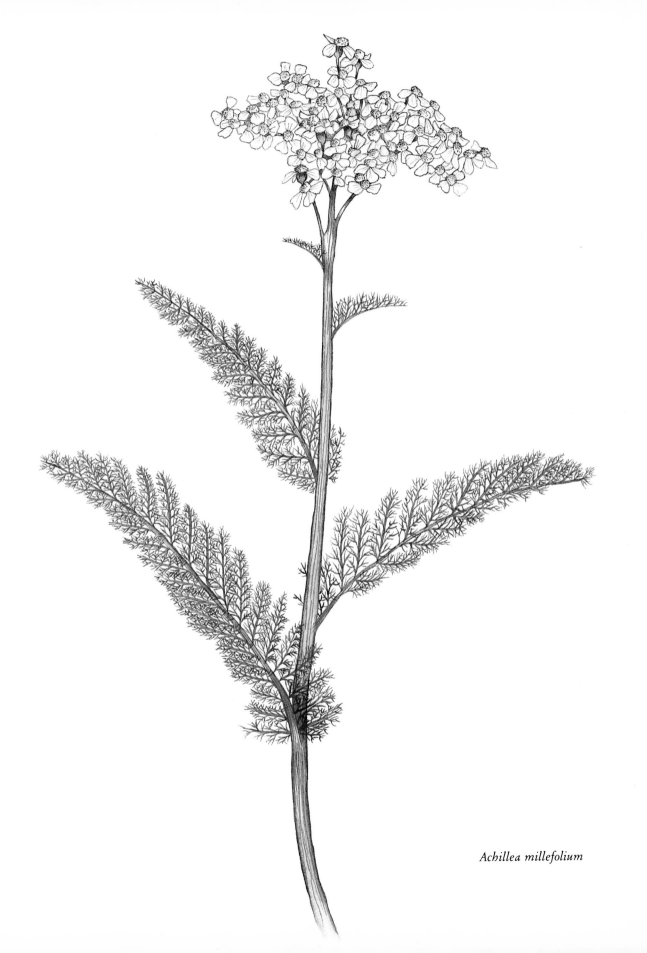

Achillea millefolium

The boy quickly gathered the plant and took it to his grand-father. The grandfather was pleased that the boy had found the right plant but was amazed at the small star-shaped flowers that still clung to it. Even now, we can still find these soft white lights on the plant we call yarrow.

Fossils of yarrow have been found in Neanderthal burial caves dating back sixty thousand years, suggesting that this plant served some purpose in ancient burial rituals. In more recent history, yarrow was used during the Trojan War. Achilles is said to have used it to treat his wounded comrades. The genus name, *Achillea*, honors this ancient Greek hero.

The medicinal use of yarrow continued into the Middle Ages when monks used the plant extensively. It was known as allheal, and decoctions made from it were used to treat an amazing number of ailments. Navajo Indians called it the "life medicine" and used it as a general spring tonic. According to *Rodale's Illustrated Encyclopedia of Herbs*, forty-six different native American Indian tribes used yarrow, finding twenty-eight separate medicinal uses for the plant.

The plant was also thought to contain magical powers and was included in many different kinds of amulets. Witches included yarrow in several of their magical brews.

Dried yarrow keeps its color and shape well, making it useful for many kinds of crafts. As a dye, yarrow imparts an olive color if the entire plant is used with an iron mordant.

Name: Yarrow *(Achillea millefolium)*
Family: Compositae
Description: Attractive fernlike leaves are finely dissected and aromatic. The blossoms are white or cream-colored and occur in clusters at the tops of the stems. The plant generally grows to a height of one to three feet.
Blooms: June through September
Natural habitat: Occurs in fields and grassy places throughout the region.
Propagation and cultivation: Yarrow spreads easily by means of underground runners. The plant can be divided in spring or fall and will quickly take root in a new location. It is a highly adaptable plant and will withstand a variety of soil and moisture conditions. It will perform best in full sun.

Aster
(Aster novae-angliae)

The time between summer and fall is marked by change, and nature celebrates this change by redecorating the earth. Trees gradually shed summer's dark green suit for autumn's vibrantly colored wardrobe. Underneath this brightly colored canopy, fall wildflowers tentatively show their heads. As summer flowers retreat and go dormant, fall flowers grow bolder until finally one by one, they blossom into such beauty that summer petals become merely an echo of past grandeur.

In the *Sand County Almanac* Aldo Leopold writes of plants and how they appeared on the prairie: "During every week from April to September there are, on the average, ten wild plants coming into first bloom. . . . No man can heed all of these anniversaries; no man can ignore all of them. He who steps unseeing on May dandelions may be hauled up short by August ragweed pollen. . . . Tell me of what plant-birthday a man takes notice, and I shall tell you a good deal about his vocation, his hobbies, his hay fever, and the general level of his ecological education."

I wondered, as I picked the first aster of the fall season, what Mr. Leopold would guess about my hobbies and ecological education. I always celebrate the aster birthdays. They are the first sign that fall is around the corner, the first hint that the stifling heat of summer just might come to an end one more time.

Not all asters bloom in the fall. Many species begin to bloom during mid-July. A somewhat confused New England aster in my meadow always starts blooming in early June and continues to dribble sporadically forth a few blossoms every week until frost.

In England asters are called Michaelmas daisy because they are almost always in bloom on St. Michaelmas Day, September 29. This is primarily an English celebration in the Christian church, honoring the archangel Michael.

According to Greek legend, asters were created from stardust

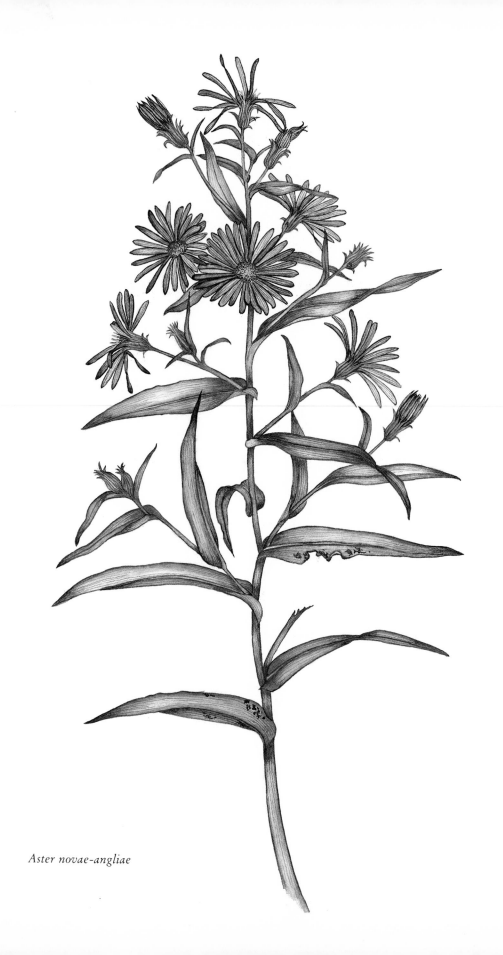

Aster novae-angliae

when Virgo looked down from heaven and wept. Where his tears fell, asters began to grow. The word *aster* is from the Greek and Latin words for "star." Asters were considered sacred to all gods and goddesses, and wreaths made from the blossoms were placed in the temples on festive occasions. Considered the herb of Venus, asters were carried as talismans of love.

The Shakers used asters to make a lotion to clear their complexions. Ancient Greeks believed that asters, strewn on the floor of a house, would keep away serpents. Greeks also believed that boiling aster leaves in wine and placing the resulting liquid close to a hive of bees would improve the taste of honey.

Known as starworts in Germany, asters were used as an antidote for the bite of a rabid dog. In France asters were thought to hold magical powers and were burned to keep away evil spirits.

But the greatest magical power that the aster holds is as a messenger, letting us know that the cool and gentle breeze of autumn is blowing our way.

Name: Aster *(Aster novae-angliae)*
Family: Compositae
Description: This bushy plant has bright lavender ray flowers with gold disc flowers. The flower heads are small but occur in profusion at the top of the stems. The leaves are two to five inches long, have smooth edges and clasp the stem. Height is three to seven feet.
Blooms: July through October
Natural habitat: Grows in meadows, thickets, and swampy areas in our region from Maryland and Virginia south to Alabama.
Propagation and cultivation: New England aster prefers slightly acidic, well-drained soil. Though it will tolerate partial shade, it prefers full sun. It will perform best with moist, cool roots, so generous amounts of mulch applied during summer months will help. Plants can be divided every two to three years and, because germination of the seeds is generally quite low, division is the easiest means of propagation. Plant one to two feet apart in average soil. Too rich a soil results in lanky, sprawling plants.

Blazing star
(Liatris aspera)

Think of prairies, and you probably think of wide expanses of grasses and forbs. The image is probably one of mile upon mile of untouched prairie, the wind moving the grasses in undulating waves from one horizon to the next.

Think of prairies again, and this time think of small plots of land, vigorously guarded by enthusiastic conservationists. Unfortunately, this picture is much more accurate. Today's prairies are mere shadows of what they once were—remnants of a glorious past.

In 1839 J. Plumbe, Jr., wrote in his *Sketches of Iowa and Wisconsin*:

> The scenery of the prairie is striking and never fails to cause an exclamation of surprise. The extent of the prospect is exhilarating. The verdure and the flowers are beautiful, the absence of shade, and consequent appearance of light, produce a gaiety which animates the beholder. The whole of the surface of these beautiful plains is clad, throughout the season of verdure, with every imaginable variety of color, from grave to gay. It is impossible to conceive a more infinite diversity, or a richer profusion of hues or to detect the predominating tint, except the green, which forms the beautiful background, and relieves the exquisite brilliancy of all the others.

Where did these prairies go? What happened to the "gaiety which animates the beholder"? For the most part they are gone, victim to the steady march of progress. In the 1880s tile drainage transformed vast prairies into ordinary farmland, and people flocked to the area to take advantage of this land of milk and honey.

But what a pity that only small pieces of prairies are still standing, leftover crumbs to a world hungry for the beauty of

232

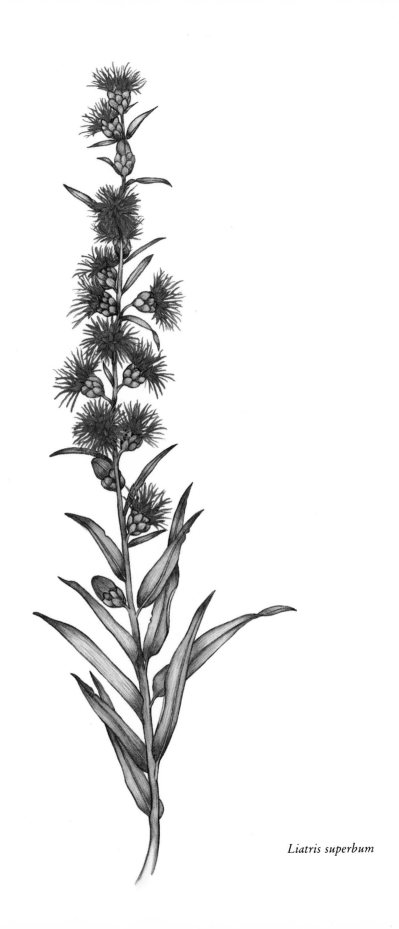

Liatris superbum

wilderness. Bits and pieces of prairies today are tragic but welcome reminders of a lost heritage.

Not all original prairies covered vast expanses of land. Along the coast of Louisiana, stretching into Texas and partially into Mississippi, is a narrow band of Gulf coastal prairie. Possibly a result of successive rises and drops of the ancient Gulf seas during the late Pleistocene age, this somewhat misplaced prairie land originally covered about eight million acres. Today only several hundred acres are left, tucked in between highways and railroad beds.

But the diversity of plant material in these prairie remnants is astounding. Dr. Charles Allen of Louisiana State University has studied a ten-acre plot and found between four and five hundred different plant species within this small area.

Grasses such as little blue stem, big blue stem, Indian grass, and switch grass provide a marvelous backdrop for colorful wildflowers. Purple coneflower, compass plant, phlox, and blazing star are just a few of the flowers that provide an unending display of color.

Four species of blazing star are prevalent in this prairie area. The most beautiful and outstanding species is *Liatris pycnostachya*. *Liatris* is a member of the daisy, or composite, family. But unlike most members of this family, *Liatris* has no ray flowers. All of the rose-purple disc flowers crowd along a straight stalk, each pushing and shoving for attention. As if there were no room for them elsewhere, long styles extend far beyond the petals. This sometimes makes the plant look light and feathery, and for this reason it is often called gay feathers. Another name for this plant is button snakeroot because it was used by the Indians to cure snake bites.

Corms of some species were sometimes stored for winter food but more often were used for medicines. Tea made from the corm was good for colic, and a tincture was used to treat backaches and pain in various limbs.

Liatris is wonderfully adaptable to the often harsh conditions of the prairies and plains. One way that the plant withstands long periods of drought is by sending out very deep taproots. One *Liatris* root was sixteen feet long.

But in spite of occasional uses for food or medicine, it is in the beauty of its flowers that the plant shows its true worth. These

rosy plumes are prairie gems, lovely mementos of past grandeur, bright jewels in today's postage-stamp prairies.

Name: Blazing star *(Liatris aspera)*
Family: Compositae
Description: Flowers are only three-quarters of an inch across but are crowded on a single flowering stalk. The blossoms are lavender and spike-like. The leaves are linear and measure four to twelve inches long. Lower leaves are generally longer and get progressively shorter higher up the stem.
Blooms: August through October
Natural habitat: Occurs from North Carolina south to Florida and west to Texas. It is most frequently found in fields or open woods.
Propagation and cultivation: Seed germination sometimes takes as long as six months. For faster propagation, divide mature plants as you would potatoes. Leaves one or two "eyes" with each clump of corms. Plant the corms one inch deep. These plants need full sun and well-drained, moderately rich soil.

Fringed gentian
(Gentiana crinita)

It was one of those incredibly beautiful fall days when colors ruled the world. The sky was a bright, vivid blue from east to west. No clouds marred the single perfection of this endless hue; no smog appeared to remind me of the reality of the twentieth century. It was a sky that went on forever, beckoning me to come closer, gently mocking because I am tied to the apron strings of Mother Earth.

Against this backdrop of flawless blue, brilliant yellow, orange, and scarlet leaves painted a portrait of autumn glory. Trees reached towards the sky as if to embrace it with their long, strong limbs. Then, as the sky remained unattainable, leaves gently floated back to earth in sad submission to the laws of gravity.

Into this world I wandered, shuffling at the feet of this grand color. My neck was stretched backwards, my eyes raised heavenward as I drank in the beauty of the autumn woods. But finally even heaven became too much, and my gaze returned to earth.

Remnants of spring woodland wildflowers were all around me. Yellowing leaves and blue-black berries of Solomon's-seal bore testimony to the grandeur of this once and future king. Dry, empty stalks of shooting star added a delicate beauty to the forest floor.

A sudden burst of blue caught my eye, and the brilliant beauty of fringed gentian lay confidently waiting for recognition. The gentians are among the last of all the wildflowers to bloom, craftily waiting until competition from other wildflowers is no longer a factor. With nothing else in bloom, gentians receive undivided attention and unabashed praise for their beauty.

Even if fringed gentian bloomed during the height of wildflower season, it would still receive a great deal of attention and praise. Striking blue color and delicately fringed blossoms make it one of our most beautiful wildflowers.

A Hungarian legend says that gentians came into being many centuries ago when a great plague killed many people. The king at

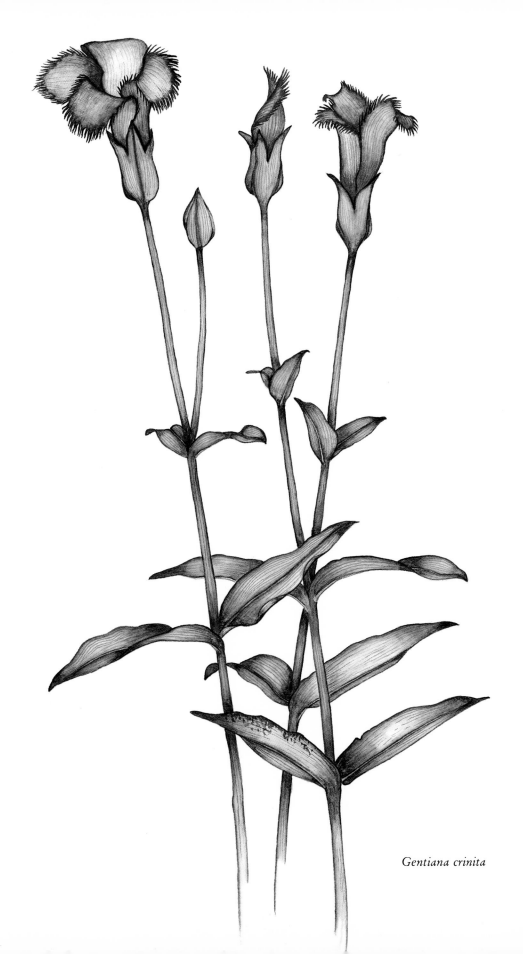

Gentiana crinita

that time was Ladislas, and he felt powerless to help his people. In desperation he finally shot an arrow into the air and prayed to God that the arrow would land on a plant that would help save his people. Legend tells us that the arrow landed on a gentian, and that this plant, indeed, saved many lives.

Many different kinds of gentians grow in our southern woods. Bottled, closed, fringed, stiff, and blind are all adjectives describing the different species and names by which they are identified.

Gentians are thought to have been named for Gentius, king of Illyria (the name of an ancient country on the shore of the Adriatic Sea). During the second century B.C. Gentius was not only king but also a skilled healer. He was well known for his use of gentians to treat digestive disorders.

The first medicinal use of gentians was actually much earlier, as they are mentioned on three-thousand-year-old papyrus scrolls found in an Egyptian tomb at Thebes.

In our own country, Catawba Indians made a compress of gentian leaves and applied them to relieve the pain of a backache. Early pioneers used a piece of gentian to flavor gin or brandy and then drank this as a tonic or to aid in digestion. In Europe many commercial aperitifs contain extract of gentian.

Name: Fringed gentian *(Gentiana crinita)*
Family: Gentianaceae
Description: Fringed gentian is considered one of our most beautiful wildflowers. It has strikingly beautiful blue blossoms. Each of the four petals is fringed on the end, and each blossom can be found at the end of the stem. The leaves are one to two inches long and pointed at the tip. The height of the plant is one to three feet.
Blooms: August through November
Natural habitat: Likes moist places and is generally found in wet woods or thickets south to Georgia.
Propagation and cultivation: Very difficult to grow from seed, gentian is much easier from nursery-grown stock. This is a biennial. Plants set out the first year will grow very little. The second year they should grow well and bloom, then die. To establish a colony of gentians, it will be necessary to put out plants for at least two consecutive years.

Goldenrod
(Solidago sempervirens)

There once was an old woman who was walking through the woods. She was dirty and haggard, her back bent and her fingers crooked with age. The hour was getting quite late, and the trees were casting long shadows, turning the woods into a dark and frightening place. The old woman was not strong, and she had walked a very long time. Finally, she felt that she could go no further without help.

Stopping, she looked around at the tall, straight trees around her. She turned to the nearest tree and politely asked, "Excuse me, please, but could you spare a nice, straight branch that I could use as a walking stick?"

The tree turned away, saying haughtily, "Go away, old woman. I will not throw down one of my branches for the likes of you!"

So the old woman walked slowly to the next tree and again asked for help. Again, the answer was the same, and as she asked tree after tree, each was too busy or too proud to give her any help.

At last she came to a small but sturdy weed. "Could you help me?" she asked wearily.

The weed answered, "I am not as tall as a tree, but whatever help I can give you, you are welcome to."

The old woman picked the sturdy stem and, leaning upon it, made her way out of the woods.

When she entered the meadow on the other side of the woods, the old woman suddenly changed into a woodland fairy. Turning to the weed she exclaimed, "Thank you, weed! You offered help when no one else did. Wish for whatever you want, and if it is in my power, I will grant it to you."

The weed thought for a long time and then answered, "I would like to be loved by children everywhere."

The fairy sprinkled magical dust over the weed until he was covered with gold. "There!" she said, satisfied with her work. "Not only will children everywhere love you, but anyone who carries a piece of you with them will find a golden treasure."

Today, we call that weed goldenrod, and even now many people believe that it will lead you to treasure.

Goldenrod was considered a very powerful healing herb for many years. The genus name, *Solidago*, means "to make whole" or "to heal" and refers to the reputed healing power of the plant.

Indian medicine men included goldenrod when preparing an herbal steam bath designed to steam all the evil spirits out of a person's body. They also made a tea from the leaves to treat urinary infections, and a tea made from the flowers was used to treat colic. A poultice made from the leaves was put on cut and bruised skin. Many contemporary folk healers recommend goldenrod tea for gas pains.

Goldenrod tea was more often drunk for its pleasant taste than for its medicinal value, however. During the Revolutionary War, after the colonists dumped imported tea into Boston Harbor, herbal teas were made from many native plants. One of the most popular was made from goldenrod; it was called liberty tea. It was so tasty that at one time it was even exported to China.

Early plant explorers sent native American goldenrod to England where the plants were enthusiastically received by gardeners. Many goldenrod species adapted well to the English climate and were soon considered an important part of the fall garden.

Contrary to popular opinion, goldenrod does not cause hay fever. Goldenrods are pollinated by bees and other insects, and the pollen is too heavy to be airborne. The real culprit is ragweed, which blooms at the same time, and has inconspicuous flowers with light, airy, irritating pollen particles.

Name: Goldenrod *(Solidago* species*)*
Family: Compositae
Description: There are more than eighty-five species of goldenrods native to the United States. Most of these are stout, sturdy plants with small yellow flowers occurring on gracefully arching stems.

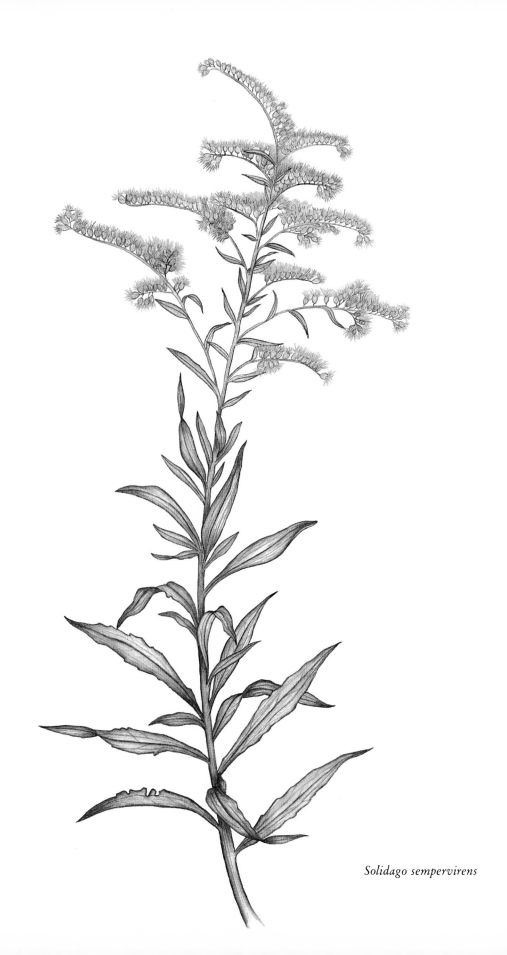

Solidago sempervirens

One of the most beautiful of all species is *Solidago odora*, scented goldenrod. It grows to a height of three feet and, when the leaves are crushed, gives off an odor similar to anise.

Blooms: Late summer through fall

Natural habitat: Found throughout our region in sunny areas with dry soils, such as roadsides and dry fields.

Propagation and cultivation: Goldenrods will generally tolerate relatively infertile soils but need full sun to flower well. The easiest means of propagation is to divide the plants in late winter or very early spring. When replanting the divisions, it is important to keep the leaves from lying on the soil, or the plant will rot. The germination rate from seeds is usually fairly low, so if you grow the plant from seed, make sure that you sow an ample number. Seeds can be collected when the seed head has turned an off-white color, indicating that the seeds are mature.

Ironweed
(Vernonia altissima)

Tall plumes of autumn flowers magically color the roadside a dozen shades of purple. Late asters sport light lavender circles that contrast prettily with their yellow centers. Joe-pye weed reaches out from swampy roots to robe the landscape in hues of dark green and mauve.

If joe-pye weed is the royal robe, then ironweed is the mighty scepter. Tall and straight as a sword, ironweed is conspicuously beautiful. Spikes of vivid purple arrogantly march along the roadside, daring any passerby to ignore their gaudy brilliance.

Ironweeds are not particularly social plants. They do not clump together gossiping like school girls but stand in solitary splendor, creating exclamation points of color in the fall landscape.

Although road travellers might appreciate the beauty of ironweed in fields and pastures, farmers who own these fields may not be quite as impressed. As the name implies, the stem of this plant is extremely hard, making it difficult to cut and remove from a field.

The genus was named for an English botanist, William Vernon, who did a great deal of botanical work in North America in the late 1600s. By 1698 he had developed an extensive plant collection in Maryland.

Ironweed was important to the Cherokee Indians for its medicinal properties. Both the leaves and root were used, most often in tea, but sometimes in a bit of alcohol as well. A decoction made from the leaves was used as a gargle for sore throats. Tea made from ironweed was thought to be particularly useful during pregnancy and childbirth. This was given to women to relieve afterbirth pains. The bruised roots, mixed with sneezeweed and made into tea, were thought to prevent menstruation for two years. The tea was also given to those suffering from stomach ulcers or hemorrhaging. For those with loose teeth, tea made from the roots and held in the mouth was thought to help tighten the teeth.

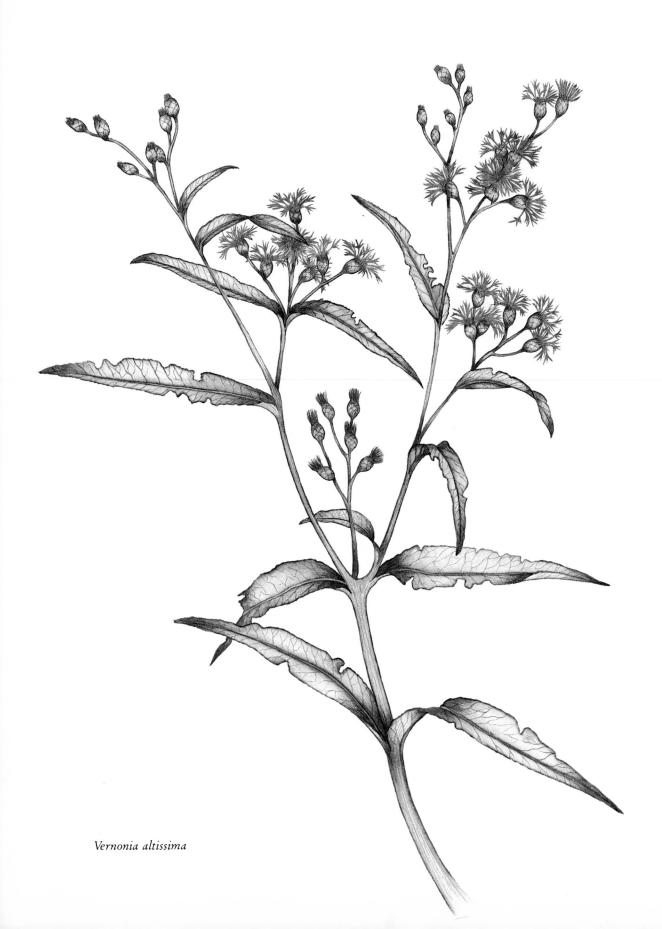

Vernonia altissima

A related species, *Vernonia galamensis*, grows wild in East Africa. The seeds of this plant have a high oil content, and this oil is made up of 73 to 80 percent epoxy acids, which are important in the plastics industry. Oil from this particular plant may prove to be of outstanding economic value.

Name: Ironweed *(Vernonia altissima)*
Family: Compositae
Description: Bright purple flowers make this an outstanding autumn wildflower. Ray flowers are missing, but each blossom is made up of thirteen to thirty lobed disc flowers. These are borne in loose clusters. The leaves are six to ten inches long and are somewhat hairy underneath. The plant grows three to seven feet tall.
Blooms: August through October
Natural habitat: Found in rich, moist soils in the region south to Georgia and west to Louisiana.
Propagation and cultivation: Ironweed needs moist soil but is adaptable to full sun or partial shade and a variety of soil fertilities. Constant moisture seems to be advantageous in growing this plant. It can be grown easily from divisions of mature plants in the fall. Stem cuttings taken in July also produce many new plants. Seeds can be gathered about a month after the plant blooms. These need a period of cold stratification, so store them in the refrigerator for a few weeks after they have been collected.

Jerusalem artichoke
(Helianthus tuberosus)

I'm really not much of one to go foraging for wild plants. I know that many of our wildflowers are edible, and some are even considered delicious. But I figure that most of these wildflowers have a hard enough time coexisting in this human-dominated world without my plucking and picking to see what they taste like.

When the plants are particularly common and abundant, I have no problems. I love dandelion salad and think that spring just would not be spring without at least one batch of violet jelly. There is one other plant that I consider a woodland staple, and that is Jerusalem artichoke.

The flowers look like a hundred other late summer and early fall yellow daisy-like flowers. Black-eyed Susans, tickseed sunflowers, true sunflowers, bur marigolds, and coneflowers fill the fields and line the roadsides.

But right there in the middle of them, looking very much like all the rest, is Jerusalem artichoke. It's not really an artichoke, but a member of the *Helianthus*, or sunflower, genus. And it's really not from Jerusalem, but is native to our region. (The name Jerusalem is actually a corruption of their Italian name, *girasole*, meaning turning toward the sun.)

The difference between Jerusalem artichoke and all the rest of the yellow guys is in its delicious root. Small, wrinkled, with a thin skin, the tubers may not at first look like the culinary treasure that they are. But boil, mash, bake, scallop, or eat them raw, and you will soon realize what a treat you have.

North American Indians have cultivated these plants for a long time, and their use was not restricted to the tuber. The yellow flowers were also boiled and eaten, though no one would argue that they are the taste treat that the tuber is.

Early settlers soon learned about Jerusalem artichokes, or sunchokes, as they called them. The plant was cultivated in

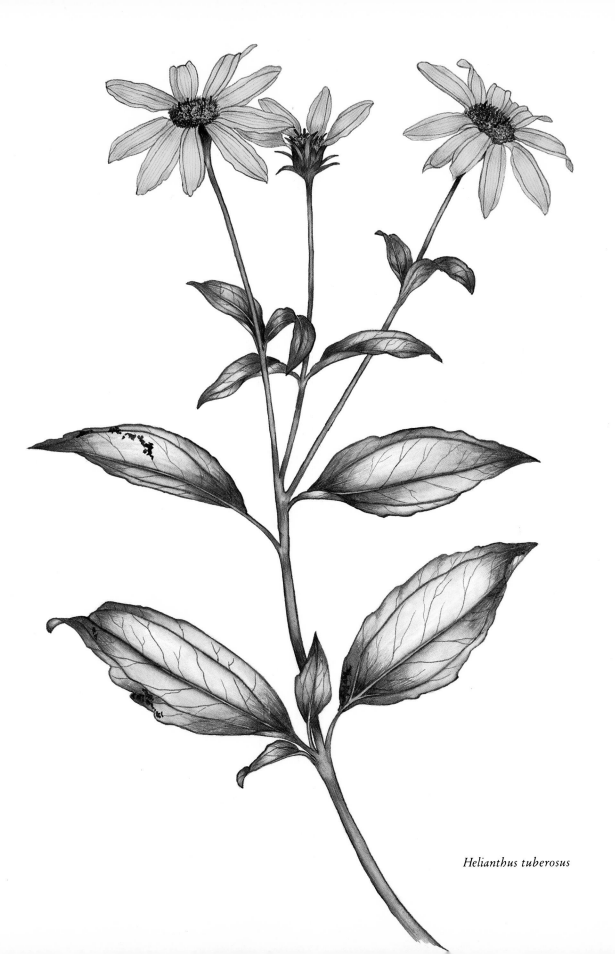

Helianthus tuberosus

Massachusetts as early as 1605 and first taken to Europe from Canada, where for some time it was called potatoes of Canada. John Parkinson, a British botanist, said of them that they were "dainty, fit for a queen."

Jerusalem artichoke can stand on its taste alone, but it has another unique characteristic that makes it even more special. Due to unusual action on the part of the plant, it stores all of its carbohydrates as insulin rather than as starch. This means that the tuber contains absolutely no starch and is extremely low in calories. In addition, it is an excellent source of potassium and thiamine.

When foraging for the tubers, it is easiest to identify and mark the plants while they are in bloom. The stalks are round and furry, the blossoms are somewhat smaller than those of the common sunflower, and the leaves are slightly more narrow. Flower centers are yellowish, and many blossoms are borne on branched stems. For positive identification, however, dig up one of the roots. Jerusalem artichoke is the only sunflower with this large, plump root.

Do not gather the tubers until the plant has quit blooming. While it is flowering, all of the plant's energy and resources go to the flower. It is not until the blossoms have died back and the plant begins to store energy in the roots once again that you will want to collect them for eating. The tubers last but a few days in the refrigerator before they spoil, so it is necessary to collect frequently during fall and early spring.

Jerusalem artichokes can be eaten many different ways. Commercially available products include a line of pasta made from the tubers of this plant. Billy Joe Tatum, in her book *Wild Foods Field Guide and Cookbook*, includes no less than fifteen different recipes using Jerusalem artichoke tubers. Some of the more interesting ones are hash-brown Jerusalem artichokes, Jerusalem artichokes in orange sauce, and sherried Jerusalem artichokes. Euell Gibbons, however, takes the cake for the most delectable recipe. His favorite is Jerusalem artichoke chiffon pie.

Although exotic recipes are fun and interesting, the tubers can be substituted in nearly any recipe calling for potatoes.

Name: Jerusalem artichoke *(Helianthus tuberosus)*
Family: Compositae
Description: This species produces bright yellow sunflower-like blossoms that measure three inches across. There are generally ten

to twenty ray flowers and numerous yellow disc flowers. The thick leaves are four to ten inches long and have toothed margins. It grows five to ten feet tall.

Blooms: August through October

Natural habitat: Found throughout the Southeast in sunny locations with moist soil.

Propagation and cultivation: Easy to grow, this plant needs full sun and prefers rich, moist soil. It may become leggy and weedy looking, but many people grow it for its flavorful root rather than its questionable beauty.

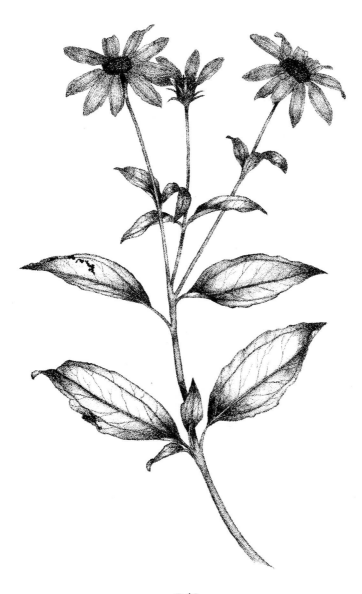

Joe-pye weed
(Eupatorium purpureum)

Tall, stately sprays of dusty rose flowers crowd along the stems of joe-pye weed. Although the wildflower is enormously tall, sometimes growing as high as ten feet, it does not seem to be overpowering. The blossoms are small, light, and airy, and on their stout stems the entire effect is one of a dainty, gentle giant.

If you happened to sneak up on this gentle giant early in the morning before the world is truly awake, you would find him laden with bumblebees. Perhaps the nectar is so sweet and rich that the bees have become groggy. Perhaps they find a safe and secure resting place in the flowery beard that this giant has. Whatever the reason, the fat black-and-yellow bodies of many bees can often be found peacefully snoozing until the sun wakes them and warms their small bodies.

Joe-pye weed likes to keep his feet wet and prefers growing in swampy land or on the banks of a river or stream. Drive drown the road during autumn and masses of the flower greet your eye and will easily point the way to wet spots in the landscape.

Although medicine men and folk healers played a vital role in the daily lives of both Indians and pioneers, rarely have they been remembered. Joe-pye was lucky, however, for the plant he used most often in his cures was finally named for him. Joe was an Indian medicine man who lived in colonial New England and was most famous for his use of *Eupatorium purpureum* for treating typhoid fever victims.

Both joe-pye weed and its close cousin, boneset *(Eupatorium perfoliatum)*, were used quite extensively for medicine. Soldiers during the Civil War were given boneset tea both as a treatment for coughs, colds, and fevers and as preventive medicine. Leaves and flowers were steeped in a large pot; then infusions were given by the teaspoon or sometimes even by the half-cup. Iroquois Indians used joe-pye weed to treat kidney disorders. Other tribes used

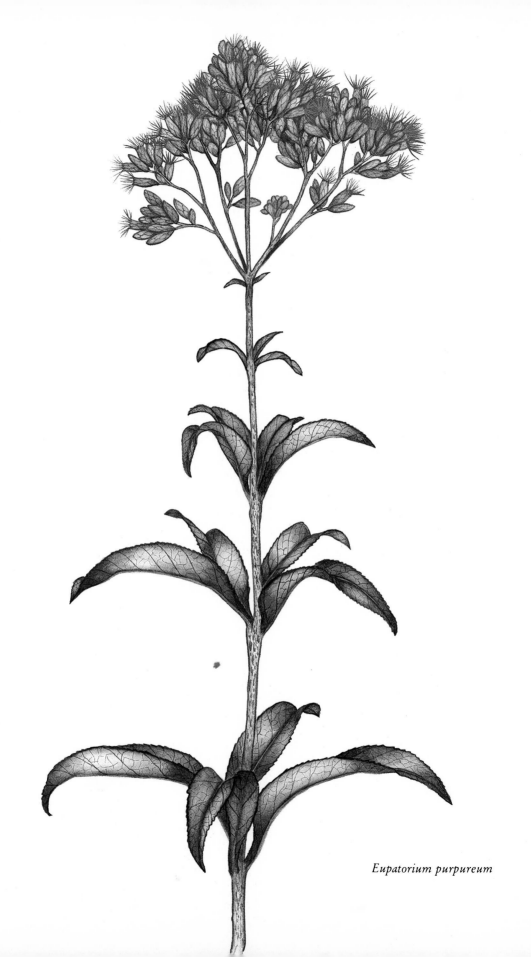

Eupatorium purpureum

decoctions made from the plant to improve the appetite and soothe nerves. Externally, the plant was used to clear the complexion.

An Indian brave who was courting a young woman often put a wad of joe-pye weed in his mouth before he went visiting. This supposedly gave him good luck in his endeavors.

The genus was named for Mithridates Eupator, who was a Persian general during the time when Rome ruled the world and few generals could fight the Romans and win. General Eupator had uncommonly good luck when fighting Romans which, he said, was due to the fact that he always carried a piece of this plant with him.

Unfortunately, although it has been reputed to be wonderful medicine, joe-pye weed contains no substances that have proven to be medicinally effective.

Known as queen of the meadow in southern Appalachia, joe-pye weed's greatest contribution today is as a tall, handsome sentinel standing guard over the fall landscape.

Name: Joe-pye weed *(Eupatorium maculatum)*
Family: Compositae
Description: Quite tall and stately, this plant often reaches a height of six to eight feet. The flowers are borne in loose terminal clusters and are a lovely mauve color. The stem is purple or spotted with purple. The leaves are two to eight inches long and occur in whorls of three to five.
Blooms: July through September
Natural habitat: Prefers wet places such as damp meadows or stream or lake banks. It grows in the Southeast from Virginia south to Georgia.
Propagation and cultivation: Seeds can be collected late in the fall and sown immediately. These will germinate the following spring. Established plants can be divided in the fall or early spring. These divisions should be replanted immediately and watered thoroughly. Space about three feet apart. Grow in full or filtered sun in moist soils.

Pipsissewa
(Chimaphila maculata)

"Whatcha drinking, Walter?"

The man looked down at the boy beside him. He had been janitor at the small school in the Tennessee mountains for more than thirty years. In all those years he had never come across a youngster with more curiosity than this one.

He took a sip from the steaming mug in his hands and answered, "Rat vein tea."

The boy turned to look at him in surprise.

"Aww . . . what is it really? Can I have a taste?"

Walter grinned. "Sure can, but I'm not kidding. It really is rat vein tea."

The boy sniffed at the mug and hesitantly took a small swallow. Then another and yet another as the pleasant herb tea warmed his small body.

He was full of questions. "Why do you call it rat vein tea? Is it really made from rats? Couldn't be, it tastes too good. What is it really made from?"

Walter laughed and held up his hand. "Hold it! One question at a time. Come back after school, and I'll show you how to make rat vein tea."

A few hours later the boy and the man left the schoolhouse and walked through the woods nearby. After a while Walter stopped and pointed to a small plant with waxy evergreen leaves, each with a center white stripe.

"There," he said, "rat vein. The Indians called it pipsissewa, and other folks call it wintergreen, but I've always known it as rat vein, and it makes up a mighty good cup of tea."

Together they picked a few leaves and took them back to the schoolhouse, where they made tea by pouring boiling water over the chopped leaves and letting the mixture steep for about five minutes.

253

What Walter knew as rat vein and the Indians called pipsissewa is a plant that carries a multitude of common names and an equal number of medicinal uses. Prince's pine, fragrant wintergreen, waxflower, and rheumatism weed are just a few other names that this attractive woodland plant goes by. The genus name is from two Greek words, *cheima*, meaning "winter," and *phileo*, meaning "to love." This refers to the fact that the leaves are evergreen and stay attractive throughout the year.

The Indians used it to treat many different ailments. The name pipsissewa comes from the Creek Indian word *pipsiskeweu*, which means "it breaks into small pieces," for they used the plant to treat kidney stones. Other tribes made a poultice from the leaves to heal blisters or reduce swelling in the legs and feet. Still others used it to treat backaches and sore eyes.

Pipsissewa was used most extensively, however, to treat kidney problems. Early settlers drank tea made from the plant to induce perspiration to break a fever caused by typhus. During the Civil War, soldiers used the plant to treat rheumatism. Pipsissewa was listed in the *U.S. Pharmacopeia* from 1820 through 1916.

The bittersweet taste of pipsissewa made it a popular ingredient in soft drinks. Until fairly recently this plant was a staple ingredient in commercial root beer.

For a small Tennessee farm boy, though, who grew up to be one of the South's leading botanists, pipsissewa would always remain "rat vein" and a cup of rat vein tea would always be welcome.

Name: Pipsissewa *(Chimaphila maculata)*
Family: Pyrolaceae
Description: Dark evergreen leaves have a startling white center midrib and white mottling throughout the leaf. The flowers hang in clusters on the same stalk as the leaves. The plant stands three to nine inches tall. The white or pinkish blossoms are somewhat waxy and fragrant.
Blooms: June through August
Natural habitat: Common in dry woods south to Georgia and west to Tennessee and Alabama.

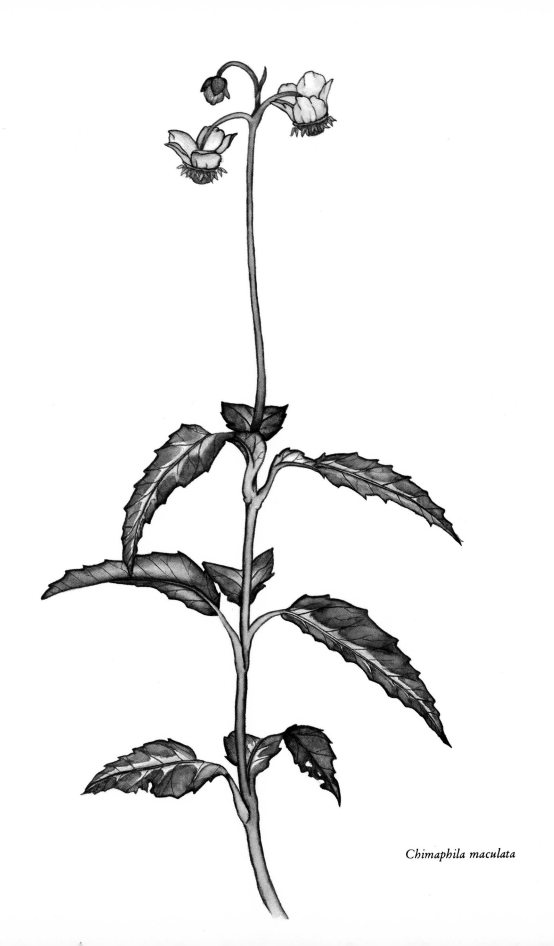

Chimaphila maculata

Propagation and cultivation: Within its natural range, pipsissewa is easy to grow in a wildflower garden. It prefers slightly acidic soil and light shade. This plant also does well in a terrarium. The seeds of pipsissewa are tiny and difficult to work with. A better way of propagating the plant is by taking stem cuttings during mid-summer.

Appendices

Planting a Wildflower Meadow

The concept of meadow gardening has earned much praise and publicity during the past several years. The idea of planting a bit of wilderness right outside the home is appealing to many people. Couple this with a low-maintenance landscape and an endless number of cut flowers, and the idea becomes more and more enticing.

It is possible to establish a sunny wildflower planting or a meadow in any region of the country, but southern meadows have a particular charm and appeal. In this region we are able to grow a good combination of annuals and perennial plants. The annuals will not reseed here as well as they might in some of the western areas, but the perennials usually grow and bloom quite well. To get yearly bloom from annuals, it will be necessary to reseed each year.

Although a meadow is considered low maintenance, it does take considerable time and effort to establish the area. Once established, however, an annual mowing and occasional weeding are all the maintenance necessary. The following steps should lead you to a successful meadow of your own:

(1) Choosing a site. Many places in the landscape can be easily transformed into a meadow garden. The primary requirement is that the site receive full sun—at least six to eight hours daily. Almost all of the plants traditionally grown in a meadow garden need this much sunlight to grow and bloom well.

It is not necessary to have wide expanses of land to create a meadow. My own meadow is within the city limits of Atlanta, Georgia, and covers only twenty-two hundred square feet. This is plenty big enough to supply me with cut flowers throughout the growing season and to give me a generous taste of wilderness.

Even smaller areas can be planted as a meadow. "Mini-meadows" or "pocket meadows" can be planted in a side yard or even in a portion of an existing lawn. If you are working with a small area, be sure that your plants are in scale with the site.

The majority of meadow plants are drought tolerant, but it will be necessary to get water to the seedlings until they get

established. Therefore, it is nice to place the meadow in an area where you can get water to it. If you are planting large expanses of land or plant in an area that is far from a water source, you might have to take your chances on rainwater. If it does not rain for several weeks after you sow your seeds and you can not get water to the site, you might have to start over the following year.

(2) Choosing plant species. Research at the Atlanta Botanical Gardens and other spots throughout the country has proven that plants native to or naturalized within a particular region will grow more successfully there than plants from another region or another country. For example, don't try to grow California wildflowers in a Georgia meadow. Some plant species, such as the California poppies, are so adaptable that they will grow in every region of the country. Other plants are so specific in their environmental needs that they will grow only within a very small area.

The following list is not designed to be a balanced meadow mixture. These are merely suggestions for plants that grow well in the Southeast in a meadow environment:

New England aster *(Aster novae-angliae)*
Butterfly weed *(Asclepias tuberosa)*
Bachelor's button *(Centaurea cyanus)*
Oxeye daisy *(Chrysanthemum leucanthemum)*
Calliopsis *(Coreopsis tinctoria)*
Coreopsis *(Coreopsis lanceolata)*
Coneflower *(Dracopis amplexicaulis)*
Purple coneflower *(Echinacea purpurea)*
Indian blanket *(Gaillardia pulchella)*
Texas plume *(Ipomopsis rubra)*
Black-eyed Susan *(Rudbeckia hirta)*
Goldenrod *(Solidago odora)*.

For other plant species that you might want to include, observe roadsides and fields in your area to determine attractive plants that you might want to put in your meadow. If possible, collect seeds from these plants and sow them in the fall or spring.

There are now many native-plant seed nurseries. From these companies you can purchase a premixed blend of wildflower seeds, or you can buy seeds of individual plants. If you buy a mixture, make sure that it is designed for your own region. A general all-

American mixture will leave you with seeds for many plants that will not grow in the Southeast. If you put together your own mixture, check the recommended planting rates. Germination rates vary greatly from one species to the next, and it will be necessary to sow different amounts for different flowers.

(3) Preparing the soil. Getting good seed-to-soil contact is of prime importance when you are sowing the seeds. Just as you would never stand on the back porch and throw zinnia seeds out into the grass and expect them to grow, you can't expect wildflower seeds to germinate without proper soil preparation either.

The primary goal in preparing an area for planting a meadow is to create a seedbed with loose, friable soil containing the fewest weeds possible. The way to attain this goal will in large part be determined by the size of the area you are working with and the resources you have available to you.

If you are establishing a relatively small area of one-half acre or less, till the soil to a depth of six to eight inches. Allow this to lie fallow for three to four weeks. After this period of time, you will probably have many weeds that have germinated and grown in your meadow site. Using a general herbicide, kill back all the weeds. Wait another week or ten days for the herbicide to dissipate, and you will then be ready to seed the site.

If you are working with a larger piece of ground or if you want to eliminate the need for an herbicide, you need to surface till the area. That is, till the soil to a depth of only an inch or two. This shallow tilling will cause fewer weed seeds to germinate and will result in far fewer weeds in the site. The downside, however, is that the seedbed will not be worked as well. The result will probably be not quite as great a concentration of wildflowers as in a site that was deeply tilled.

After tilling, by either method, rake the seedbed as smooth as possible.

(4) Planting. Once the ground has been prepared, you are ready to sow the seeds. Wildflower seeds are generally very small and are almost always very expensive so you want every seed to count.

In the Southeast it is possible to plant the meadow in either spring or fall. Generally a fall sowing is recommended, for this

allows the seeds to go through alternating periods of warm and cold, which is necessary for many of the seeds to germinate.

Take the seeds and mix them with twice as much dry sand or sawdust. Take the seed-sand mixture and divide it into two equal portions. Either broadcasting by hand or using some sort of mechanical sower, sow one part of the seed-sand mixture walking in a north-south direction. Cover the entire area. When you have broadcast all the seeds from this portion, get the remaining mixture of sand and seeds and begin broadcasting again, this time walking in an east-west direction. This essentially creates a grid and provides for more complete coverage of the site.

Once all of the seeds have been sown, rake the area very lightly to get them well into the soil, then tamp them down. Tamping may be accomplished either by walking over the area or by using a water-filled sod roller.

A light mulch of weed-free straw may be beneficial if your site is on a steep hillside. Otherwise, mulch is not necessary.

After the seeds have been planted, it is essential that they be watered. The seeds will not germinate unless they receive water. Ideally, you will be blessed with weeks of light rain after you plant your meadow. If this does not prove to be true, get water to the area if at all possible. The seedlings will need good moisture until they become established, usually for three to four weeks.

(5) Maintaining the meadow. Low maintenance does not mean no maintenance. In planting a meadow we are putting nature on hold at one of her most glorious stages. Without our management of the area, however, nature would continue with natural succession, and our meadow would soon turn into a young forest.

It is necessary to cut the meadow at least once a year. This not only prevents tree seedlings from invading and becoming established but also allows sunlight and air to penetrate and facilitates the growth of small wildflower seedlings.

Cutting is usually done at the end of the growing season. If you have several fall-blooming plants, such as asters and goldenrods, you will want to wait until these have stopped blooming. Otherwise, you can cut by the middle of September.

The site should be cut to a height of six to eight inches. Conventional lawn mowers will not cut at this height, so alternative

mowing machines will have to be used. For a large area a tractor with a mowing blade will be sufficient. For a small home meadow, the site can be cut surprisingly quickly with a hand scythe, a swing blade, or a weed eater.

In addition to the annual mowing, periodic weeding will also be necessary. How much you weed will depend on the size area you are dealing with and your personal preference. It is possible to maintain a manicured, weed-free meadow, but this is quite labor intensive and really defeats the purpose of a meadow garden.

It will be necessary to keep a lookout for invasive weeds that could become established and destroy the balance of the meadow. In the Southeast, the worst offender is kudzu. Honeysuckle, pokeweed, blackberries, and Johnson grass are also aggressive weeds that you will want to keep out of the meadow.

In a small area, the weeds can be controlled by hand weeding. On a larger scale, it might be necessary to instigate a spraying routine to keep them under control.

The following is a list of seed companies selling wildflower meadow mixtures for our region:

Applewood Seed Company
5380 Vivian Street
Arvada, CO 80002

Clyde Robin Seed Company
P. O. Box 2366
Castro Valley, CA 94546

Green Horizons
500 Thompson Drive
Kerrville, TX 78028

Herbst Seedsman, Inc.
1000 North Main Street
Brewster, NY 10509

Moon Mountain Wildflowers
P. O. Box 34
Morro Bay, CA 93442

Passiflora Nursery
Route 1, Box 190-A
Germanton, NC 27019

Prairie Nursery
P. O. Box 116, Route 1
Westfield, WI 53964

Creating a Woodland Garden

"Help! My garden is too shady. I can't grow a thing."

This is a common complaint in the Southeast. Many of our cities and suburbs are filled with grand old trees—which we would not trade for anything in the world. And many rural homes are surrounded by trees, just where we would like to grow a few flowers too.

Of course, you can grow things in the shade, and one of the best is a profusion of wildflowers that will delight you for several months.

The first step in designing a woodland garden is to determine what environmental conditions exist for your particular site. Although you might know the overall conditions for your region or even for your particular area, your piece of property might involve particular ecosystems that are suitable for special kinds of plants.

The trick is not to redo your entire landscape so that you have appropriate conditions for particular flowers, but to determine which flowers will fit the conditions you already have. Wildflowers need to look free and natural, and it is much easier—to say nothing of being more aesthetically pleasing—to establish a partnership with nature rather than trying to dominate her. There are many wildflowers that can grow in many different kinds of conditions. Find the plants that match your particular environment and grow these.

To determine the growing conditions that you have present in your woodland site, measure the following:

(1) **Ratio of sun to shade**. There are several different kinds of shade. Full or deep shade occurs when the area receives no direct sunlight and stays shady throughout the day as a result of evergreen or deciduous trees growing close together. Temperatures in an area like this are generally several degrees cooler than surrounding areas.

High, open shade is a result of a high tree canopy that allows some light to filter through. The most light will come from slanted rays early in the morning and late afternoon.

265

Partial shade occurs when open areas are next to trees or buildings that offer shade. In this spot sunlight will reach the ground during some part of the day, but not during others.

Filtered sunlight or light shade occurs when light can filter through an uneven canopy, such as under deciduous trees in early spring.

(2) Type of soil. Soil type includes composition as well as acidity and fertility. To determine the composition, observe drainage. If you often have standing water for long periods after a rainfall, your soil probably drains poorly and probably has a high clay content.

Another method for determining composition is digging a shovelful of soil. If the soil feels gritty to the touch and does not stick together well even when moist, it probably has a high sand content. Although this type of soil drains well, it also often leaches out important nutrients. If the soil feels slippery and clumps together when wet, it probably has a high clay content. Unfortunately, clay soils drain poorly and are difficult to work with.

Generally the best soils for a woodland garden are high in organic matter and have a combination of clay and sand. They must have good drainage, good air circulation, and be able to retain moisture and nutrients.

To determine the nutrient content and acidity of your soil, test it yourself with a soil-testing kit or have it tested at a local county extension service.

Harry Phillips, in his excellent book *Growing and Propagating Wildflowers*, suggests that the gardener begin working to amend his soil two to three months before he plants. This allows the soil time to settle before the plants are put in. To help keep weeds in check during this settling period, Phillips suggests putting in mulch four to six inches deep.

(3) Moisture level. The amount of moisture that your area gets in large part depends on the local rainfall. It also depends on the type of soil that you have and the amount of moisture that it retains. Within your woodland site, you might have a spring or boggy area that stays wet throughout the year. You also might have a rocky slope that drains so well that it is almost always dry.

The only way to know what kinds of ecosystems exist within your own particular site is to go out and observe. Snoop around

and take notes. If you have a site that looks promising enough to grow some unusual plants but you are uncertain, ask for help. Many landscape architects are knowledgeable about native plants and where they grow best. Native plant societies or local botanical gardens are also a possibility.

You will also want to work with any existing natural features. A stream offers tremendous opportunities for growing moisture-loving plants. A rock outcrop or big boulders in the woodland area offer a marvelous backdrop for many different kinds of plants.

Paths throughout the woodland area will make your garden more enticing. Take advantage of any open shady areas by putting in a bench. This kind of garden can be one of the most pleasant of all landscapes. It can provide color and beauty as well as being a welcome oasis of cool shade.

When choosing plants for your particular site, first make a list of plants that you like and would like to grow. Then check to see if these plants grow naturally in your area. Plants that are native to or naturalized within your area will probably grow best. Next check to see if they match the particular ecosystems of your site.

When purchasing plants, make absolutely certain that all you buy were propagated and not dug from the wild. There are many excellent native plant nurseries in the Southeast that take great pride in propagating all of their nursery stock. If you are in doubt about any plant or species, ask questions. If the nursery or garden center personnel cannot give you a clear answer as to where the plant came from, don't buy it. Too many of our native plant species are being dug from the wild at an alarming rate, threatening natural populations. The most effective means of ending this unethical practice is to refuse to buy any plants that have not been propagated properly.

The most outstanding season for the woodland garden is spring when so many of our small, ephemeral wildflowers are in bloom. However, with careful planning, it is possible to have interest and color in the woodland garden throughout the year.

The following lists include wildflowers that are generally easy to grow in most parts of the Southeast. Check individual growing requirements to make certain these will do well in your area and on your particular site.

Spring:
Bloodroot *(Sanguinaria canadensis)*
Green and gold *(Chrysogonum virginianum)*
Virginia bluebells *(Mertensia virginica)*
Birdfoot violet *(Viola virginica)*
Columbine *(Aquilegia canadensis)*
Foamflower *(Tiarella cordifolia)*
Dwarf crested iris *(Iris cristata)*
Jack-in-the-pulpit *(Arisaema triphyllum)*
Wild geranium *(Geranium maculatum)*
Mayapple *(Podophyllum peltatum)*

Summer:
Cinnamon fern *(Osmunda cinnamomea)*
Royal fern *(Osmunda regalis)*
Christmas fern *(Polystichum acrostichoides)*
Turk's-cap lily *(Lilium superbum)*
Jewelweed *(Impatiens capensis)*
Indian pink *(Spigelia marilandica)*

Fall:
Joe-pye weed *(Eupatorium fistulosum)*
Cardinal flower *(Lobelia cardinalis)*
Bottle gentian *(Gentiana clausa)*
Aster *(Aster divaricatus)*

There are many excellent native plant nurseries in the Southeast who take great pride in propagating all of their stock. You can buy from these companies and be assured that the plants were not dug from the wild.

Native Nurseries
Route 5, Box 229-A
Covington, LA 70433

Tom Dodd Nurseries, Inc.
P.O. Drawer 45
Semmes, AL 36575

Shadow Nursery
Route 1
Winchester, TN 37398

Woodlanders
1128 Collecton Avenue
Aiken, SC 29801

Sunlight Gardens, Inc.
Route 3, Box 286-B
Loudon, TN 37774

Natural Gardens
113 Jasper Lane
Oak Ridge, TN 37830

Bibliography

Coats, Alice M. *Flowers and Their Histories*. New York: McGraw-Hill, 1956.

Cunningham, James A., and John E. Klimas. *Wildflowers of Eastern America*. New York: Knopf, 1974.

De Brays, Lys. *The Wild Garden*. New York: Mayflower, 1978.

Dobelis, Inge N., ed. *Magic and Medicine of Plants*. Pleasantville, NY: Reader's Digest Books, 1986.

Duncan, Wilbur. *Wildflowers of the Southeastern United States*. Athens, GA: U of Georgia P, 1975.

Durant, Mary. *Who Named the Daisy? Who Named the Rose?* New York: Dodd, Mead, 1976.

Gibbons, Euell. *Stalking the Healthful Herbs*. New York: David McKay, 1966.

Gordon, Lesley. *The Mystery and Magic of Trees and Flowers*. Devon, Great Britain: Webb and Bower, 1985.

Gupton, Oscar W., and Fred C. Swope. *Wildflowers of the Shenandoah Valley and Blue Ridge Mountains*. Charlottesville: UP of Virginia, 1979.

Headstrom, Richard. *Suburban Wildflowers*. Englewood Cliffs, NJ: Prentice-Hall, 1984.

Hutchens, Alma R. *Indian Herbalogy of North America*. Ontario, Canada: Merco, 1983.

Huxley, Anthony. *Green Inheritance*. Garden City, NY: Anchor, 1985.

Johnson, Lady Bird, and Carlton B. Lees. *Wildflowers Across America*. New York: Abbeville, 1988.

Kowalchik, Claire, and William H. Hylton, eds. *Rodale's Illustrated Encyclopedia of Herbs*. Emmaus, PA: Rodale, 1987.

Leopold, Aldo. *A Sand County Almanac*. New York: Ballantine, 1966.

Martin, Laura C. *Wildflower Folklore*. Chester, CT: Globe Pequot, 1984.

———. *The Wildflower Meadow Book*. Chester, CT: Globe Pequot, 1986.

Mohlenbrock, Robert H. *Where Have All the Wildflowers Gone?* New York: Macmillan, 1983.

Mooney, James. *Myths of the Cherokee*. Nashville, TN: Charles and Randy Elder, 1982.

Myers, Norman. *A Wealth of Wild Species*. Boulder, CO: Westview, 1983.

The Book of Wild Flowers. Washington, DC: National Geographic Society, 1924.

Phillips, Harry R. *Growing and Propagating Wild Flowers*. Chapel Hill: U of North Carolina P, 1985.

Padilla, Stan, and Walking Night Bear. *Song of the Seven Herbs*. Summertown, TN: Book, 1983.

Peattie, Donald Culross. *Flowering Earth*, New York: Viking, 1939.

Peterson, Roger Tory, and Margaret McKenny. *A Field Guide to Wildflowers of Northeastern and North Central North America*. Boston: Houghton Mifflin, 1968.

Shosteck, Robert. *Flowers and Plants*. New York: Quadrangle, 1974.

Sperka, Marie. *Growing Wildflowers: A Gardener's Guide*. New York: Scribner's, 1984.

Tatum, Billy Joe. *Wild Foods Field Guide and Cookbook*. New York: Workman, 1976.

Teale, Edwin Way. *North with the Spring*. New York: Dodd, Mead, 1951.

Thompson, William A. R., ed. *Medicines from the Earth: A Guide to Healing Plants*. San Francisco: Harper and Row, 1978.

Tull, Delena. *A Practical Guide to Edible and Useful Plants*. Austin: Texas Monthly, 1987.

Tyrrell, Esther Quesada. *Hummingbirds, Their Life and Behavior*. New York: Crown, 1985.

Notes

Notes

Notes

Notes

Notes

Notes